JUST ONE MORE...

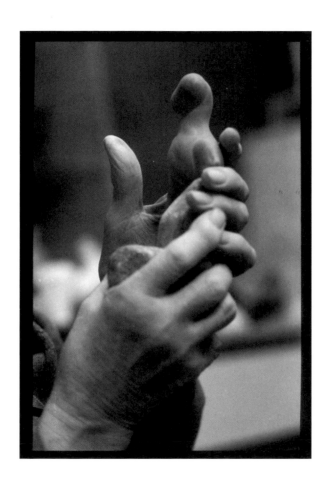

COVER: **Gemma Levine in Jerusalem, 1975. Photograph © David Foster OBE**

PREVIOUS PAGE: **The hands of the sculptor Henry Moore, photographed in 1977.**

PAGE SIX: **Detail of *Oval with Points* 1968–70 in bronze by Henry Moore.**

First published 2014 by
Elliott and Thompson Limited
27 John Street, London WC1N 2BX
www.eandtbooks.com

ISBN: 978-1-90965-382-5

Text © Gemma Levine 2014

Picture credits:
All photographs © Gemma Levine, except the following: pp. 13, 30, 213–17, which are from the archive of Gemma Levine; and p. 190, which is by Peter Bowles.

All images of Henry Moore and his works reproduced by permission of The Henry Moore Foundation.

The author and publisher would like to acknowledge: The Tate Archive, Tate Britain, which holds Gemma Levine's photographic archive of Henry Moore (1975–1986); The Maybourne Hotel Group, which holds Gemma Levine's photographic archive of Claridge's Hotel (2003–2005); The Hebrew University of Jerusalem, which holds Gemma Levine's photographic archive of Israel (1975–1985); The Henry Moore Foundation; Getty Images; and LOC: Leaders in Oncology Care, London.

Every possible effort has been made to locate and credit copyright holders of the material reproduced in this book. The author and publisher apologise for any omissions or errors, which can be corrected in future editions.

9 8 7 6 5 4 3 2 1

A catalogue record for this book is available from the British Library.

Design: Karin Fremer

Printed in China by 1010 Printing Group Ltd.

JUST ONE MORE...

A PHOTOGRAPHER'S MEMOIR

GEMMA LEVINE

In memory of my dear parents
Mae and Ellis Josephs

And to
Eric Levine
to whom I was married for twenty-four years, who
fathered our two remarkable sons and who supported
and encouraged me from the beginning of my career.

My sons, James and Adam

My grandchildren
Yael
Ariella
Emma
Charles

My dear friends and family, who have been the core
of my existence through these decades. Their lives
have not gone unnoticed; I have been their witness –
as they have been mine.

CONTENTS

FOREWORD BY PROFESSOR PAUL ELLIS

IT IS AN HONOUR FOR ME to be asked to write the foreword for this wonderful book. Unlike many others who feature in the book, I have known Gemma for only a relatively short period, first meeting her in June 2010, when I had the enormous privilege of caring for her following her diagnosis with breast cancer. Over that time, in addition to getting to know her very well, I have come into contact with countless friends and colleagues of hers and have come to understand what an extraordinary life she has led.

Gemma has made an enormous contribution to society in many different areas through her professional work as a photographer and the many charitable causes that she has been able to support as a result of her work. The combination of her incredible energy, zest for life and her profound skill behind the lens, has enabled her to capture many different people and topics and present them in a unique way.

I have come to know and admire her many qualities as she has had to overcome her biggest challenge to date; her battle with breast cancer. Like many patients she has fought a life-threatening illness and debilitating chemotherapy. She has done that with great courage and dignity, and is now slowly recovering from the effects of this. What is unusual, however, is that throughout this period she was always thinking about what she could do for others. She developed the energy to put together a book of her experiences (*Go with the Flow*) told through her photographs, reaching out to touch the lives of many other patients going through the same experience. I remember when she first mooted with me (right in the middle of her treatment) the idea of undertaking such a book. I smiled initially; thinking to myself that there was no way that this was actually going to come to fruition. At that stage I do not think I had truly understood the ambition, drive and sheer single-mindedness that Gemma brings to a task once she has set her mind on it (does anybody ever say no to Gemma Levine?). Needless to say, the project came together beautifully and the book was an enormous success. Since that time I have lost count of the number of patients that I have found reading *Go with the Flow* who have found solace in it. It went on to sell thousands of copies and has touched the lives of many, whether they are patients themselves or have loved ones affected by cancer.

I mention the above story in detail, because I think it goes to the heart of what Gemma Levine is about. Despite going through a great personal crisis, she was able to reach out at that moment and try and touch the lives of others, something that in my experience very few people are able to do. *Just one More ...* captures the warmth, the humanity and the vibrancy of this extraordinary person and the amazing life she has led through the beauty and passion of her photographs.

It has been a privilege to get to know Gemma, first as a patient and subsequently as a friend. I hope you will enjoy this book as much as I have.

PROFESSOR PAUL ELLIS MD FRACP,

PROFESSOR OF MEDICAL ONCOLOGY

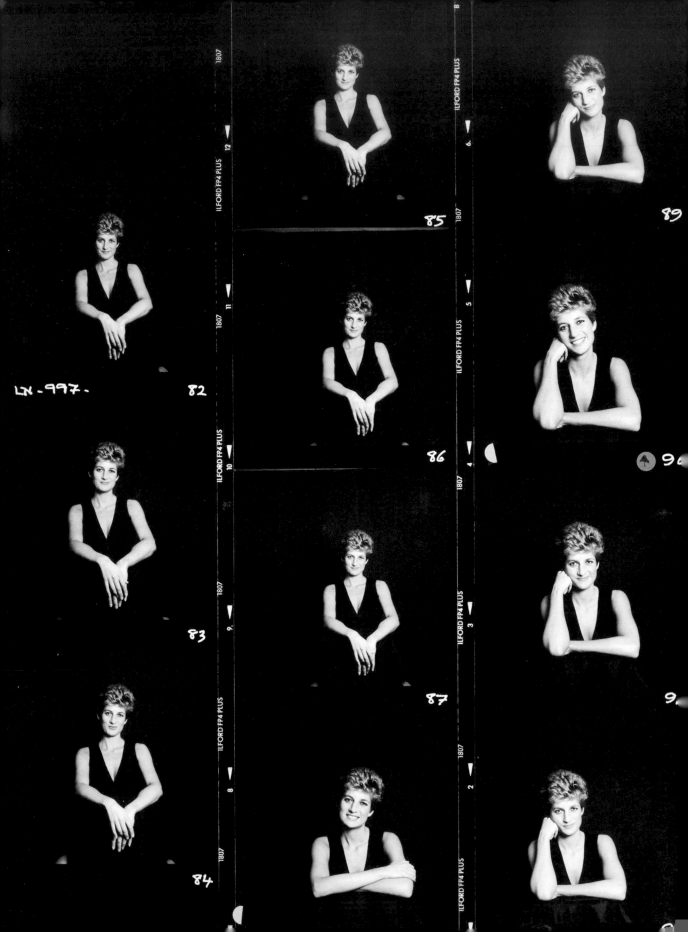

INTRODUCTION

I STARTED MY CAREER AS A PHOTOGRAPHER thirty-eight years ago; a love affair that has lasted a lifetime.

It was before cameras went digital; before megapixel DX formats, CMOS censors; dual TF memory cards; backdrop recordings. All I had in the beginning was a small Kodak Instamatic that took a picture at the press of a button ... needless to say, it had to be at exactly the right moment.

This small, unprofessional camera carried me into the world of one of the greatest artists of our time: the sculptor Henry Moore. He surprised me when he glanced at a selection of photographs that I had 'snapped' on our first encounter, with the Instamatic, and announced that I was 'a very good photographer'. It was a casual remark, but it contained the germ of a possibility; I had a vision of creating my own work from this chance meeting, and that excited me beyond belief. I went on to collaborate closely with this remarkable man over the next ten years, and this experience was the passport to my career.

I would describe myself as a 'professional amateur'. Henry Moore always told me that one should not try to teach, and to keep one's work and philosophy as simple as possible. I had no kind of formal technical education. But I seemed to have a natural instinct for capturing an image with the lens of a camera. With a painting, one can take time, and cover up any errors; photography is instantaneous, a creation of the moment, and I was intuitive.

When, in the 1980s, I started working as a portrait photographer, I photographed many remarkable people, and was both thrilled and intrigued by the intimacy created in such a situation: engaging and connecting with an individual, and then capturing that moment forever. Each portrait expressed something of that rapport, and looking back now, I see in these photographs a lifetime of unique moments frozen in time.

One of my favourite subjects was Diana, Princess of Wales, who seemed to possess immense self-assurance. I felt it might have been difficult to establish a real

OPPOSITE: **Diana, Princess of Wales, photographed in Wimpole Street, London, 1994. An image from this session was selected by the Palace as the Princess's official photograph for 1995.**

relationship between photographer and subject in this case, Diana being a member of the Royal family. But I soon discovered that Diana was completely natural; she talked to me about her boys, and I spoke of my own sons. We discussed all the people she knew whom I had also photographed, and gossip and laughter brought us closer. We were totally at ease in each other's presence; without any hesitation, she changed clothes in front of me, asking me if I minded. The sessions were so relaxed, and together we created the perfect understanding. Diana not only sat for photographic sessions in my studio, but also entertained me in her own home in Kensington Palace. There was one funny occasion when late at night the telephone rang. 'Hello, is that you, Gemma?'

'Yes,' I said, 'who's that?'

'Diana.'

'Diana who?' This was followed by bursts of laughter.

I have been genuinely surprised by the development of my career. Being simple in my approach has done no harm; and a huge amount of enthusiasm and a genuine interest in people have helped me along the way. With a camera in my hand, the familiarity akin to the presence of a loyal friend, I have come to see the world as full of infinite possibilities.

In 2010, I was diagnosed with breast cancer, an experience I shared in my book *Go with the Flow*. I underwent months of treatment at the oncology clinic with chemotherapy and radiotherapy; and then, as time passed, I discovered I had swelling in my right arm. I visited my surgeon and was told I had lymphoedema, due to a build-up of fluid in the body tissues that occurred when part of the lymphatic drainage system had been removed by surgery. I have been told this condition is for life. This, of course, has implications for my work as a photographer.

Throughout all my years, I have never used a tripod. My style, rightly or wrongly, has been to use 'the moment', working spontaneously and cropping the image by eye, and I found that a sturdy and heavy camera steadied my hand. I often wondered whether I was the only professional photographer in the world who did not have a tripod as part of my standard equipment. Today, with lymphoedema, I cannot hold anything for more than a minute or two with my right arm or hand. My arm is bound in a tight compression sleeve. I cannot see myself ever holding the weight of a camera again. Perhaps, if I change my way of thinking, I might go out and buy myself a tripod. Go with the flow … why not?

◆ ◆ ◆

ABOVE: **Gemma Levine, age seven, in Angmering-on-Sea, West Sussex, in 1946.**

As a youngster, I was unaware of photography. But I did find myself inspired to translate images that excited me, whether it was the bark of a tree, a frozen leaf, or an expression on a face. It was then, in the 1960s, that I purchased my first 35 mm format camera. I bought Kodak colour film and photographed landscapes and nature.

I believe at that time I had a sense of innocence and, perhaps, even ignorance. I only wanted to explore, and had no aspiration to be a professional. I would wander alone. If I wanted to climb a tree so I could photograph from a height, there was no one to say, 'Be careful!' I was happy, uninterrupted. This feeling of great freedom and creativity in nature is something I yearned for. To witness the desired moment without intrusion meant everything.

I was born in 1939 in Hampstead Garden Suburb, amidst acres of wide open spaces and woodland. My parents, Mae and Ellis Josephs, had lived all their lives in London. When war broke out that year my family were evacuated to Little Gaddesden in Hertfordshire, where I was brought up on a chicken farm. As a child I was shy, skinny and lacking in confidence. If anyone spoke to me in an untoward manner, I would cry, run away to find refuge and sit in a corner sucking my thumb and twisting at a strand of my curly black hair. I recall the bombing, and running at speed to a small home-built shelter in the garden, wearing a Mickey Mouse gas mask. With my mother, elder sister Sally, mongrel dog Betsy and one or two stray chickens, we were huddled together in close proximity, but felt safe.

My father was in the Home Guard, so we rarely saw him. He was well-built and about 5 foot 8 inches in height, had wavy black hair and a suntanned complexion. As a young child I thought he was the most handsome man alive. He was a serious man, an academic, but with a dry, wicked sense of humour. He was the youngest of eleven children, born in England, to parents who were originally from Germany. All through the years, I remember he smoked a pipe constantly every day, which balanced on the right corner of his mouth. To this day, each time I smell

the aroma of Clan tobacco, either in a cigar shop or on the street, my mind races back to my childhood with fond memories.

At the end of the war, we returned to London and lived in a small leafy cul-de-sac in Cricklewood. We had a home help, who looked after my sister and me whilst my mother went to work. Mrs Muckle, a refugee from Germany, was the kindest woman I had ever met, who made delicious fairy cakes topped with coloured icing and decorated with comical faces. (In later years when I would bake each week for my boys, we called them 'humpties'.)

In 1950 I went to the Hasmonean Grammar School for Girls in Hendon. I showed little interest and achieved little success in academic subjects. In the field of sport, however, things were different; I came to life during these activities. I admired my teacher, Mrs Pankhurst, who encouraged me and instilled in me a sense of competitiveness.

At the start of term, I would rush to school to secure a desk near the window so I could watch the boys pile onto the bus from our 'brother' school down the road. I would search for my favoured few, just to get a glimpse or a wave as the bus accelerated past. This, of course, did not help my curricular activities; when the O-level exam results came through, I had just three passes in English Literature, History and Art. Bang went what little confidence I had amassed. I left school in 1955, insufficiently bright to take A-levels, and was lured into my mother's dress shop, Gertrude Carol, in Knightsbridge.

My mother, with her brother, Wilfred, and my grandmother, Ada, had run the business since before the war and worked throughout the war years. They catered to the upper classes, Ladies in Waiting to the Queen and other members of the British aristocracy. Ada died when I was in my teens, therefore I knew little of her, but I remember small things: her highly polished oak table was always immaculate, adorned by fresh flowers and beautifully ironed white linen table mats with crisp napkins to match. Whatever time of day it was, there was a gleaming silver toast rack with delicately sliced toast, in the shape of triangles, the crusts removed. She truly understood and appreciated the importance of aesthetics in our personal environment; this has had a lasting influence on me, to this day.

Ada, born in Wales in 1881, had rather delicate features that were overpowered by thick, heavy-rimmed spectacles made of dark tortoiseshell. The reason they were so thick was that she was virtually blind, although that did not affect her attention to detail. She was intuitive, instinctive and bright as a button. She dressed simply and immaculately and always wore a hat. She would arrive at Gertrude

Carol and sit majestically in the back office listening to my mother talking to clients. My mother, being very sociable, often took her customers into the office for a gin and tonic, as she felt this would improve sales (which it did). Ada enjoyed this, and we would hear her distinctive laugh: she would draw breath, her head jolted back, and snort. The customers would politely ask how she was, and, repeatedly, her reply would be, 'Fair to middlin'.' This quaint old-fashioned expression always remained with me.

Each time I went into the shop I had a sense of coming home. My mother always rushed out from the back office to greet me: 'Let's have a glass of champagne and a smoked salmon sandwich,' she would say with such warmth, embracing me. She would then lure me into a fitting room and insist on making me try on dresses and would generously give me one, two or three. When we were children, she always dressed my sister Sally and me alike, and each time I visited the shop even in later years, she would encourage me to have the same dress as my sister's but in a different colour. I hated this, and rebelled. The shop was old-fashioned and smelt of wax polish, clothes fresheners and a whiff of gin. Heavy draped velvet curtains lined the walls, with pulleys on poles to cover the clothes. The light from the brass low-hanging chandeliers was dim. There was a basement with a washroom and toilet. I was never permitted down there, as my mother said there were rats and she didn't want me to scream. I remember she was on the telephone constantly, haggling with the council over the rent. In all the years that she was there, from the ages of seventeen to seventy-five, she never got rid of the rats.

After my O-Levels, the thought of a career in the dress shop did not appeal, but my mother sent me to fashion school for a year and then, under duress, I took an apprenticeship with the dress manufacturer Frank Usher as a pattern cutter. I soon saw my way out of the manufacturing side of the trade, having produced for them 1,000 left sleeves for coats, instead of 500 left sleeves and 500 right sleeves!

◆ ◆ ◆

At the age of nineteen, I met my husband-to-be, Eric Levine, at a youth hostel on the campus of London University, Hillel House. He was a law student, a lively, bright young man with a shock of blond hair and a ruddy complexion, always dressed in a worn beige duffle-coat and wearing open sandals, even in the snow of mid-winter. He was small in stature but had a magnetic personality that encouraged all around him to draw closer. I was no exception. A couple of years after meeting, in 1960 we became engaged to be married.

Eric sought permission from my father, who was horrified: a penniless student from Sunderland without a suit to his name! The answer was no, but we persevered and finally married in 1961. The ceremony was at an orthodox synagogue in West Hampstead. As I was a member of a choir, the Zemel Choir, I arranged for the entire assembly of sixty choristers to perform at our wedding. It was a sensation. A reception followed and we were lavishly sent on our way, as Mr and Mrs Eric Levine.

We embarked on our new life, modestly setting up home in a rented one-bedroom apartment in Primrose Hill for £6 a week. Eric worked as an articled clerk in a prestigious firm of lawyers in central London. He was bright and, on qualifying, became a junior partner of the firm. When I was first married, I was convinced by my mother to start making dresses for Gertrude Carol. She proudly put them in the window and this pleased me. As I passed the shop on the bus, I would tell the person seated next to me to look, exclaiming, 'Those are my dresses!' The rag trade was still not for me, however, and this did not last long, but it certainly formed a part of my artistic awareness.

Not long afterwards, we moved to a small house in St John's Wood and started a family. James was born in 1963 and Adam in 1965. We had a dog called Cindy, the family traveller, who was often found by the local police boarding a train to faraway places. We also had two blond Persian cats, Honey and Musky. We lived there for seven years, during which time I did not work, but spent time at home with the children and extending the family to include cats, dogs, hamsters, rabbits and fish.

I was, however, involved in several charity projects. I organised a children's film premiere, *Chitty Chitty Bang Bang*, and even went so far as to initiate and run two charity shops in central London, selling an enormous variety of products, often sourced directly from the wholesalers. I also volunteered part-time at the local Montessori school, where I assisted with children who had mental and physical disabilities. My husband and I entertained many business colleagues and friends, and sometimes gave charity evenings. One, I recall, was for the Israel Philharmonic Orchestra and our guest of honour was Rudolf Nureyev. I was so shy at that time that I could not bring myself to speak to him; I could only gaze with sheer adulation.

When my sons started school, I became interested in interior design. My speciality up to this point had been table decor. I used to go to the park and take leaves of the season, matching the colours of flowers to lie along the length of the table before placing the linen, china and cutlery. I was passionate about this and, to this day, spend just as much time adorning a table to make it special, always accompanied by music in the background, which gives me a tremendous feeling of joy and calm.

We had a friend, Adrian Share, who was an interior designer and had furniture stores in Newcastle. He asked me one day to help him with the company's artistic design section in London. With time to spare, I readily accepted, and soon ventured out and acquired a few independent design jobs. It was also around this time that I began experimenting with painting and photography. With my Instamatic camera I would take photographs of the changing seasons in London's parks, and would then paint in watercolour an artistic interpretation. With that camera I felt, from the first click of a button, a desire to capture more than just an image. I wanted to reach out and capture quality and depth, whether a profile, a bleak winter's seascape, a barren desert or a sunset.

In 1969 there was a brief but enlightening interlude when our family, along with Sheba, our red setter dog, and Honey the cat, moved to France for one year. Eric had been offered a position in Paris by the hotelier Charles Forte, who was one of his clients. My time in France truly inspired my creative leanings: visiting Monet's gardens in Giverny; the Orangerie museum in the Tuileries; weekly trips exploring the colourful landscapes of the French countryside. In particular, my passion for Monet's water lilies fuelled my interest in watercolour painting and encouraged me to try my hand at it. It was a very exciting and enlightening time for me, experiencing a different language, culture and lifestyle, and it proved to be an important stage in my artistic development.

It was in 1974 that my interest in the arts started to become a much more important part of my life. I was at a dinner party one evening when I met a man named Jeremy Robson. Jeremy, an up-and-coming publisher, had just started a small publishing house in Poland Street, London. I told him I had a love of photography, and had taken some pictures, but only for my own personal use; so Jeremy suggested I take some photographs for his book jackets and, in return, I could keep the negatives for my portfolio. It seemed to me that this could be a wonderful opportunity to meet people whom I would not otherwise encounter. We made a deal.

For my first assignment I photographed the poets Laurie Lee and Dannie Abse, together with Robson himself, who, I discovered, was also a poet. I have in my box of treasured letters one from Laurie Lee dated 22 September:

Thank you so much for taking the special trouble to print and send me the photograph. It is in no way your fault, but I would be obliged if you would never show or reprint this. You were unfortunate with your subject. I look like a building society manager, on the defensive …

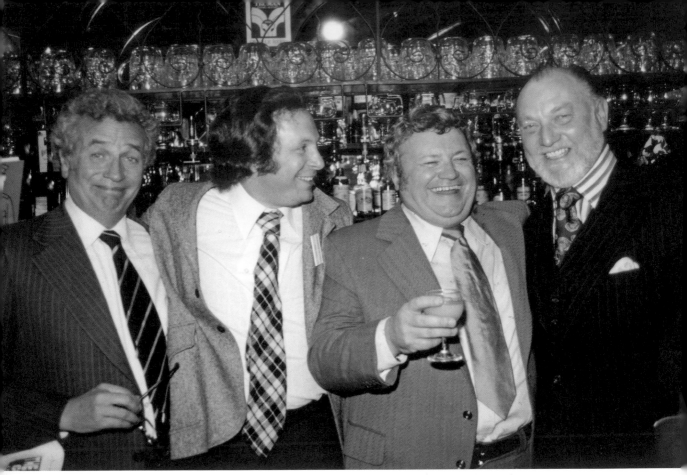

ABOVE: **Photographing the Goons. From left to right: Michael Bentine, Jeremy Robson, Harry Secombe and Jimmy Grafton, at the Grafton pub, London, 1975.**

Perhaps this was not the best start but, fortunately, both Jeremy and I were undeterred. Shortly afterwards he asked me to go to the Grafton, a London pub where the Goons regularly gathered with their scriptwriter Jimmy Grafton. I photographed the brilliant Peter Sellers, Harry Secombe and Michael Bentine. I soon realized what terrific fun this was. The laughter never stopped and, with a few glasses of wine in between jokes (and, in my case, snaps), time went by too quickly. Not long after that, I was assigned to photograph Robert Morley, Alan Coren, Alfred Brendel, Claudio Arrau, Frank Muir, Steve Race, the Amadeus Quartet, the King's Singers and many more. I was amazed by the young Robson, who clearly had a gift for attracting famous people and publishing books about them. I looked forward to each memorable session and loved every one of them.

Around the same time, I received a telephone call from a local photographer called Sydney Harris, an acquaintance of mine, who knew that I had been taking some photographs for Robson. Harris had been asked to photograph at the Royal

Albert Hall where Golda Meir, the former prime minister of Israel, was making a public appearance. He needed my help. Would I be prepared to act as his assistant, even with my primitive Instamatic? I felt that this was too good an opportunity to turn down. When I arrived, the base of the rostrum was packed with about one hundred and fifty world news photojournalists. All the men seemed to be over six feet tall; I could not see as far as the stage, so decided to crawl in between their legs. It was as near to a rugby scrum as could be. I pointed my camera at random and managed to take a couple of snaps of Golda Meir, who was addressing the huge audience. At that stage I thought I would never be tempted to become a professional photographer. But then, when one of my photographs was printed in a daily newspaper, I was ecstatic; and I started to feel differently about the whole experience.

By 1975, I had photographed a few famous people. Very few, but it turned out to be a fruitful beginning. Charles Forte introduced me to his daughter, Olga Polizzi, who at that time was organising exhibitions, and she suggested that she could arrange a viewing for my current collection of work. I was very much an amateur at this point, but Olga bravely staged the exhibition at the Café Royal that

BELOW: **The Goons making merry outside the Grafton. From left to right: Harry Secombe, Peter Sellers and Michael Bentine.**

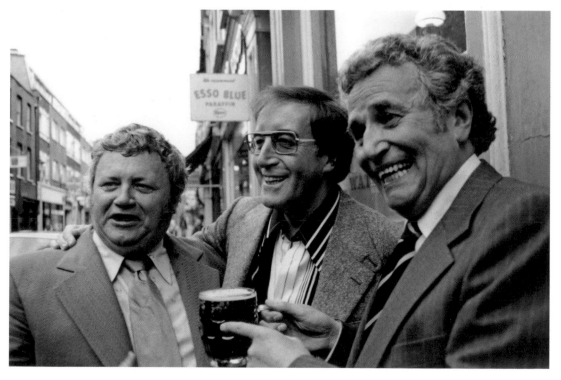

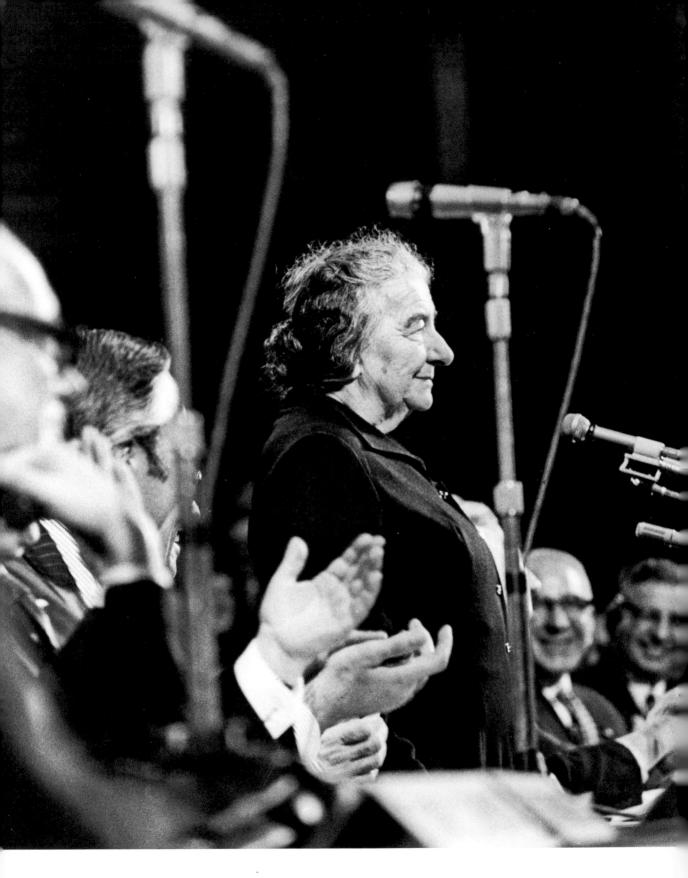

year; it would prove to be the first of many. It was well received, and Olga and I formed a lasting friendship. She is one of the most talented and generous people I have met and I will always be grateful to Charles for bringing us together.

These small but significant events allowed me to move forward with confidence and a grain of experience; to start seeing myself as a photographer. In my pictures, I have always tried to capture the moment; and, in life, seizing the moment is just as important.

◆ ◆ ◆

It was three chance meetings around this time that led me to the beginning of a real career as a photographer. On a tourist trip to Israel, in an unexpected encounter with Moshe Dayan, I asked him if he would allow me to photograph him – and, to my delight, I was invited to his home in Zahalah. Armed with a new Olympus camera, I was certainly still a novice, but Dayan's charismatic character and his professionalism, together with wonderful natural light, made it a cinch.

It was these photographs that I showed to the publisher George Weidenfeld, to whom I happened to be introduced shortly afterwards. To my great surprise, George commissioned me to return to Israel with a 'fresh eye', to produce two books for him. Over the next seven years I returned to Israel many times and published five books. Touring the country alone, I came to know the land well. I got lost many times and found myself in some dangerous areas on – and sometimes beyond – the borders. I must confess I was not good at following maps. However, I felt that, when this period was over, I could have made a good guide. Meeting so many ordinary folk, and discovering such scenic beauty, I began to fall in love with the country.

It was also around this time that I was first introduced to Henry Moore, through a friend. When we met, I was shy and lacking in confidence. But this unexpected encounter was to change my life in ways I could never have anticipated. We went on to work together for ten years and published a comprehensive record in three volumes: *With Henry Moore*, 1978; *Henry Moore: Wood Sculpture*, 1983; and *Henry Moore: An Illustrated Biography*, 1985. In 2011, Tate Britain acquired my Henry Moore archive, and I began to show slide lectures that were authorized by Henry Moore in the early days, at the Tate and other art galleries.

OPPOSITE: **Golda Meir, former prime minister of Israel, at a public appearance at the Royal Albert Hall, London, 1975: Gemma Levine's first venture into the world of photojournalism.**

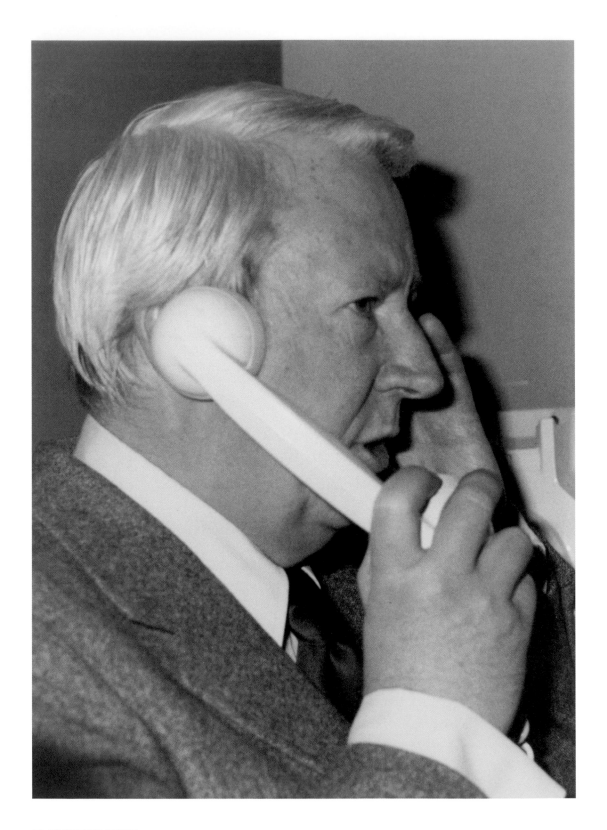

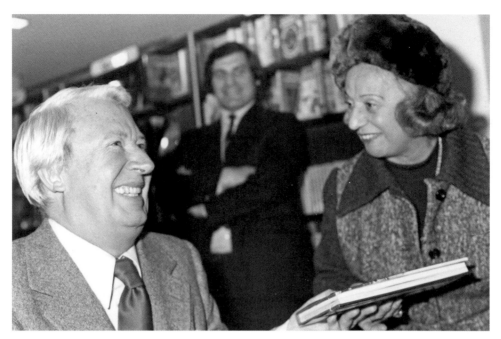

OPPOSITE: **Edward Heath on the telephone to Downing Street on the day of Prime Minister Harold Wilson's resignation, 16 March 1975.** ABOVE: **Earlier that day, Edward Heath sharing a joke with Mae Josephs, the author's mother, at a book signing in Harvey Nichols department store, London.**

Back in 1976, however, I was still very much an amateur. One day, in March, my mother called me in great excitement. She had seen a sign at the Harvey Nichols department store in Knightsbridge, which was just opposite her dress shop. The sign said: EDWARD HEATH MP WILL SIGN COPIES OF HIS BOOK *SAILING* AT 12 NOON TODAY. And so the two of us went up to the signing, where my mother, who was not shy, went straight to Edward Heath and asked if he would mind if her daughter took a couple of snaps. 'Not at all,' he replied, in good humour. With my little camera I took a roll of film; thirty-six shots in total.

In the middle of the signing, the telephone in the store rang: an urgent call for Edward Heath. It was from Downing Street, to say that Harold Wilson, the Prime Minister, had just resigned. A journalist from the *Daily Express* stood next to me, grumbling that his photographer had not showed up. 'Could I borrow your film and take it to my paper to be processed ... NOW!' he shouted at me. My film was biked over to Fleet Street. One shot was used as the *Express* front-page photograph, with the caption: 'Edward Heath on the telephone to No. 10.' I was paid a handsome £35; my first pay cheque for a published photograph! I was so proud.

I was then invited by a friend, Marcia Falkender, who was private secretary to Prime Minister Harold Wilson, to his farewell reception at No. 10 Downing Street where I met many of the famous and distinguished personalities who would in later years feature in my professional life. I took photographs that evening, at Marcia's suggestion. Even though I tripped over a wire and fell heavily at Harold Wilson's feet (while Eric Morecambe looked on and laughingly shouted out, 'I didn't trip her up!'), I did manage to take one or two that turned out well.

I always tried to make the most of opportunities when they arose; and, through learning from my mistakes, being in the right place at the right time, and, ultimately, following my intuition, I found myself with a growing confidence and an ever increasing understanding of my new trade.

When I received the commissions for those first books, my husband bought me a Hasselblad, the Rolls-Royce of cameras, with a couple of alternative lenses. This camera – which today I look at lovingly, but cannot use – was a genuine enhancement to my career. It did justice to my subjects, and gave me the quality to which I aspired. Owning such a piece of equipment was not only a privilege; it gave me the desire to bring my work as close to perfection, using this instrument, as I possibly could.

◆ ◆ ◆

In 1986 there was a drastic change in my life. One winter's night, whilst a storm was brewing, I sat alone on the floor of our home in London, when the telephone rang and my husband, speaking from Denver, Colorado, announced our marriage was over. There was no more to say. The flat turned icy cold. Paintings lost their allure, the fridge emptied and life seemed to come to a halt. During the course of those days and weeks, my sons left home: James to get married, and Adam boarded a flight to Boston University. My Persian cat was stolen and my beloved red setter dog, Sheba, died.

Shortly afterwards, as I was struggling to find my feet again, Marcia Falkender came to see me with an interesting idea: I would photograph famous people of the decade, to be included in a book called *Faces of the 80s*, with proceeds going to a leukaemia charity. This was certainly an explosive start to a new life as a single woman.

I was thrilled at the prospect of becoming a portrait photographer, though a little daunted, having had no training or experience in this specific area. I felt I was at a crossroads, not knowing which way to turn; but, as always, the desire to explore the unknown drove me onwards. I was yet to create my memories.

ABOVE: **Marcia Falkender, private secretary to Prime Minister Harold Wilson in 1974, was co-creator of the portrait book** *Faces of the 80s*.

This turned out to be the first of a series of portrait books that I would create over the next twenty years. During this time, I was incredibly fortunate to meet some remarkable individuals: Margaret Thatcher; John Gielgud; Princess Diana; Quentin Crewe; Joanna Lumley; Judi Dench; Terry Waite; Peggy Ashcroft; Joan Sutherland; Jonathan Sacks; Bob Hoskins; Jonathan Miller; John Mortimer, to name but a few.

I had a duplex apartment in Wimpole Street in London, and used the upper floor as a studio. The camera I used was my Hasselblad with predominately black-and-white film. I became completely involved in my subject. With my eye, together with my gut feeling, I knew when I had the image. And I was quick, so

boredom could not set in. I needed the setting to be tranquil. Plain white walls, pine wood flooring, with just one chair strategically located a few feet in the foreground of the backdrop. The studio flash lights, Broncolor, were positioned as soon as the sitter was seated. At this point Henry Moore's words would echo in my head: 'Flashlight flattens the form of photographs, the object looking as though it has been whitewashed ...' I soon found a way of using my lights to give as much shading and contrast as I needed. Subdued classical music in the background added to the ambience. A small circular table against the wall was prepared for refreshments; flowers, which have been my trademark throughout my life, adorned the little table. There was tea and coffee during the day, wine or champagne in the evening. I often wondered why there were so many requests for the evening sittings. I guess word got around.

One element that surprised me, working on studio portraits, was the fact that sitters whom I met for the first time would confide in me, particularly women. Generally, the session would begin with a conversation over a cup of tea or an evening drink, and I would listen to the most confidential stories. More often than not I would not respond, unless I was specifically invited to comment with an opinion. Thereafter, with a few women, friendships blossomed and to this day we are still in touch.

Over the years, I have gone on to create several other pictorial 'coffee-table' books, and for nearly every project the proceeds were donated to charity. One of my favourites was *Faces of British Theatre* – meeting so many remarkable people was indeed dramatic. Each day was a revelation; I never knew who I would come across next. One charity faced the task of getting every photograph signed – the signed copy was sold at an auction for about £100,000.

Looking back from this memory, back to the person I was in my early thirties, the difference is immense, both in terms of confidence and, simply, in the ability to grasp a moment. There is one experience in particular from my younger years that brings this into stark relief. One night, in New York, on a business trip with my husband Eric, we were invited by his close friend and associate Abba Schwarz to join Frank Sinatra in a horse-and-buggy carriage ride through the streets of New York. It was an awe-inspiring experience. Abba, who was a friend of Sinatra's, encouraged him to sing whilst we were being driven in the open air under the stars. He sang 'New York, New York', and, at the traffic lights, people clambered up to the carriage thrusting bits of paper, matchbooks, anything, into the carriage for Sinatra to sign, which he did willingly and with humour.

When we returned to our hotel that night I did not sleep for an instant; the echo of the familiar music repeated over and over in my ears: 'Start spreading the news, I'm leaving today …'

If I had been then the person I am now, I would have left the carriage that night with a contract in my hand for a new book and a dozen wonderful black-and-white photographs of this incredible man, to be followed at midnight by a reverse-charge phone call to my publisher in London. That could have been my beginning, but it was not. As Charles Forte said to me later, 'Take one thing at a time.'

◆ ◆ ◆

In 2010, when I was diagnosed with breast cancer, I used my connections to write a book about my daily experience of coping with the drastic changes, mental and physical, and donated the royalties to Maggie's Cancer Care Centres. This book, sadly, was a bestseller – and I say sadly because this indicates just how many cancer victims were searching for information. However, the most important thing is that today I still receive notes and emails from people saying how this book has helped them to cope. I have the greatest satisfaction, however traumatic it was for me to compile this book, in having reached the hearts of so many people.

The majority of the vignettes in this memoir were written in 2009; I was about to conclude them when I was diagnosed with cancer. I stopped abruptly. However, three years later, I now feel that it is worth concluding these stories from my professional life. I have encountered endless people who enriched my life with their mere presence, and I could not believe that I was given such a unique opportunity to relate and communicate with all of these individuals. I have encountered such beauty: the wild anemones in the spring in the Galilee; the sun bursting forth at sunrise over the mountains of Jebel Musa; the sun setting over the Judean hills in Jerusalem; the sculptures of Henry Moore; Paris in the spring; New York in the fall. And here in London, at my home and studio in Wimpole Street, where most of my sitters came for their sessions. All have provided a rich and vibrant haven, and for that I will be eternally grateful.

During a surprising and unexpected career, over three decades I have met many high-powered and influential people in this country. In Israel, too, I met and worked with the commanding leaders of the land. In the end, however, the reality was meeting ordinary people from all walks of life, different religions, different nationalities, different personalities – just like you and me.

Meeting Henry Moore

LIFE IS STRANGE. A person we meet or something we read can lead us in a new and unexpected direction – or is it destiny? In my case, life changed dramatically in a very short time.

It happened this way. In 1975 a friend had just come back from visiting Henry Moore and asked me how I felt about his sculpture. I was ashamed to admit that I was not familiar with much of Moore's work. He suggested that I should visit Hoglands, the house in Much Hadham where the world-famous sculptor lived, displayed his sculptures and worked from numerous studios. My friend thought I would gain a huge amount just by listening; he felt that my life would be enhanced by Moore's presence, and I would be excited and stimulated by watching him at work.

Intrigued, on 16 January 1976 I sent a letter to Moore saying, very simply, that I would appreciate so much to meet the greatest sculptor of our lifetime. In response, to my great surprise, I received a telephone call: 'Hello, Gemmalevine.' (One word – for all the years I was with him, he called me 'Gemmalevine'; he thought this was my first name.) 'I received your kind letter and would like to invite you to tea, 23 March at 4 p.m. Is that all right?' he asked abruptly, in a strong Yorkshire accent. Without waiting for a reply, the receiver was replaced.

On 23 March I drove down to Hertfordshire not quite knowing what to expect. On arrival, I was greeted by a middle-aged lady: Mrs Tinsley, Henry Moore's secretary, who was to become a valuable part of my life over the following ten years. She was known as Mrs Tinsley (or Mrs T) by everyone; no one ever addressed her by her first name, Betty.

At the time, Henry Moore was receiving a number of overseas visitors, and when I arrived he was engrossed in showing some of them a large sculpture in bronze on which he was currently working. He did not glance my way and I was far too shy to interrupt him. I proceeded to stroll through the grounds, weaving my way in and out of studios and workshops with my small Instamatic. I snapped everything in sight, from tools to small stones in cardboard boxes, pieces of wood lying on the ground and smaller sculptures, called maquettes. Feeling uncomfortable wandering around on my own, I interrupted Moore and, in a whisper, muttered my

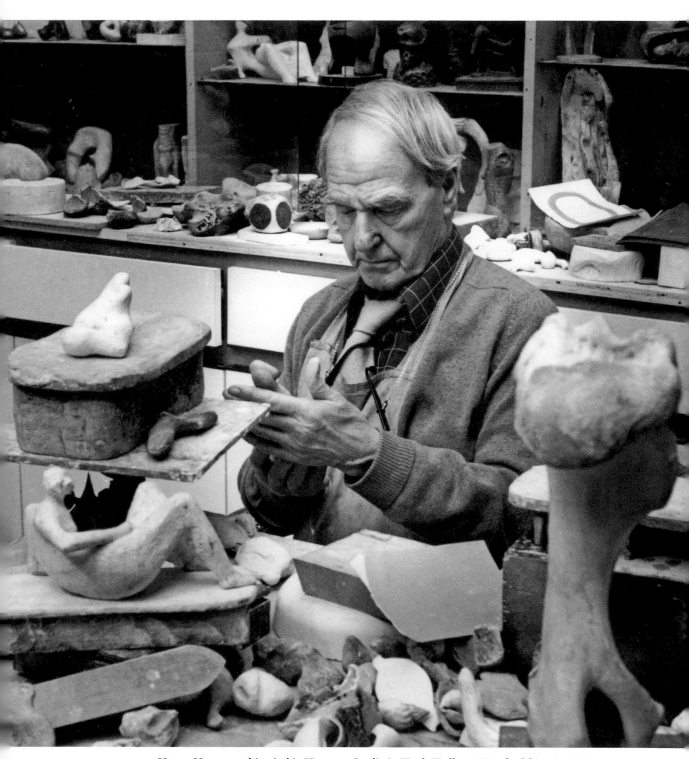

ABOVE: Henry Moore working in his Maquette Studio in Much Hadham, Hertfordshire, in 1976.

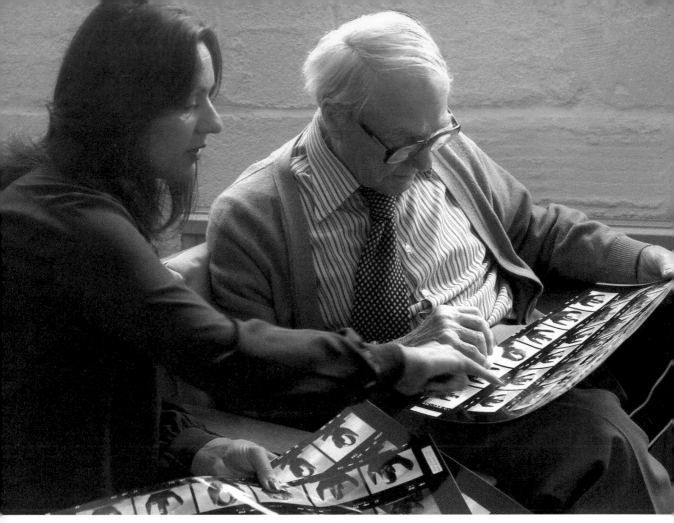

ABOVE: **Gemma Levine with Henry Moore at the Gildmore Graphic Studio in 1980, selecting photographs from a series of contact sheets of *Bird Basket* 1939, for the book *Henry Moore: Wood Sculpture* (1983).**

farewells and drove back to London without so much as a word spoken by him or even a cup of tea.

Back in London I had the film developed, scanned the results and requested a technician to enlarge several shots. Some, to my surprise, were acceptable. To my untrained eye, they looked quite interesting. I telephoned Mrs Tinsley and told her that I would like to show Mr Moore the results, and she made an appointment for me a few weeks later.

So I returned on 24 May, and on this occasion there was a cup of tea. I showed the sculptor the enlargements of my photographs, and he was complimentary. 'You're a very good photographer,' he said. I was flattered, but did not disclose I was an amateur. We walked together through the grounds and I noticed, deposited on the grass, the trunk of a large elm. We paused and he told me that shortly he

would begin carving the wood, over a two-year period, resulting in *Reclining Figure: Holes* 1976–78, which was to be exhibited in 1978 at the Serpentine Gallery in time for his 80th birthday. I said that the ordinary person in the street, like me, could not envisage that this basic tree trunk could eventually form one of the most desirable works of art in the world. I then put forward the idea of a stage-by-stage progression of the piece of wood, from the moment the concept was conceived, through a series of photographs taken periodically to show how a great sculptor worked. He nodded, agreed the format was simple and said that he would think about it. Just like that! At the time I did not dare to dream – this could happen. I had a vision but certainly no technical knowledge. The challenge was daunting, but exhilarating.

That evening my husband and I were having dinner at home. I was seated next to Charles Forte, one of Eric's clients. He asked me how I had spent my day, and so I told him about my visit and explained in detail my thoughts about how we, lay folk, might understand how a sculptor works: what are his influences? What are the stages? With whom does he work? How does he use his environment? I told Charles Forte that I had suggested to Henry Moore that this could be an interesting book. There was a short silence, and then, holding my breath, I was given the challenge perhaps of my lifetime: 'If you can persuade Henry Moore to undertake this project with you, I will get you a publisher.'

Some time later in 1976, it all started to come together. I persevered with monthly telephone calls to Mrs Tinsley, Henry Moore said yes, and Charles Forte kept his promise and introduced me to William Armstrong, editor in chief at the publisher Sidgwick & Jackson, which was then owned by the Fortes. For my birthday, my husband bought me a Hasselblad camera. I spoke to Barry Taylor, managing director of Olympus Cameras, about the assignment, and he provided me with my first real 35 mm camera; and so began my photographic career in earnest. On 8 October 1976, I escorted William Armstrong to Much Hadham to meet Henry Moore, but it was to be a lengthy wait before I was permitted to go ahead and proceed with the work; sculptures had to be finalised and exhibition deadlines met before we could start our work together. Henry Moore was not ready for me.

In a letter to Moore on 16 November 1977, I wrote: 'I think it will only take seven days to complete the photography.' Was I naive or just crazy? It was a substantial project. As a novice I had no idea whatsoever. I was embarrassed to have written such nonsense – how could I have thought like that? But I soon learned. I also wrote: 'I would be quite unobtrusive and the photography would not interfere with you going about your work.' That, too, was naive, as no person or thing

ABOVE: Henry Moore in 1976 examining the trunk of an elm at Perry Green, 1976.

ABOVE: Wood chippings from *Reclining Figure: Holes* 1976–1978.

ABOVE: Uncompleted elm-wood sculpture.

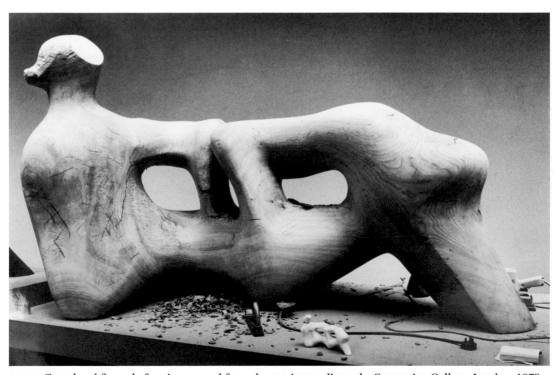

ABOVE: Completed figure before its removal from the carving studio to the Serpentine Gallery, London, 1978.

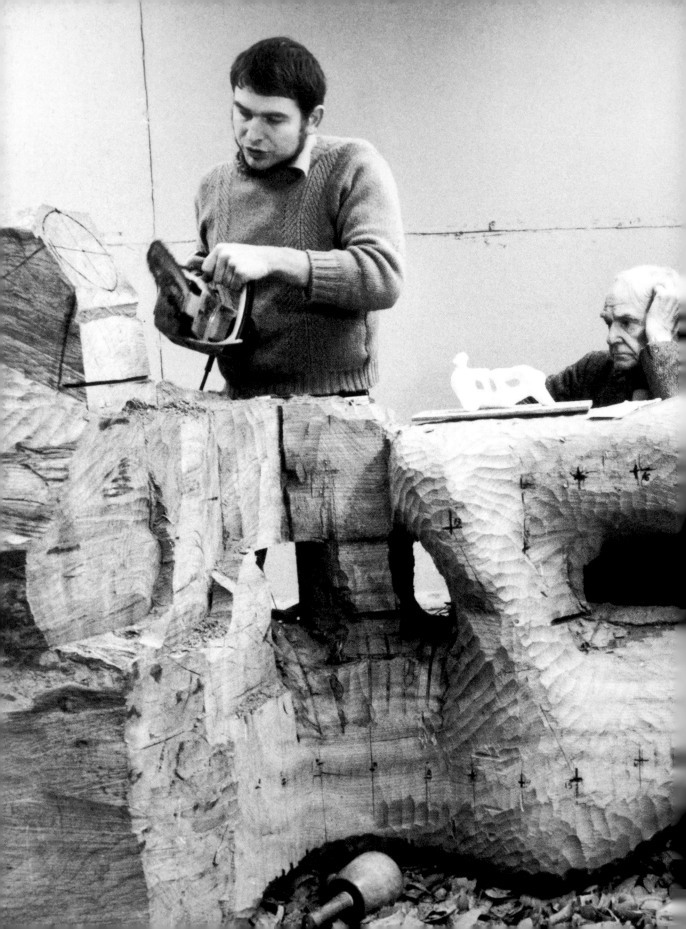

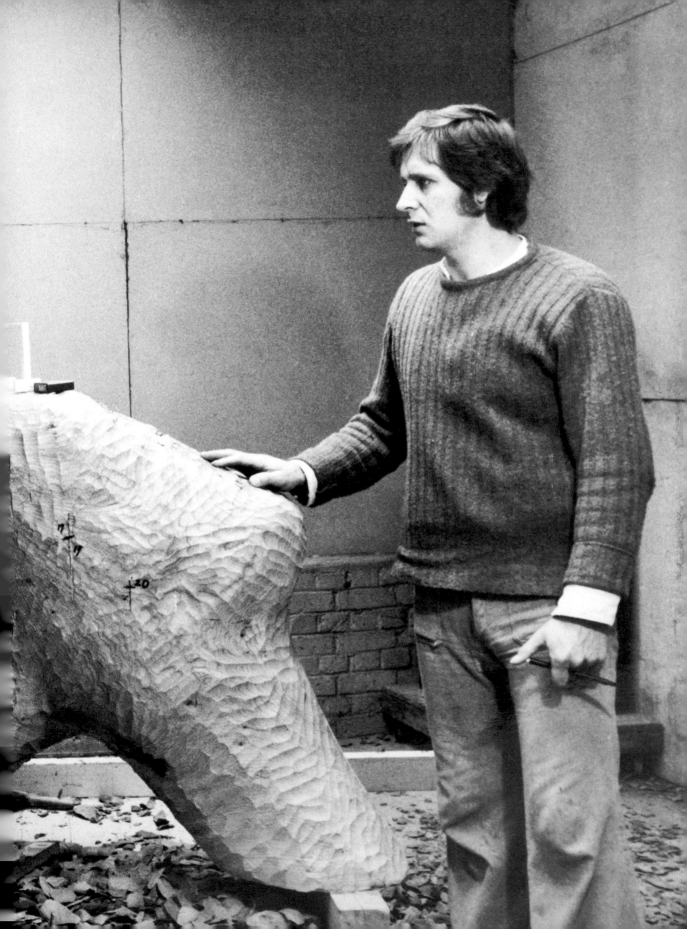

would ever interfere with his work, not even if the house burnt down; during the war years, Moore did some of his most creative work in the shelters throughout the most difficult conditions. Nothing would keep him from his creativity. Nothing!

It was in December 1977 that I finally started work on the book. At the outset I was very shy and, whilst working, remained out of sight. So much so that on one occasion I overheard Henry Moore say to Mrs Moore, 'Gemmalevine is part of the furniture.' I obviously blended in with the background in my determination not to interrupt the artist at work. He was so absorbed with his work that at times he was unaware that I was right there with him. We had a silent symbiotic relationship.

I was told that I was the only female permitted to work with him; all his other assistants were male. I suppose I was fortunate that he had liked the simplicity of the book idea. I formed a firm relationship with David Mitchinson, his archivist, who would work alongside me on our publications, editing my photographs, and we spent many an indulgent lunch at the local pub, the Hoops.

For *With Henry Moore, the Artist at Work*, my first book (1978), I worked once a week over a period of twelve months at Hoglands, following the sculptor with my camera through his various studios – the graphic studio, the maquette studio, the wood-carving studio – as well as the various barns and galleries that housed his finished work. In total, the workshops, studios and his home covered many acres, including park and farmland. Some days I would find him being interviewed for TV or showing foreign visitors around, and I would follow, recording the events. Often, I would join 'Mr Moore' (as I called him) for his 11 a.m. Bovril break.

Watching Henry Moore so intently, always in the background, not disturbing him, allowed me to see the style and manner in which he worked, whether drawing, making maquettes or sculpting large figures. I even had the chance to accompany him to The Morris Singer Foundry in Basingstoke, where we

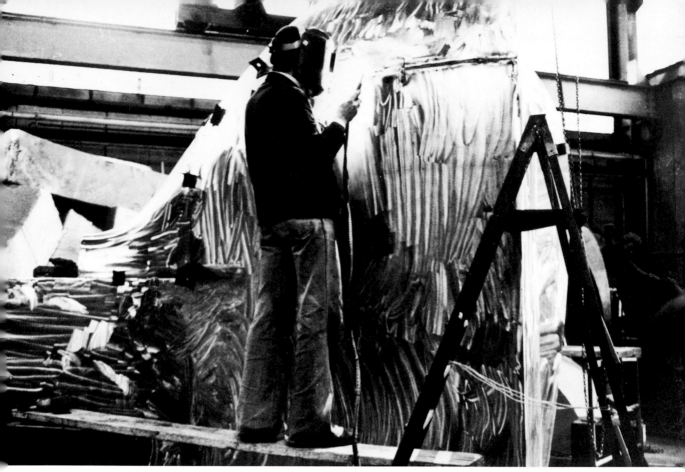

PRECEDING PAGES: Henry Moore with two of his principal sculpture assistants, Malcolm Woodward and Michel Muller, in the carving studio, working on *Reclining Figure: Holes* 1976–78. ABOVE: Sections of *Mirror Knife Edge* 1977 being welded at The Morris Singer Foundry in Basingstoke. OPPOSITE: Henry Moore enjoying an 11 a.m. cup of Bovril at Hoglands, 1978.

watched a large figure being cast, *Mirror Knife Edge* 1977. There were ladders everywhere and about twenty men clad in boiler suits and protective hoods and masks. The heat from the furnaces melting the bronze was extremely intense. We stayed only a short time. It was far more restful to watch Moore in his maquette studio. He would use drawings as the basis for his sculptures, but then would also make maquettes, which were three-dimensional, usually 3 or 4 inches in size, so he could see the shape from all angles. He used plaster for these small sculptures, which ultimately would be used to sculpt large pieces.

I was photographing all the time, quietly out of his way, but I had a great fascination for Moore's hands: they moved like lightning, and he seemed to feel every crevice. Instinctively, the pieces that were superfluous were smoothed away like a puff of air. In 1978 Moore made a three-dimensional sculpture in plaster in response to a painting in his collection, *Trois Baigneuses* 1875–77 by Paul Cézanne. Later in 1980, I was privileged to watch him draw these three romantic figures,

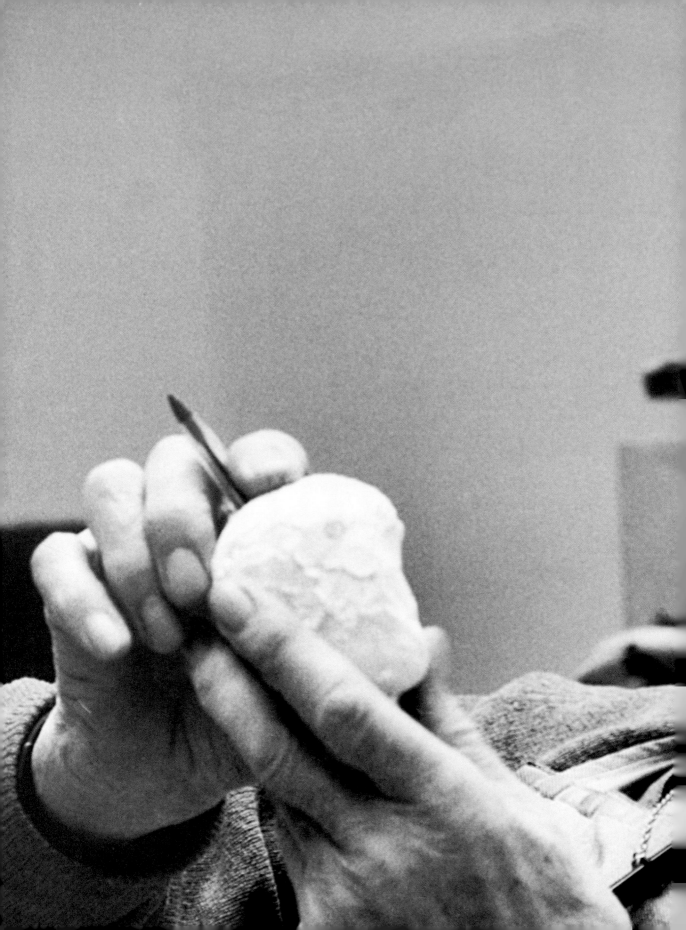

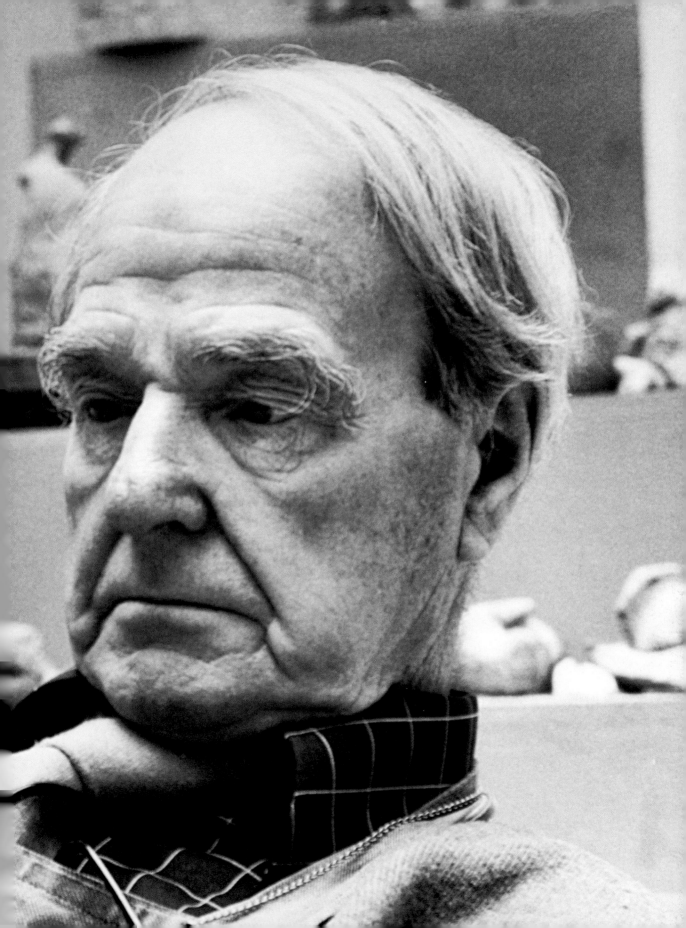

using watercolour, one of a series of drawings entitled *Study after Cézanne's 'Bathers'*. Witnessing such skill and expertise was a highlight of my time there. I learnt to use my camera swiftly and worked with a telephoto lens, not wanting to miss a second. My eye was attuned to this type of speed and my concentration was full.

The beautiful and extensive grounds at Hoglands provided me with the perfect space to explore and develop my own style of photography. On one winter morning, which was particularly memorable for me, Moore and I walked through the woodlands together. We both had cameras, as he was taking his own photographs to serve as references for his drawings and etchings. As we walked we would stop and look at a tree. He would shift the branches around to show me where the light fell, and explain how to photograph three-dimensional objects. That day, pausing, examining branches and trees, we pondered light, shade, dimension, form and space. Moore took a great interest in how I was approaching the subject and would guide me in the right direction. We discussed bark and, in much the same way, he showed me light changes in the crevices. He taught me to look at a face and see its definitions and shadows, and how to capture on film the contrasts between light and shade.

PRECEDING PAGES: **Henry Moore studying a small plaster head, 1978.** BELOW: **Henry Moore photographing trees in the woodland at Perry Green, 1977.** OPPOSITE: **Looking past cast concrete** *Seated Man* **1949 in the coppice at Perry Green.** FOLLOWING PAGES: **The hands of the sculptor.**

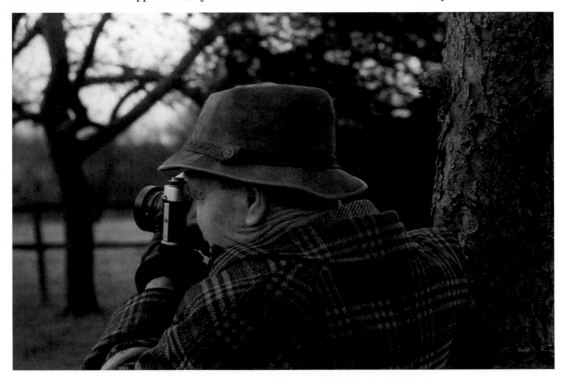

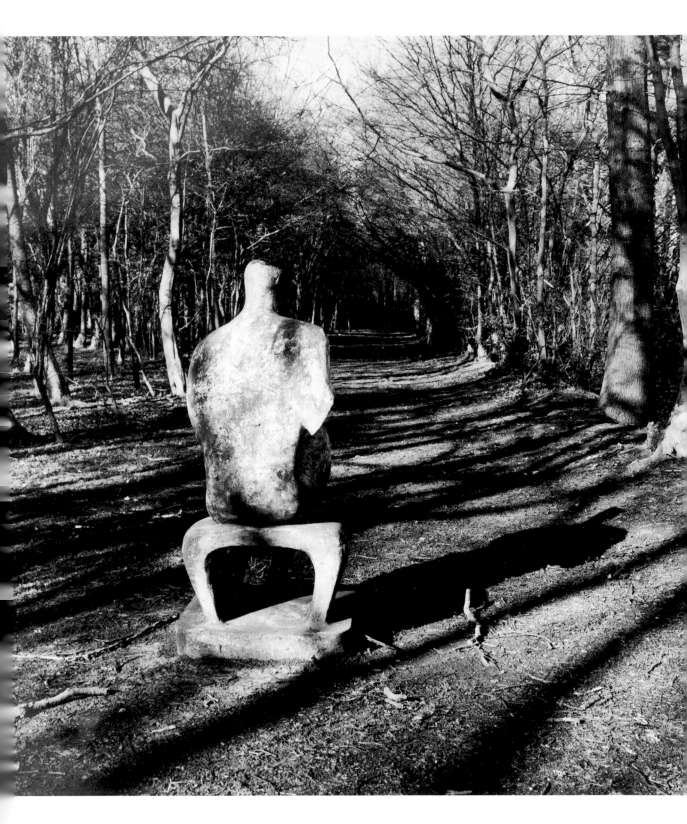

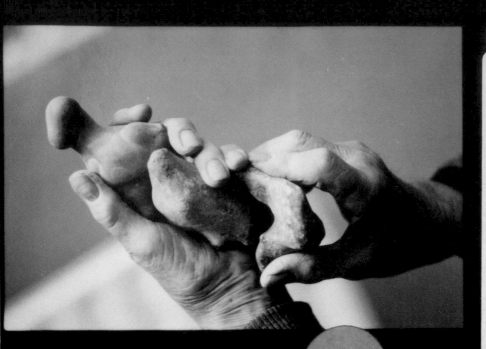

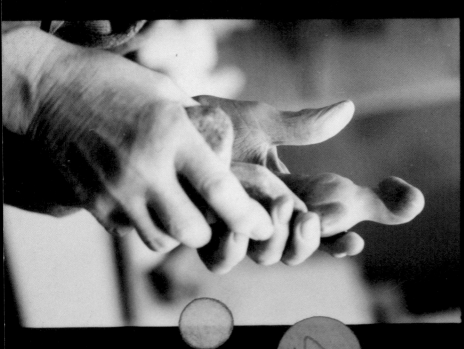

16 → 16A ILFORD 17 → 1

MISSING GORDON E

22 → 22A ILFORD 23 →

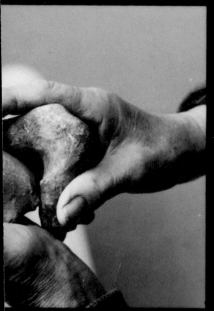
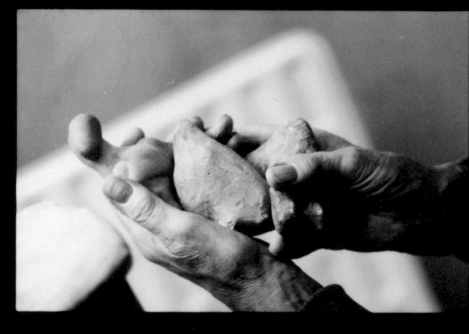

M.Y
Wall

18 → 18A

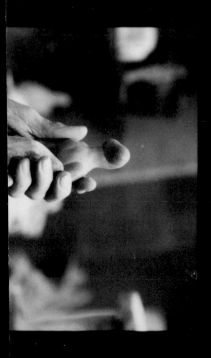
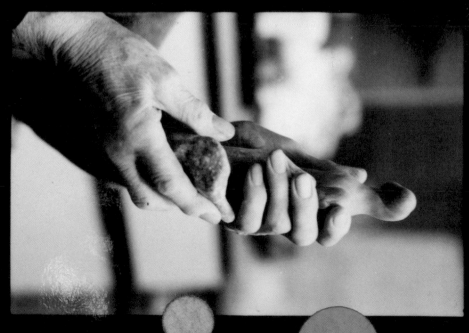

24 → 24A

This opening of my eyes and senses in such a way was to have a huge influence on my career. To this day, when observing nature, I recollect moments of those remarkable hours with him. It is a time I will always treasure as I am sure, on that day, with such a guide and teacher, I learnt more in a couple of hours than I could have learnt in a lifetime on my own.

On 26 November 1982 we took the train to the the inauguration ceremony for The Moore Sculpture Gallery and The Henry Moore Centre for the Study of Sculpture in Leeds, where he was exhibiting the artwork that I had watched him carve directly into the elm trunk after our first meeting back in 1976. The Queen opened the new gallery, and the following evening we held a celebration dinner for Mr Moore. I have a letter from the Queen thanking me for my book, *With Henry Moore*. She wrote that she was 'delighted to have this addition to her library to mark a very special occasion'. It most certainly was.

For our second book in 1983, *Henry Moore: Wood Sculpture*, I was sent overseas to America for one week – to Atlanta, Boston, Buffalo, Dallas, New York – and, finally, to Paris, travelling from city to city, photographing private collections and visiting collectors and museums. It was an exciting project; some of Moore's most striking works were created from wood, which is, as he said, 'one of the most beautiful natural materials'. He carved only forty-three wood pieces in his career and, through him, I was fortunate to gain an insight into this unique sculpting medium. I learnt a great deal about the types of wood, the tools that are necessary to avoid splitting and how weather conditions are crucial when deciding whether a piece should be exposed to the elements or kept inside. The material was special to Moore, as it became to me. As he said, 'Carving direct became a religion and I have practised it during my career as a sculptor. I like the fact that I begin with the block and have to find the sculpture that's inside it.'

In 1985 we began our third book, *Henry Moore: An Illustrated Biography*, with text by William Packer. I travelled to northern Yorkshire in November and, whilst photographing, was blanketed by eerie mists surrounding the moors. I visited Leeds and Castleford, places that were relevant to Moore's working-class background, as well as Roundhill Road, his birthplace in 1898 and the street where he was brought up. As a seven-year-old, his father took him to Adel Rock, a beauty spot on the moors, to play on the monumental stones that would become an influence and a feature of his imagination in later years. I loved this area and sat for many hours contemplating what I saw. To voice my feelings I wrote a poem whilst sitting there, hardly able to see through the November mists, but honoured and content to be part of his past.

MOORS

Cold, wet, windy, ice on foot

As we climb the rocks to the crusty craig.

November slips away unnoticed.

As a chill catches our breath,

Dense is the mist

With heather reaching out across the treacherous way.

Leaves rusted – crusted.

As the moors sing their chords

Somehow no bird can reach the craig.

The history, the mystery only we can know.

Some tens of years away

A man – a boy

Would run and play

The boy would dream of space and time,

The rocks would soar

So endless were those dreams.

Shapes and space

Space and shapes

One day – would encounter more.

I visited Moore's studio in Belsize Park, The Mall Studios, which were a row of shed-like buildings, the very opposite of the grand studios at Perry Green. Moore had been a war artist, and I was fascinated by the Belsize Park underground station on which he based his first shelter drawings. Standing there, when the platform was deserted, it was not difficult to imagine the sleeping figures during the London Blitz in 1940.

Perhaps one of the most thrilling excursions was going down the mines in the coalfields of Wheldale Colliery where Moore sketched. In those days the mining industry was difficult and dangerous. I was afraid and claustrophobic, and so this was the first time in my career that I felt the need of a close friend to accompany me. Susan Bradman rose to the occasion. Following the men in a single line, we crawled on our knees for 250 yards, the length of the shaft. It was frightening and exhausting. I was not permitted to use a flash on my camera, so had to manage with the

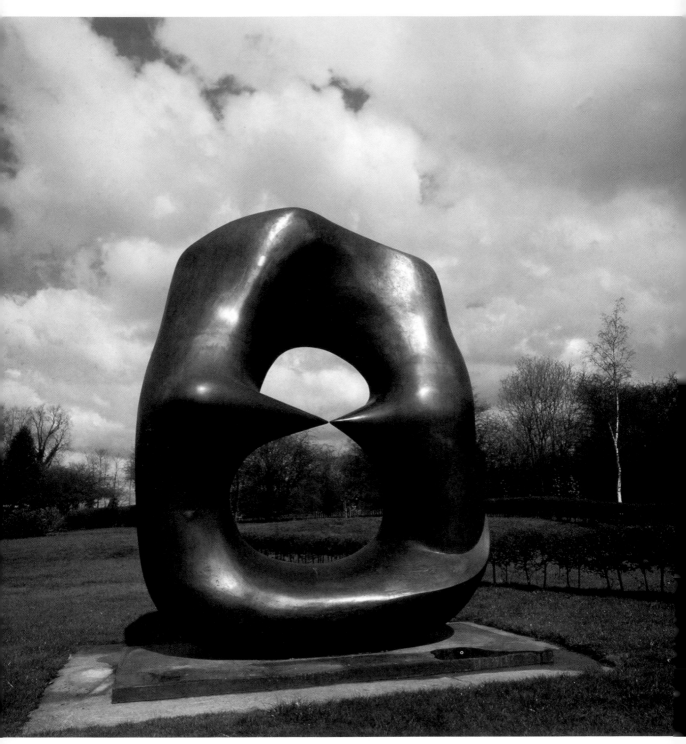

ABOVE: The bronze *Oval with Points* 1968–70 sited at Perry Green.

light from my helmet or anybody else's that I could borrow. Finally, after a couple of hours of photography, feeling a great sense of achievement, we took the shaft up to ground level. Then, thankfully, we were outside again, inhaling fresh air with great relief, surrounded by trees looming up against the vast open sky, and I threw my helmet up into the air exclaiming, 'Thank the Lord!'

◆ ◆ ◆

As time went by I did get to know Moore, and certainly the way he worked. He became my mentor, though we always retained a professional distance. Much later, in 2012, I went to a publishing event for David Mitchinson in a pub in Mayfair. There I met Malcolm Woodward, who had been Henry Moore's assistant, and whom I had not seen for twenty years. He was reminiscing about the carving for the large elmwood *Reclining Figure: Holes* 1976–78, the process I had followed and documented in 1977 and 1978. I recalled the moments as though it had been yesterday. So did Malcolm. He remembered that Moore hardly visited the carving studio and left Malcolm and Michel Muller, his other assistant, to carve there alone having, of course, left precise instructions. I had been under the impression he was there for every session, but Malcolm said it was only when he thought I was coming that Moore would appear. One day he had waited an hour for me, when a message came through saying that I was marooned in a snow drift en route to Much Hadham. Moore left the studio and returned a week later when I was due to arrive. I was rather chuffed to know, many years later, that there had been one occasion when he had waited for me.

I have been asked so often whether any one of Moore's sculptures meant something special to me. The short answer is yes. Moore talked a great deal to me about a sculpture he made called *Oval with Points* 1968–70. The 'pointing' action contained a physical – and emotional – element, where things are just about to touch, but don't. The anticipation is what remains; it is rendered static. Michelangelo used the same theme in his fresco on the ceiling of the Sistine Chapel, of God creating Adam, in which the forefinger of God's hand is just about to touch and give life to Adam. Another of Moore's sculptures with this same theme was entitled *Three Points* 1938–40. None of these points actually touches another; rather, the gap between them is essential. This philosophy has remained with me through the years in many areas of my life: the anticipation is greater than the deed.

There are many things that Moore taught me that have left a deep and meaningful impression. I can still hear Moore's voice:

There is an infinite amount to be seen and enjoyed. Everything in the world of form is understood through our own bodies. From our mother's breast to our bones, from bumping into things, we learn what is rough and what is smooth: To observe, to understand, to experience, the vast variety of space, shape and form in the world. Twenty lifetimes would not be enough. There is no end to it.

<div align="center">◆ ◆ ◆</div>

On entering the main sitting room at Hoglands, on a cold grey drizzly morning in October 1985, I approached Henry Moore. The bed had been placed next to the window, overlooking the gardens. At first glance I saw his back as he was facing the window, and from this view he appeared thin and frail. Wearing blue pyjamas, propped up by pillows, he was tucked up snugly under the bedcovers. When I saw him, his face seemed half the size of the face I had seen just a month before. I was shocked by the change. His deep blue eyes, which I remembered as small, now seemed so large as they stared back at me. He appeared pleased to see me and took both my hands, holding them tightly for the duration of the fifteen minutes I was there.

During the entirety of those ten years that I spent closely with him, we had no personal contact whatsoever. This day was different. We discussed briefly the pictorial biography I was working on; he wanted to know the details of the photographs I had taken. He looked tired and weak. It was fatiguing for him to talk, so I soon felt it was time to leave. He clutched my hands, incoherently murmured some words of farewell and leant over to kiss me gently on the cheek, uttering my name – 'Gemma'. Just 'Gemma': not 'Gemmalevine', as he used to call me. The intimacy of the moment was so different from my understanding of the man I had known throughout ten exceptional years.

I left with great sadness, knowing I would never see him again. These moments I would treasure for the rest of my days, together with our three books, which became a monumental reminder of my years with this great man and genius, whose guidance inspired me and set me on the path to becoming a portrait photographer. I think everyone in life has a mentor, and he was mine. He formed a special place, not just in my life, but in my heart.

His words remain with me: 'Twenty lifetimes would not be enough.'

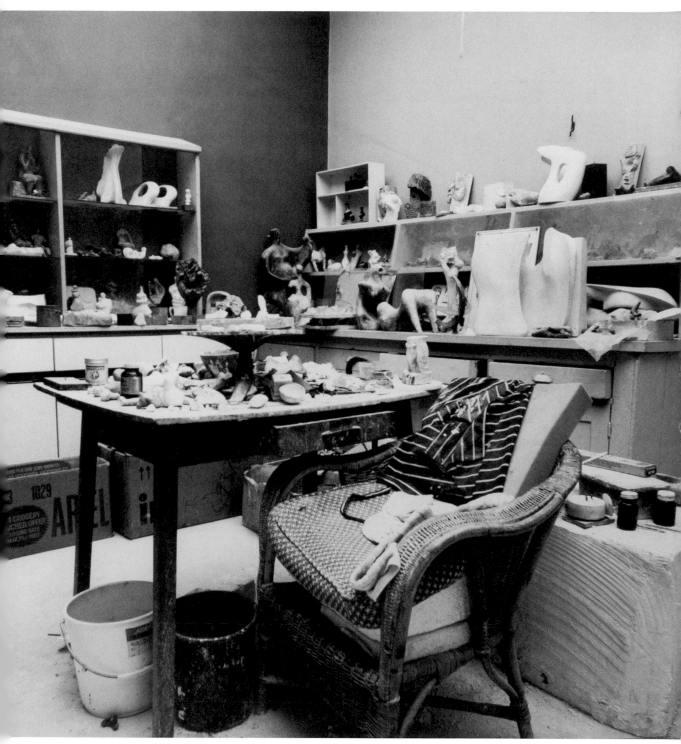

ABOVE: The Bourne Maquette studio became central to Henry Moore's life, from which only illness could keep him.

Journeys through Israel

I FIRST VISITED ISRAEL WHEN I WAS SEVENTEEN, to participate in an international song festival. We performed in auditoriums, army camps and amphitheatres, mostly in the open air under the stars. We travelled the country, north to south, east to west, staying in kibbutzim, army camps and even occasionally sleeping on beaches. We were a young, enthusiastic group, very excited at the opportunity to travel, and the whole experience made a great impression on me.

I returned a number of times later in life, with my husband and boys, sightseeing in Jerusalem, travelling throughout the south, and relaxing by the coast in the north. I loved these holidays, rediscovering the country I had been so taken with during my teens, and having the chance to revisit favourite places with my family. Back in those days, I wasn't involved in serious photography; I was just a passionate holiday snapper, eager to fill the family albums. Even so, I felt an immense appreciation for the diversity of the country – all contained within an area of land no larger than Wales – with its beautiful architecture, old and new, the breathtaking variety of the landscapes, and the many different people, cultures and religions all to be found in one place. I acquired a thirst to learn more about this fascinating country, and, as fate would have it, I was able to devote many years to doing just that as my journey began.

Moshe Dayan

On one particular visit to Jerusalem in the spring of 1974, I had already embarked on my 'career' as an amateur photographer in London, mainly for the publisher Jeremy Robson. On this occasion, I was chatting with a friend from London, who bet me that I would not be able to photograph anyone famous. I have always loved a challenge and said frivolously, 'How about Moshe Dayan?' He responded, 'Don't be silly!'

It probably was silly; nonetheless, I telephoned the Knesset (the Israeli parliament) and asked to speak to General Moshe Dayan, the Israeli defence minister,

ABOVE: **General Moshe Dayan in his garden at home in Zahala, near Tel Aviv, 1975. He adopted his trademark black patch after losing his eye to a bullet in 1941.**

with a view to taking a photograph of him. I did not disclose that I was an amateur, but I was still taken aback to be put through immediately to his office, with no questions whatsoever, and find myself speaking with the man himself. I put forward my request, and received the inevitable response: 'You can get a photograph of me from any newspaper in the country, there are thousands …', whereupon the line went dead.

The following evening, a Friday, I was in the lobby of the King David Hotel, where it seemed that the world and his wife were passing by. There was a buzz of activity, and upon enquiring what was happening, I was told Moshe Dayan was coming in for a meeting. I continued on my way out for dinner, and walked towards the revolving doors; at the exact moment I reached them and started pushing, Moshe Dayan was pushing the door against me, anti-clockwise. With his distinctive eye patch, there was no mistaking him. I started to laugh, and let the door swing around once again so that we ended up facing each other in the entrance hall. 'Hello,' he said, and spoke a few words in Hebrew. I said I didn't understand. He

ABOVE, OPPOSITE AND PAGE 57: Moshe Dayan in his garden, where he would spend much of his time restoring archaeological artefacts excavated from many areas of Israel; it was a great passion that would result in the book *Living with the Bible* (1978).

then asked, in English, what was I doing in Israel, and I replied, 'Trying to establish a meeting with you in order to take a photograph.'

'Why don't you just ask?' he said.

'I did, on the telephone yesterday, but you brushed me off.' He was thoughtful for a moment as he recalled the conversation.

'OK. Come to my home next weekend – call Aviva, my secretary, and she will make the arrangements.'

A few days later, I arrived at Moshe Dayan's home in Zahala, near Tel Aviv. He had a bungalow with a small rocky garden at the rear, filled with antiques of archaeological interest. He greeted me warmly, like an old friend; no mention of the fact that I had rather 'gate-crashed' into his life. He was dressed in khaki – a crisp khaki shirt with rolled-up sleeves, baggy khaki trousers and a traditional Israeli soft cap called a *kova tembel*.

Before my arrival he had been engrossed with his hobby, which was restoring old coffins with fragments of pieces he had found in ancient sites in the desert. He told me with enormous enthusiasm that over the last twenty-five years he had spent all his free time renovating his treasures. At one point some years earlier, while

digging for pieces that were deeply buried, he had broken his back, and this had curtailed his explorations.

I felt in awe of this man and what he represented; I had never met a general before. I managed to take a roll or two of film without letting my nerves interfere, I think because he was hardly aware of my existence – while I photographed, he was completely absorbed by his work. When I left I thanked him and said I hoped to see him again, although privately I thought it very unlikely I would have such an opportunity. He shook my hand, gave me a half salute and then I left, feeling exhilarated and privileged to have been allowed this insight into his private world, particularly as an amateur photographer.

Back in London, I was pleased to have won my bet, and was proud of the images, but it was only through another chance encounter that anything more would come of my connection with Moshe Dayan.

One evening in 1975 I took my twelve-year-old son James to the opera for the first time – to the Royal Opera House in Covent Garden to see Puccini's *La bohème*. It was a spectacular evening, a Royal Gala of which Prince Charles was the

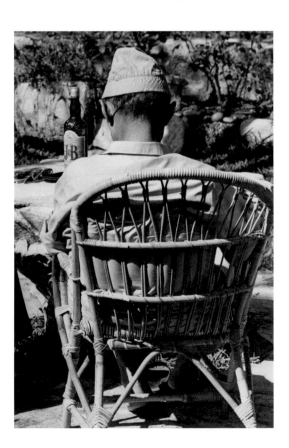

guest of honour, seated in the royal box. As the lights dimmed and the curtain rose, the orchestra stood up to thunderous applause. The atmosphere was electric. James sat gazing wide-eyed at the colourful stage before his eyes. The sheer magic of the experience lit up my son's expression.

During the interlude I left James reading his programme, and went out to join the crush at the bar to buy a drink. I was caught in the crowds at the rear stalls. As I stopped I was conscious of a tall, striking blonde lady standing next to me. I thought her face was familiar from the press. She too was unable to move forward, so as we looked at one another, we began to laugh. We started talking and I learned that she was the prime minister's private secretary, Marcia Falkender. It also turned out that we had some mutual friends and, after a

few minutes, it seemed we had known each other for ever. As the 'gong' sounded at the end of the intermission, an acquaintance of Marcia's approached, who turned out to be the publisher George Weidenfeld. We were introduced amid hurried exchanges and brief promises of telephone calls and further meetings.

Several weeks after this significant evening, I made an appointment to see George at his home and office in Chelsea, overlooking the Embankment. It was very grand, as one would expect of a world-renowned publisher. Bookcases lined the walls, completely filled, so that stray piles of books were also stacked high on tables and chairs, dominating the room.

George was a large, imposing man, with thinning grey hair and alert, piercing eyes. For the size of the man, his hands were quite small. He was nervously edging his large Cuban cigar between two fingers, which he lit and puffed at short regular intervals. The aroma from the smoke was heavy but somehow suited the atmosphere in the vast room. On that day, he was dressed in a dark green velvet smoking jacket, with a mustard yellow silk cravat tucked into a pristine cream shirt, appearing dapper and elegant. Puffs of smoke trailed behind him as he strode from his large nineteenth-century mahogany desk to a padded, well-worn leather armchair. We settled down to our discussion over a cup of coffee.

George was Austrian, born in Vienna in 1919, and spoke coherently and precisely but rather hurriedly in his accented English. He was articulate and got straight to the point. We discussed my forthcoming work on Henry Moore and he wanted to know why I had not suggested doing the publication with his company. He went on to ask whether I might like to work on a similar book with Marc Chagall, or Graham Sutherland. My heart skipped a beat. Embarrassingly, I still felt that I hardly knew one end of a camera from another. What was he talking about? Did he mean what he was saying? I did not know George; I was not used to his quick mind and off-the-cuff decisions.

The conversation changed course. I proposed a book of my nature photographs, depicting the changing seasons, with a possible poetic text by Laurie Lee. He thought this was a terrible idea and hurriedly moved on. 'I would like to see the portfolio of photographs you are clutching,' he said. I handed him a selection of my shots of Moshe Dayan at his home in Zahala. 'This is a coincidence. I will shortly be authorising a new book with Moshe Dayan. I will need a fresh eye to do the photographic work. Are you interested?' I heard myself impulsively say, 'Yes,' before I had any idea what it would entail. He plunged into a confusing amount of detail and I decided that before I could agree, I had to discuss things with my husband.

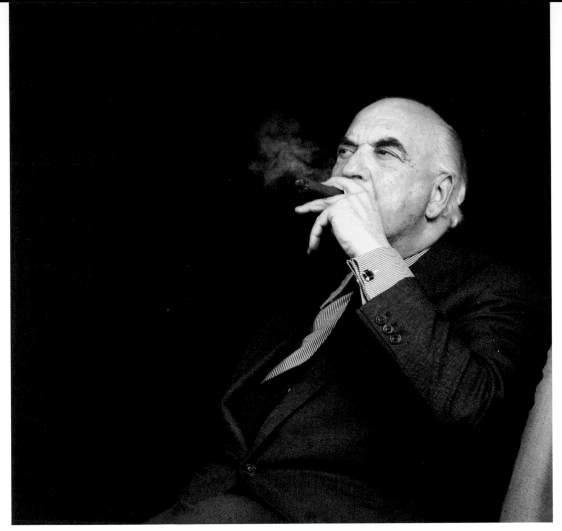

ABOVE: George Weidenfeld, founder of the London publishing house Weidenfeld & Nicolson, photographed in 1978.

My main considerations were my family; any project I took on would need to fit with my boys' school schedules. My husband thought it was an exceptional opportunity and, providing I was away for only a week at a time during the four seasons of the year, it could work. I knew that it would be extraordinarily interesting but also strenuous and tough at times, and there were several practical considerations I had to take into account: travelling alone in a strange country; not speaking the native language; and working with an author, Moshe Pearlman, whom I had not met and who would be in charge of planning my day-by-day diary. It seemed I would have no control, which made me a little apprehensive. I spent several sleepless nights and engaged in numerous family discussions, but I finally accepted the commission in May 1975.

The following week the publishers called to say General Dayan was coming

to London, and I should meet with him and his wife, Rahel, at the Carlton Towers Hotel for breakfast. That morning, coming out of the lift and walking towards the suite, I saw two security guards standing solemnly outside the door. This was an unusual sight for me at the time; needless to say, it became a natural part of my life in the following years while I worked in Israel.

When I entered, Rahel greeted me and ushered me into the lounge area. She said Moshe would be a few moments. While I was absorbed with pouring my coffee, he suddenly appeared in his dressing gown, standing by the door of the bedroom, and walked over to greet me. I was embarrassed as he was not wearing his black eye patch, but thankfully, at that moment, Rahel rushed forward and thrust the patch into his hand, saying in Hebrew, 'Moshe, put it on.'

As we discussed the logistics of the book, he was curious to know why I had accepted this commission. He also asked questions such as, 'What's a gazelle? Where would you find one? Have you been to the wadis in the southern Sinai?' He demanded detail in my responses, as he tried to establish how much I already knew about his country. It was becoming clear to me that he was a very powerful, single-minded general, and I started to feel a little apprehensive in the face of the enormous responsibility I had undertaken. But I decided to commit to the task, however challenging; I was about to embark on a bumpy but wholly significant ride.

To do my photographic work for the project, I visited Israel on four separate occasions, for one week, spread throughout the year. On each trip, I visited Moshe Dayan's home once, and the rest of the time I toured the country to photograph for the extensive work list I was given by his ghost writer, Moshe Pearlman. It involved a considerable amount of travelling – I covered approximately fifty different areas around the country, including Qumran, where the Dead Sea Scrolls were found; archaeological excavations near the Temple Mount; ruins of Philistine Temples at Beth-Shan; St Catherine's Monastery in Sinai; the Church of Nativity in Bethlehem and the crypt beneath it; the ancient fortifications at Masada … I wish now I had noted the mileage. It was quite a task, but I was grateful for the chance to see and photograph such striking and significant places.

When I was with the Dayans, I tended to spend more time with Rahel, as Moshe was anxious to work all the hours he could before sunset. Rahel was pretty and petite, hospitable and charming. I could see she adored her husband, and showed great concern as she felt he was straining himself working such long hours in addition to his other duties. After the book was completed, we met again a few times in London and on the odd occasion in Israel.

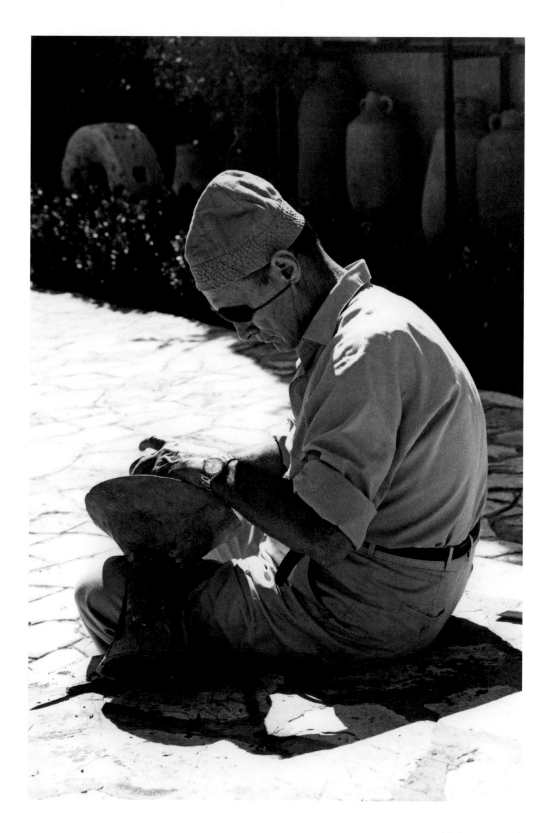

My work was concluded in a year, and the book, *Living with the Bible*, was published in 1978; it described the history of the land of Israel and how modern-day Israelis live within it. When I received my first copy of the publication, I was so proud. Inscribed in my edition were the words, 'With warmest wishes, M. Dayan. September 1978'. It was such an honour to have been able to contribute both photographs and watercolours to the book, and to have had the opportunity to work with one of the most colourful leaders of modern Israel.

Golda Meir

After I had finished working on *Living with the Bible* with Moshe Dayan, George Weidenfeld suggested I create a second book entitled *Israel: Faces and Places*, since I had already taken so much film of the land and its people.

I started the photography for the book, once again travelling the length and breadth of the land. I sought to portray the rare and delicate beauty of this spiritual

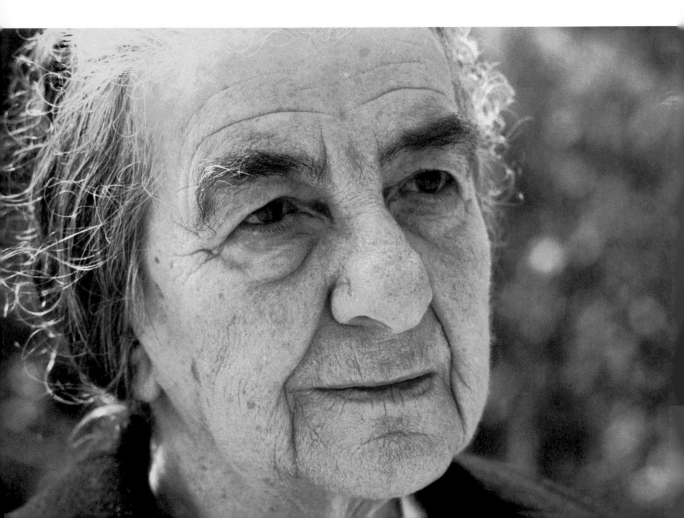

ABOVE AND OPPOSITE: **Golda Meir, former prime minister of Israel, photographed in the grounds of Tel Aviv University, 1977. She was Israel's first female prime minister, and is considered to have been one of the country's greatest leaders.**

and biblical country, together with the vivid contrasts to be found among both its people and its landscapes. Standing in the stillness of the valleys and deserts that had witnessed battles, both ancient and modern, I had an overwhelming sense of the unwavering faith that sustained the Jewish people. Meeting many Israelis of different backgrounds, races and religions, I discovered a common quality – a spirit and a rare strength they seemed to draw from the ancient crusted soil itself. Young people had the surging desire to enjoy life, not to waste it, and wherever I went there was a feeling of human warmth and unity.

I was particularly fortunate to share my impressions of Israel at that time with Golda Meir, one of its most respected and beloved leaders. On 30 March 1977 I spent ten minutes photographing her in the grounds of the Tel Aviv University. We held a brief conversation and she asked me who was writing the text. I told her it was Yehuda Avner, who happened to be one of her speechwriters at the time. She then went on to ask who would be writing the preface. Spontaneously, I asked whether she would. To my great pleasure, she agreed. I was simply ecstatic at the

prospect that she would be involved in my project, and I hurried back to my hotel to call George Weidenfeld, who was also delighted.

I then arranged to meet with Golda Meir again, this time at her home in Rehavia on the outskirts of Tel Aviv, to discuss the book further. When I arrived she brought out a tray with a pot of tea and selection of sponge fairy cakes – which, I was taken aback to discover, she had found the time to bake that morning. She was interested to hear how I was coping with my work, with being a foreigner in her country, and my feelings towards the people and places I had visited.

I told her about some of the highlights of my trip, such as the nature reserve Ein Gedi, where I photographed animals like the ibex, dorcas gazelle and white oryx; trips along the Dead Sea to the south; photographing wadis in the desert; the mountains of southern Sinai; the city of Jerusalem with its diverse religious communities; the kibbutz Degania, where we picked fruits at dawn; swimming in the sea of Galilee, surrounded by the perfume of the wild anemones and orange blossoms; and the stunning panoramic views of the coast from the sand dunes in Ashquelon.

A couple of years later, in 1978, when the book was published, I wanted Golda Meir to be the first person to see a finished copy. I heard that she was in hospital and, after speaking to her personal assistant, Lou Kaddar, was granted permission to see her for five minutes. As I entered the hospital bedroom, she was sitting upright in her bed, reading. She greeted me warmly, and seemed very pleased with the book, signing it: 'In admiration, Golda Meir.' I was humbled by her words. She passed away two months later.

I count this book as one of my greatest achievements. It allowed me the opportunity and honor of meeting and working with one of the most respected and remarkable leaders in history. I asked myself: how, in my lifetime, could I improve on that?

Atonement: Sinai, 1976

Jerusalem: The alarm went off at 3 a.m., shrill and echoing through the darkness of the room. I awoke abruptly and fumbled for my jeans and T-shirt, which I had placed at the foot of my bed the night before. As I was groping in the dark, the phone rang: 'Ma'am ... your wake-up call.'

I thought to myself, what am I doing getting up at this hour? Is this really going to be worth it? But I took comfort in the fact that within twenty-four hours I

ABOVE: **In the beautiful but inhospitable expanse of the Sinai desert, this medical hut provided a safe meeting point and a refuge for an unexpected overnight stay.** FOLLOWING PAGES: **A girl from one of the ancient Bedouin tribes who still inhabit the Sinai leads her goats through the desert, 1976.**

would be back in the luxury of my hotel room, so, in a positive mood, I gathered my things together and rushed out.

Cameras slung over my shoulders, I left the hotel at 3.30 a.m. The full moon shone brightly, giving me enough light to turn my key in the lock of my car door. I revved the engine, headlights full on, catching the early morning mist in the Judean hills. I began to look forward to the journey ahead, feeling a sense of adventure. I reached the tiny airport at 4.30 a.m. and joined the other passengers who had congregated in the lounge to fly south to the desert. I shivered slightly as I felt the chill of the morning air. I took a front window seat, placed my cameras at my feet, closed my eyes and tried to visualise the day, although, never having been in the desert before, I really had little idea what to expect.

On arrival, I was due to meet General Peru, the area patrol manager. It had been arranged that he would collect me in his jeep to take me further into the desert

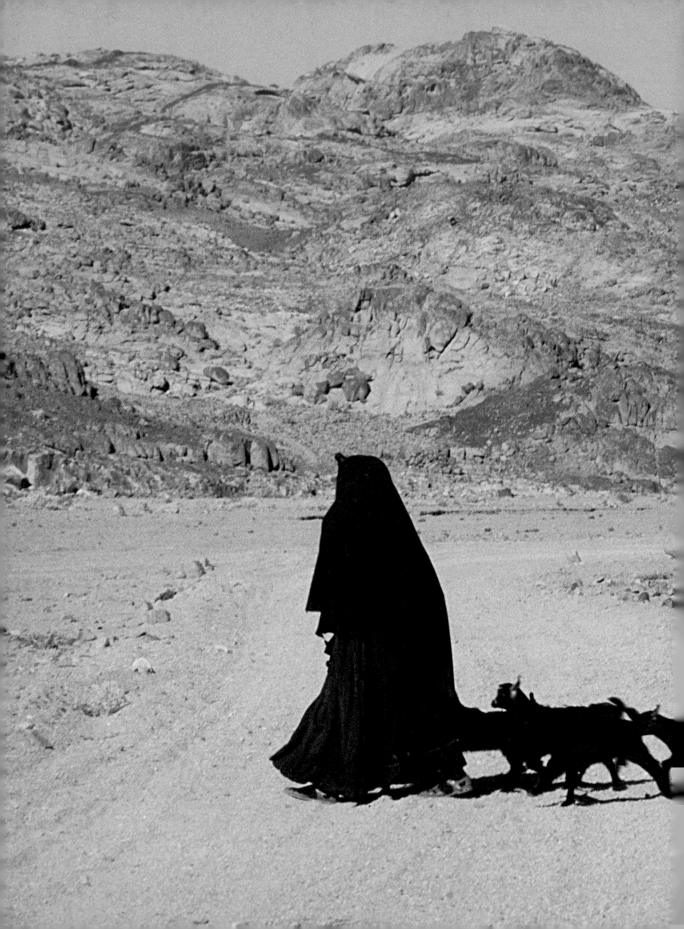

to photograph desert scenes as part of an assignment for *Living with the Bible*: caves; multi-coloured rock-strata in the Sinai mountains; Bedouins; tamarisk trees; wadis and their astounding lush vegetation in the surrounding barren desert. Then, after dark, the general would return me to the airport, so that I could take the night flight back to Jerusalem.

Once outside the tiny desert airport, the bustling passengers dispersed into a dusty, dilapidated bus. Within five minutes I was alone. I looked around the deserted area, wondering how long I would have to wait. After an hour I started to panic, thinking of the vast amount of work I had to cover in a limited time. So it was with relief that I finally saw a small open two-seater truck approaching down the dusty tracks. A man in faded blue jeans, yellow open-neck shirt and a large frayed straw hat jumped out, and I ran over to him. 'Do you speak English? Can you help me?' I told him that I was waiting for General Peru, who would take me to Wadi Firan. With an Australian accent, he replied that he could drive me to the central desert Bedouin medical hut, where he knew the general appeared each day. He added: 'You can't stay here; you'd be better off coming with me, it's only an hour away.'

We drove along winding tracks through the desert, bumping on stones and rocks. The scenery was magnificent. The rock formations were extraordinary, with rich, earthy colours. Shapes seemed to loom from nowhere. The occasional camel could be seen feeding at the foot of an acacia tree, shaded from the midday sun. We came across a Bedouin tent, where women were drawing water from a primitive well. We passed Wadi Firan, the desert oasis on the main approach route to Mount Sinai, evergreen with palm trees showing filigree patterns of the palm roots. It was awe-inspiring.

Eventually we arrived at the medical hut. The Australian asked at what time General Peru would arrive. No one seemed to know, and they were leaving the hut at noon. I was given a blanket, something pink and sticky to drink, pita bread and two tomatoes, and was told I was welcome to stay.

I was alone. The afternoon slowly slipped away into night and, as the sun set, it started to turn very cold. No longer concerned about my work being on hold and delayed, I was more worried at the prospect of spending the night in the desert on my own. I looked at my watch, which my husband had given me on the birth of James, our first son, and thoughts of my family warmed me and gave me courage. At 6.20 p.m., there was the sound of an engine and flashing headlights appeared

on the horizon. I strained my eyes to see if it was a jeep. But no, as it came closer, I recognised the Australian in his white truck.

Screeching on worn brakes, the engine heaved a sigh of relief, and finally stopped. 'Are you all right?' he asked. 'I got a message through to Peru. He understood you were arriving tomorrow, so wishes you a good night and will see you around 5 a.m.' He bent down to open the boot of the car and produced a brown paper bag. 'I've brought you some fruit and cheese, I trust you won't be hungry.' He thrust the bag and a bottle of water into my trembling hands, jumped into the truck and with a wave, shouted, 'Good luck,' and was off amidst a flurry of dust and sand.

Left alone again, I sat down on my camera case, put my head into my arms and sobbed. A faint echo resonated through the sharp mountain air. After a few minutes, which seemed like hours, I returned to the hut, washed my face with ice-cold water and felt somewhat refreshed and ready to face my predicament. A full moon emerged from behind a mountain peak, so I wrapped the one well-worn blanket around me and took a stroll in the moonlight. I felt lucky at least to be able to appreciate the rugged beauty surrounding me.

I reflected on my life, family and relationships. I listened to the sounds of the desert, piercing animal cries that I did not recognise, but suddenly felt, with the moonlight catching the surrounding vistas, an affirmation of my faith. I was unafraid. I have always believed in God, but never so fervently or intensely as at that moment. This day and night had been a 'day of atonement'; a reconciliation with God. I had never experienced such deep sentiments before.

Ever since I was a young child living in London, every year on Kol Nidre (the eve of the Day of Atonement, Yom Kippur) I have gone to synagogue; it has been an important ritual that I have kept religiously. Here in the heart of the desert, the contrast between those visits and this night was immense. I recalled sitting in the gallery of the synagogue, overhearing conversations on the latest fashions, restaurants and other idle gossip. I often wondered who read the prayers; who needed reconciliations; who had dreams and thoughts of their Jewish heritage; who was comforted and wedded to their traditions; who cared? That night, I heard only echoes through the darkness of 'Shema Kolenu' ('Hear our voice, O Lord our God'); these were the soulful words of a familiar melodious chant, which I sang in synagogue as a chorister on Kol Nidre night, feeling a lump in my throat each time. Here, alone in the desert, with only the humming and shrill calls from the desert wildlife (there could have been the strident sounds of a shofar), I realised this was

the real thing. I felt I knew who I was and where I came from. I felt comfortable in my own skin.

Unhurriedly, I returned to the hut and dozed on the cold stone floor for a while, to be awakened early the next morning by the sound of a running engine outside. I peered through a small pane of glass to see the arrival of a jeep. A strong, deep voice hollowed through the silence: 'Are you there? Arnold Peru here. Are you ready? Let's go,' he snapped.

I picked up my camera case, paused a moment and glanced fleetingly behind me into the sparse hut. I hesitatingly closed the door with a fresh feeling of awareness.

St Catherine's Monastery: Jebel Musa, 1976

The Monastery of St Catherine in the southern Sinai is one of the oldest in the world; the Greek and Arabic inscriptions that sit above the entrance record that it was built in the sixth century by the Byzantine Emperor Justinian. The monastery rests at the foot of enormous mountains located, according to early Christian belief, near the site of the Burning Bush where Moses was summoned to his historic mission.

I was visiting St Catherine's to photograph for *Living with the Bible*, and found the monastery was simple, cared for by the Bedouins. It was a rugged two-storey grey stone building with long, narrow corridors that were dimly lit. The building had attracted pilgrims throughout the ages, and passing travellers who would rest and take light refreshment. In fact, today it still serves a similar function. Water for drinking and washing was fetched in wooden pails from the well. The kitchen was the most primitive I have ever encountered. It was lit sparsely by candles but was sill intimidatingly dark. The only glimmer of light came from the sparks of reflection on the brass and copper cooking utensils. The tiny narrow corridor where I slept with several other people was basic and very cold. I slept fully clothed and with as many blankets as I could find.

Leaving the monastery before 3 a.m., I was assigned a Bedouin boy and a donkey to help carry the equipment and supplies for the strenuous climb up the famous steps of the mountain. We walked slowly up the narrow pathways in the dark, guided by shafts of light shining from our torches.

We reached the summit of Jebel Musa (where, it is believed, Moses received the Ten Commandments) after a taxing 2,285-metre climb. It was still early, not yet 6 a.m., so I was able to capture the first rays of sunlight. I recall standing there,

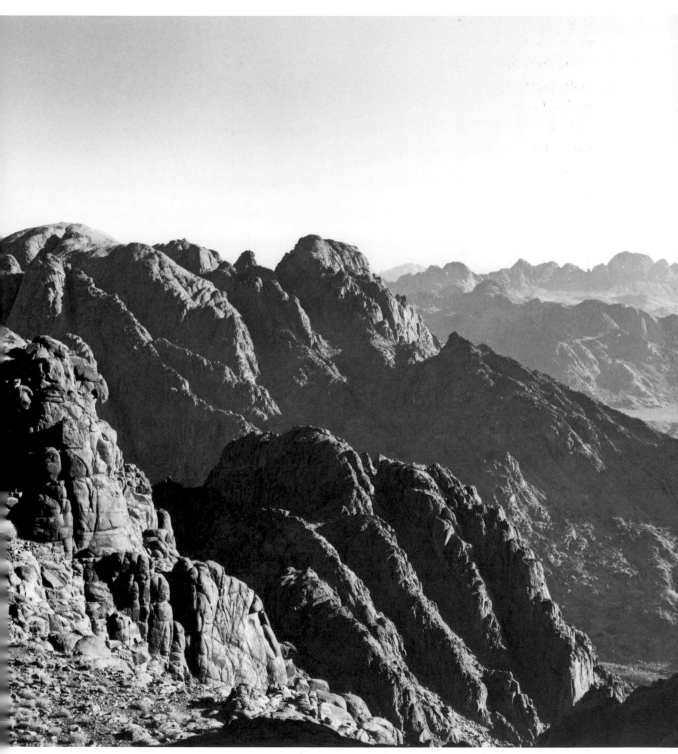

ABOVE: The view from the peak of Jebel Musa, also known as Mount Sinai or 'the Moutain of Moses', in the southern Sinai, where Moses is believed to have received the Ten Commandments.

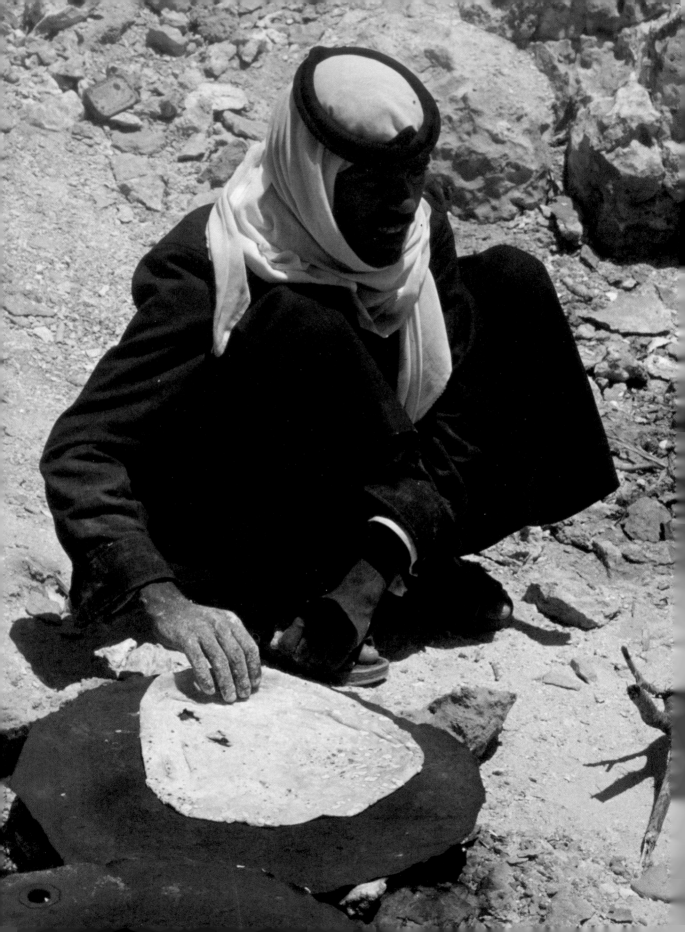

OPPOSITE: A Bedouin man in the southern Sinai desert baking pita bread in the traditional way, on an open stove. This morning meal of bread and mint tea was shared with characteristic Bedouin hospitality. ABOVE: A Bedouin mother with her child, drawing water from a well.

overwhelmed and holding my breath as I witnessed the unique beauty of the rapidly changing light spreading out before me. Soft iridescent blues and greys gave way to a medley of yellows, then bright oranges and pinks, and finally a spectacular vibrant burst of flame in vivid red. Watching the light ranging for miles over the vast span of mountain peaks, and the sheer beauty of the glowing skies at sunrise, brought tears to my eyes. I could understand why Jebel Musa is sometimes called the 'Gateway to Heaven'. Standing there in silence, with a gentle wind blowing from the south, I could almost sense the presence of angels silently gliding through space. I felt a sense of infinity. Walking back down, I could see the bleakness and barrenness of the land below. We were tired and hungry, and fortunately we soon came across Bedouin women with black goats by their tents, and men baking pita bread on open stoves. A rug was spread for us to sit upon, and water was drawn from the well to make mint tea. The beautifully scented tea and the sizzling bread on the scorched stone were about to become the best breakfast I have ever had in my life.

White Chrysanthemums: Tel Aviv, 1976

One very hot August morning I arranged to meet with Hillel Black from Morrow Books, the American publisher of *Living with the Bible*. Our engagement was for 1 p.m. at the museum in Tel Aviv.

I arrived early and sat in one of the corridors by a large picture window overlooking a small courtyard, built within the inner walls of the building and shaded from the sun. In the centre of the area, in the midst of foliage, was an olive tree, and strategically placed in front of the thick ancient bark was a statue of a soldier.

Carved in grey stone, the statue was of a young boy in uniform, seated with a gun at his feet. As I was studying the simplicity and the beauty of the sculpture, a tall blonde woman came into the courtyard from the opposite entrance, cradling a bunch of white chrysanthemums in her arms.

She placed them lovingly at the foot of the statue and stood back, motionless, just staring, her face pale and forlorn. As I watched, tears ran down her cheeks uncontrollably. I could feel the grief and pain emanating from this woman. She fumbled in her bag for her handkerchief and produced a couple of crumpled, pink paper tissues, and proceeded to clean the statue with tenderness. She wiped his face, the sides of his nose and ears and in the crevices of his tight, curly hair. Watching this genuine suffering, I felt I was intruding on the most private and sacred moment of her day. I wept for this unidentified woman. This was the young mother of a dearly adored son, a recent victim of war.

I was mesmerised by this moment and could not bring my concentration back to my mundane routine. I wondered how many other mothers were experiencing the same acute agony in this way. As she slowly walked away from the statue, not glancing back, she appeared as lifeless as the statue.

All that remained of her visit were the white chrysanthemums, lying at the base of the statue on the edge of the hefty worn-out boots of this soldier, with petals that had fallen and scattered onto the rifle placed at an angle, immobile.

Peace Within Reach: Jerusalem, 1979

'The Israel-Egypt process reached a crescendo of tension and intensity yesterday, as US President Jimmy Carter spent six hours in tough talks with Israel Premier Menachem Begin …' /Jerusalem Post, *Sunday 11 March, 1979*

On the afternoon of Friday, 9 March 1979 I was staying at the King David Hotel, which overlooks the ancient walls of the old city of Jerusalem. The hotel, renowned for providing regal splendour to kings, queens, presidents and prime ministers, was in turmoil due to the imminent arrival of American President Jimmy Carter.

Earlier in the day, guests had been asked to vacate their rooms and were directed to alternative hotels, so that five hundred bedrooms could be allocated to the President's staff, the international press, security and aides. The six-storey hotel had to be cleared twenty-four hours beforehand so that the rooms could be prepared and security checked. I was in Jerusalem to cover the historic event for the British press. The agency Camera Press, with whom I was working closely, asked me to cover the event in pictures and, as I was there anyway, it seemed an interesting diversion from the other work I was doing on my books. As I was a frequent visitor to the hotel and they knew me well, the management agreed that I, alone, could remain.

American flags were hoisted onto sturdy marble pillars throughout the lobby. In between the heavy potted plants and in front of the dark wood panelling were three life-sized bronze busts of President Carter, the Israeli Prime Minister, Menachem Begin, and the Egyptian President, Anwar Sadat.

Hotel staff scurried about with pots of paint, ladders and cleaning materials, giving the grand building a facelift. The ceremonial red carpet was cleaned and new carpet laid on the stairs. Jewellery cases were emptied and ornamental jewels arranged in such a way that the word 'Welcome' appeared in the colours and shape of the American flag. Florists placed red, white and blue flowers in huge urns on the reception desk and on every available table. Every detail was attended to with the utmost skill and competence. The lobby dazzled with a commemorative spirit.

That Friday evening, when the final preparations were complete, I walked through the lobby alone. It was as unfamiliar as a Sabbath night in Jerusalem, standing in sharp contrast to the usually warm and energetic atmosphere. The night held a definite chill. The telephones, which rang constantly, were ignored. There was an air of unreality.

I retired to my room through equally silent corridors. I switched on the radio to hear the news in English. 'There is hope that President Carter, arriving in Israel tomorrow, will bring the final leg of the sixteen-month peace process between Israel and Egypt to a conclusion. In three days of crucial talks here, which begin within an hour of his arrival, the president will try to bridge the gap ... Carter says, "There is peace within reach."'

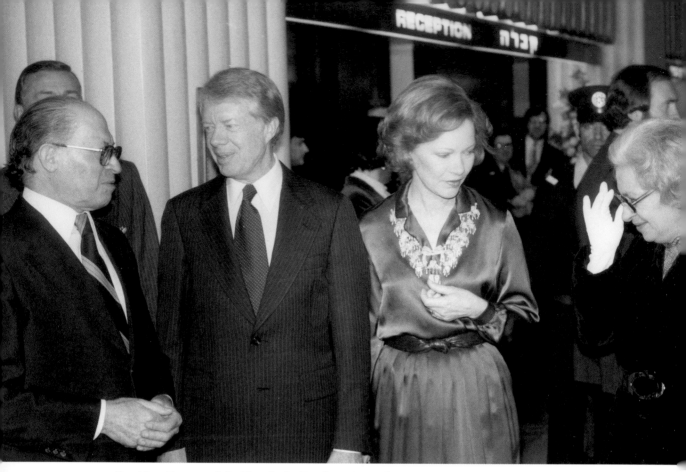

ABOVE: **President Carter and the First Lady, Rosalynn Carter, being received by Prime Minister Menachem Begin (left) upon their arrival in Jerusalem, March 1979. Later that month, the Egypt–Israel treaty was signed in Washington, DC.**

The next day I was awakened by the sun casting rays of light across the room. I dressed hurriedly and left my room to observe the developing activity. Security men were shouting loudly at each other and talking into walkie-talkies. One of them noticed my curiosity and asked me if I would care to see the Presidential Suite before it was finally checked. On entering, I saw men searching behind mirrors, pictures, under cushions and beds. What caught my attention was the 'red' telephone. A card had been inserted onto the circular dial. Inscribed was 'The White House' with a pencil sketch of the White House above the lettering. (I took a snap.) I then went down to the lobby, mingled with the international press and met and chatted with journalists from all over the world.

We were surrounded by noise from the radios; the commotion of the TV cameramen squabbling as they assembled their equipment; radio journalists trying to find peaceful areas for interviews; police and detectives searching to secure positions for the event; barriers being constructed. There was general pandemonium.

Paper mugs of coffee, cans of beer, cigarette ends and pistachio shells were strewn across the floor among shiny aluminium camera cases. The room was airless. I hoped by the time the President and dignitaries arrived, the doors would be opened to let clean cool air into the hotel lobby.

The atmosphere was tense as the moment approached. The red carpet was unrolled. The noise from the press became subdued. It was a few minutes past midnight. The lobby with its art deco lamps casting soft shadows on the marble floor set the scene for the arrival of the President of the United States of America. The heavy revolving doors swung into action. Into the lobby walked Mrs Carter, the First Lady, carrying a bouquet of red roses, escorted by the wife of the Israeli Prime Minister, followed by the Prime Minister, the American President and the Israeli Foreign Minister. TV lights shone, cameras flashed and motor drives resonated. We heard sirens from the street. People gathered by the hundreds. Public eyes peered, and private eyes solemnly observed the unfolding events. I secured my position and enthusiastically participated in the spirit of the moment. Everyone waited for history to be made.

BELOW: **For the US President's historic visit, the King David Hotel in Jerusalem installed a red 'hotline' telephone in the Presidential Suite that connected directly to the White House in Washington, DC.**

ABOVE: **Zubin Mehta and Itzhak Perlman in the swimming pool at the Hilton Hotel, Tel Aviv, 1978, in animated conversation.**

Zubin Mehta

In 1976, while in Tel Aviv to photograph for *Israel: Faces and Places*, I was advised to visit the Israel Philharmonic Orchestra, which had been founded in 1936 by refugees from Nazi Germany.

I was introduced to the manager of the orchestra at a performance in the open-air auditorium in Tel Aviv one summer night. Every seat was occupied; even among those standing, there was not an inch to spare. These classical concerts were immensely popular and, with Zubin Mehta conducting, it had sold out months before. Before curtain call, the excited buzz of conversation rose to a crescendo. I was fascinated to be backstage and peeped out from the wings. I loved listening to the orchestra tuning up and the last-minute exchanges over the scores. There was a great sense of drama.

Someone from the orchestra came to greet me. 'Are you here to photograph our conductor, Zubin Mehta?'

'Yes,' I confirmed, a little nervously – I had seen Zubin conduct several times in London, and I was a huge admirer. At that time he was the musical director of the New York Philharmonic, the Israel Philharmonic and many other orchestras worldwide. I saw Zubin in hurried conversation with the Israeli violinist, Itzhak Perlman. The fine figure in a white Indian kameez walked towards me. He was handsome, with his traditional Indian looks, dark skin and jet-black curly hair. He had a warm smile and shook my hand in a cordial greeting. He suggested we meet after the concert in his dressing room.

The concert was magnificent. After thunderous applause, and many curtain calls, I waited a while and then knocked gingerly on Zubin's dressing-room door. By then there were numerous friends and fans congratulating him. I edged my way

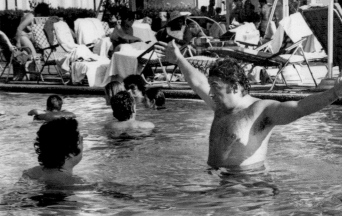

forward through the crowd to greet him. I said that I was staying in Jerusalem and he suggested that I join him backstage a couple of days later at Binyanei HaUma, the concert hall in Jerusalem, to take photographs of him and Isaac Stern, the guest performer of the evening.

As it was getting late, having waited a while for his guests to leave, I photographed Zubin for a few minutes, and then excused myself, mentioning that at 2 a.m. the following morning I was flying to the Sinai desert to climb the famous steps of Jebel Musa. I hastened to return to my hotel and dropped into bed for a couple of hours. I was woken not long after by the telephone ringing. I thought at first it was my wake-up call, but it was Zubin Mehta, wishing me a wonderful trip and asking me to remember him when I reached the mountain peak and saw the first glimpse of the breathtaking sunrise.

I did.

A couple of years went by and we kept in touch, occasionally meeting either in London or in Israel. We spoke about the possibility of publishing a book on the faces of musicians. He suggested we meet Itzhak Perlman, Daniel Barenboim and Pinchas Zukerman to discuss the project. A few months later, Zubin and I met Itzhak by the swimming pool at the Hilton Hotel in Tel Aviv. We realized in the end that the project was too ambitious and that it would be far too complicated to bring together all these musicians who were spread around the globe, but we enjoyed a great day together anyway.

Many years later, Zubin and I met at one of his concerts at the Royal Albert Hall, by which time I had changed somewhat and my hair was grey. I was sure he would not recognise me. I approached him and said: 'You won't remember me, Zubin …?' He looked at me for a moment, embraced me and said: 'Gemma … Gemma …' Zubin, the maestro! Such charm and charisma. I smiled as I recollected glorious memories. I read somewhere that his 'baton supplies us with magic and hope'. I would wholeheartedly agree.

A One-time Journalist: Israel–Lebanon, 1982

War broke out with Lebanon on 6 June 1982. I am not a political person, but listening to the radio and reading the newspapers in the UK during that period, I detected an anti-Israel campaign in the reporting. Given my previous involvement with the country, I decided to visit the Israeli embassy in London to discuss what I could helpfully achieve as a photographer, to reveal an alternative side to the situation.

I returned to Israel to sign endless forms and documents that would allow me to cross the Israel–Lebanon border, declaring I would not endanger the security of the state and the public. I formally registered as a freelance journalist for twenty-four hours and was given access to the streets, hospitals and the checkpoint in Beirut.

I was provided with transport and an escort. My first introduction to a war environment was to visit casualities in a hospital on the border, at a place called Rosh haNigra. I spoke with many women who described their experiences. A Lebanese school teacher, Naga Gigos, from Sidon, revealed details of the shelling and destruction of their homes but, she added, thousands of leaflets had been cast from

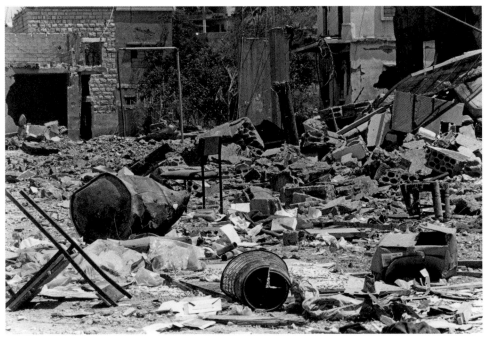

ABOVE: A scene of destruction in the city of Sidon, Lebanon, some 40 kilometres south of the capital, Beirut, during the war between Israel and Lebanon that began on 6 June 1982.

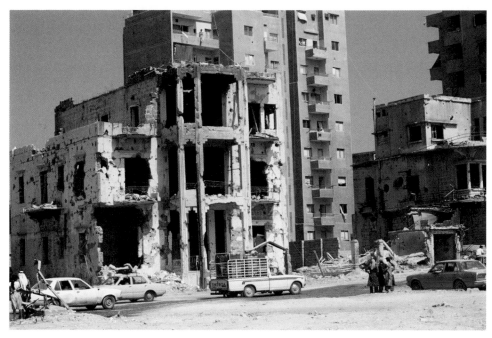

ABOVE: **In the Lebanese capital, Beirut, numerous buildings such as this were damaged by shells during the 1982 conflict.**

Israeli planes to the civilian population calling upon residents to leave the battle areas in order to avoid crossfire. Naga went on to say the Israelis sent helicopters to lift pregnant, injured and sick women and children to hospitals.

I also spoke with a young soldier called Yier Askanazi, aged 22. He had just returned from the operating theatre, having had a bullet only partially removed from his face. He had stitches from his lower neck to his forehead. I spoke with his father and asked him if I could record his son's story for the BBC. Yier started to speak gently, almost in a whisper: 'Sometimes there is no communication between government, people and nations, but there are obligations. We can talk about this so much and about the human consequences of war and the thousands of people affected, but at this moment I am so tired.' Yier ended the conversation: 'War is simply a bad thing, simply a bad thing,' and with this comment fell asleep in the arms of his father. Walking through the wards, I came across the disturbing sight of a line of beds filled with children who had been badly burnt. The nurse explained that in Sidon a field had been set on fire as the fighting broke out. I will never forget the bravery of Yier, nor these small children who had been so badly hurt. Shimon Peres said on the radio once: 'Whenever you fight in the cities it is unavoidable you hit unfortunately non-fighting civilians as well.'

Walking through the streets of East Beirut, Sidon, Damour and Tyre, I came across a surreal scene that mesmerised me: a wedding celebration in all its glory, whilst a stone's throw away the deafening sound of shelling continued. Regardless, children were playing and singing in the streets as rose petals and rice were strewn over the newly married couple. It seemed bizarre.

Amid the many bombed-out buildings and the utter devastation, surprisingly, the harbour was tranquil and some of the buildings and churches remained unscathed. For lunch, as the traffic in the centre was bad, my driver took me up into the mountains. It was startling how peaceful and serene our surroundings had suddenly become; we could not hear the faintest sound of shelling from below. It was a completely unreal interlude, eating a traditional lunch of stuffed vine leaves, *koussa warak inab*, while overlooking scenery that reminded me of France. It seemed impossible that such a terrible conflict could be happening just a few kilometres away.

Finally, I ventured to the army post on the front line. Barbed wire stretched across the street so we were unable to pass. I stood next to an American journalist and, as we were talking, rockets fired, sirens wailed. A bullet hurtled past, seemingly from nowhere. The American was hit in the leg and there was hysteria from all sides. Sirens full blast, a pulsing rhythm. Within minutes an ambulance arrived and he was whisked away on a stretcher, blood spurting from his wound. I realised at that moment, with my family back home, that I had no right to be there. With blasting smoke and debris high above the city, heart pounding, tears streaming down my face, ash and smoke almost blinding me, I turned and ran as fast as I could, back to my driver, and to Israel and, from there, the first available flight to London.

Back home, I reported my findings on the BBC and had several articles published, with photographs, in the daily newspapers. My BBC interview was transmitted on *World at One* on Israeli radio, with Shimon Peres and other guests responding to and discussing the content. Many people heard this, and for a while I became known as '*Giveret* [Hebrew for Mrs] Gemma Levine from London.

I had brought a different perspective to the debate, so done what I set out to do; but it was an experience I would never wish to repeat. As the young boy said, 'War is simply a bad thing …'

Israel's Children

I met Yehuda Avner, the advisor to Prime Minister Yitzhak Rabin, in his office in 1976, while I was photographing many Israeli politicians. I became friendly with Yehuda, who had been born in Manchester and immigrated to Israel in his youth. It was his idea that we should collaborate on a book about the children of Israel: he would write the text and I would illustrate it with my photographs.

Not all Israeli children are preoccupied with war. Many spend their days playing, or at school, or doing the myriad other things with which normal children fill their time. Family life is important, particularly in the kibbutzim, where children are a major focus of communal life, and a wedding is as much a children's party as it is an adult celebration. The kibbutz – Hebrew for 'communal village' – is Israel's true contribution to rural development. It is an experiment in voluntary collective living that has proved successful in many ways and increasingly flourished.

I spent a week in a kibbutz called Degania in the eastern Jordan valley in Galilee. The day started at 4 a.m. and we began work in the fields at 5 a.m., picking dates, avocados or grapes. It was fresh and exhilarating. The air was like nectar. The smell of the orange blossoms was intoxicating, with the birds singing, a cloudless blue sky and the sun just rising to greet the day. At 8 a.m. the young and the old all joined together to eat a hearty communal breakfast of home-grown produce: fresh orange and grapefruit juices, eggs, yoghurt, sour cream; all the fruits in season and tomatoes larger than grapefruits; freshly made bread from the bakery and cakes of all kinds. This feast was the main meal of the day. Everything we enjoyed was grown with hard toil and pride. Necessity compelled them to share everything they owned: to eat together, work together, defend themselves together, even to share the kitchen chores.

What intrigued me most during this period of immersion in Israeli family life was the fact that young people, aged sixteen and up, were preparing for the possibility of war, and joining the Gadna (Youth Corps) prior to army training. High-school students would attend summer camps, pre-army drills, courses in good citizenship, civic pursuits and lessons in self-defence – even pretty girls with long blonde curls, large eyes covered with black mascara, long legs fit for a catwalk. To protect their country even these girls would become part of the conflict. From an early age, they are their own traffic wardens, and older children patrol their own school yards. In times of tension, children living in the vicinity of a troubled frontier tend to play in the shadow of their shelters.

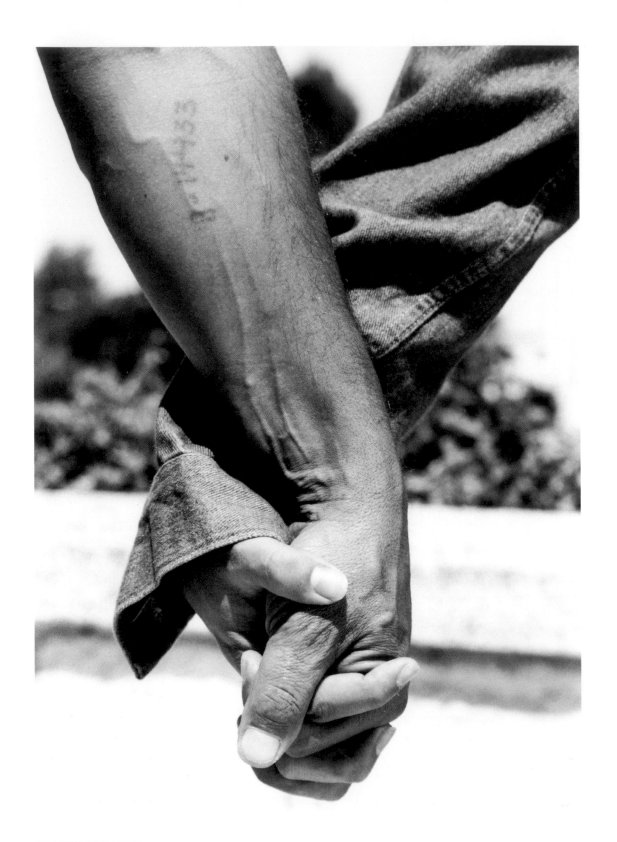

All of these children were affected, still, by the events of the Holocaust. How difficult it is for me to write just a few lines on this issue. One third of world Jewry perished between 1939 and 1945, and, in Israel, youngsters are brought up on the doctrine that the Jewish state is the historic answer to the Holocaust; these children are forever mourning their families' past. On the hills overlooking Jerusalem is Yad Vashem, meaning 'the monument'. Flagstones are inscribed with the names of the death camps, illuminated by a single flame eternally burning. The children of Israel guarantee that a Holocaust won't happen again: they won't let it. It is their responsibility to pass this on from generation to generation. I feel that *The Young Inheritors*, about the children of Israel, is one of the most important books I have published.

Yitzhak Rabin

On 4 November 1995, after spending an evening with neighbours at a local Thai restaurant in London, I returned home at 10 p.m. My answerphone displayed twelve messages. This was unusual for a Saturday night; normally there would be only a couple.

Sombre voices echoed from the machine. Zippy from Jerusalem: 'Thinking of you, we have just heard the terrible news about our prime minister, no words can express the horror and sorrow we feel.' Gordon from California: 'My thoughts are with you, we are all in total shock, as I am sure you are.' My mother: 'How shocking. Rabin, the prime minister, has been assassinated.' The traumatic news made it hard to think clearly. I became numb then icy cold.

I saw the late-night news on television, then the following day scoured the newspapers and finally watched the funeral live from Jerusalem.

I recalled having seen Yitzhak Rabin in Jerusalem just a month before, in his office in the Knesset, to take a series of photographs for Camera Press. As I walked in, he was seated behind a large oak desk with his head bent. His hair was greying and had thinned since I saw him last. There were deeply chiselled lines in his face. He rose, giving me a long, piercing look, but within seconds his eyes softened with recognition, and he clasped both my hands in his, remaining silent for a moment. He spoke then, in soft undertones. We exchanged news from the months that we had not been in touch. Time was limited, and so I proceeded to take a few

OPPOSITE: **The entwined arms of a father, a survivor of the Holocaust, and his Israeli son.**

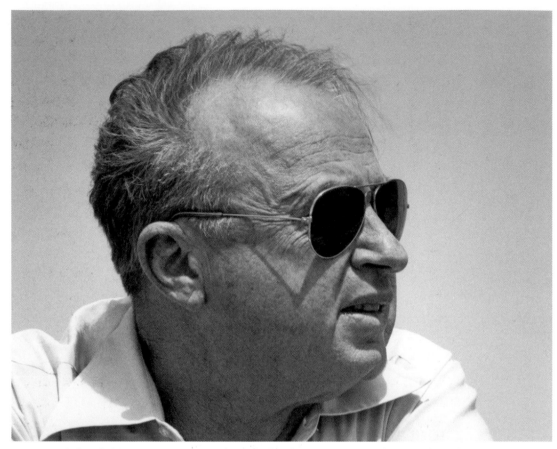

ABOVE: **Yitzhak Rabin was prime minister of Israel when he was assassinated in 1995 by right-wing radical Yigal Amir. Rabin had won the Nobel Peace Prize the year before for his role in the signing of the Oslo Accord, along with Shimon Peres and Yasser Arafat.**

photographs, not thinking these would be the last. His aide entered the room to announce that he had to leave immediately for the airport. Rabin rose, hesitating at the door, as if to say something. Then abruptly he turned and left.

On Sunday, 12 November 1995, I attended a memorial service at the Royal Albert Hall, which was arranged by the Israeli embassy. As the ceremony commenced everyone rose to their feet in silence. Thousands of people were present. Every seat was occupied and the standing room at the back was crowded. On the rostrum was a representation from the entire community of nations, many expressing their own particular sentiments, all those present honouring the former prime minister.

My thoughts went back to the day I first met Rabin, as clear as though it were yesterday. On 1 March 1982, in Rehov Kaplan, on the outskirts of Tel Aviv, I was

directed along a narrow pathway towards a line of grey government buildings. The air was impregnated with the aroma of orange blossom, the midday sun casting shadows that danced through the bushes.

It was quiet, being noon on a Friday when employees had left for the weekend. Clutching my tape recorder and camera, I entered a small waiting room and noticed, stacked against the walls, bunches of floral bouquets tied by brightly coloured ribbons. I glanced at my watch: I was four minutes early. At noon on the dot, Rabin emerged from a doorway further down the corridor. I was beckoned to approach and walked, very self-consciously, the length of the passageway into a small, basically furnished office.

I had been apprehensive about meeting Rabin, the former prime minister of Israel, but to be alone with him in a deserted building made me somewhat nervous. At first glance he was serious, but I caught fleetingly a twinkle in his eye, which transformed a sombre expression into an enigmatic gaze. My assignment was to publish an educational book for schools, called *We Live in Israel*. We completed the interview, and I suggested we go outside into the natural light to take a few photographs.

Walking towards the door, we lapsed into conversation of a personal nature. He informed me it was his sixtieth birthday, hence the bouquets of flowers. We talked of his recent visit to London and how he remembered seeing me at a dinner. He observed I had been very quiet and looked unhappy, near tears. It was a week before my husband and I separated, I recalled. Feeling vulnerable, I swallowed hard in order to overcome the overpowering emotion that was welling up inside me, but I couldn't stop the tears from flowing and I lapsed into a tirade of incomprehensible sentences. It was absurd and totally unprofessional. I was ashamed of my lack of control, but he was genuinely sympathetic. He came over to me and clasped both my hands in his, and for several minutes voiced words of encouragement. With difficulty, I became calm and composed. I assembled my camera and took a couple of portrait shots. We finally exchanged greetings and parted in silence, but in harmony.

Through the years, we saw each other from time to time. I photographed him a number of time times for my books and the press, in various locations, including one memorable occasion in the Sinai desert, where the Bedouins had assembled to listen to a political speech.

On his 61st birthday, when I was working in Jerusalem, I asked him for a celebratory drink at the King David Hotel, where I was staying. He called to say he would come to see me in between meetings at 1 p.m.

In the early morning I visited the local flower market in East Jerusalem, which I did often. On that morning I purchased a box of freshly picked anemones from Galilee. I covered the simple coffee table with the flowers. I recalled the delicate aroma that reminded me of Galilee in the spring, where the flowers grew wild, uninterrupted for miles, forming a dazzling landscape of magenta.

I waited for a knock at the door. At exactly one o'clock, he arrived; the look on his face as he entered the room was one of anguish and torment. He asked for a glass of whisky and in haste told me he had to leave immediately. I voiced 'Happy birthday', and he was gone. The profusion of anemones from the fields of Galilee remained poignantly overlooked.

This was the man: Israel's first native-born prime minister and chief of staff for Israel's Defence Force during the Six Day War. He was a powerful man with an obsessive sense of mission, loyalty and honour towards his people and his country. Glancing around the auditorium in the Albert Hall, it was evident from the speeches and tributes that my feelings about his momentous life were unanimously shared around the world.

I sat alone with my own private reflections on seat No. 9, Box 24, in the grand tier, aware of the immense privilege that had been mine, to have known the man behind the public image – this extraordinary, shy, diffident, mysterious man – maybe not as well as some, but surely better than most.

The entire gathering rose to their feet in complete silence as the orchestra gave way to an inspired rendition of the *Hatikvah,* followed by the national anthem.

◆ ◆ ◆

Working in Israel over a period of twelve years, I found that, at times, the experience drew me closer to knowing myself. The emotions I felt when faced with this remarkable landscape had a profound impact on my work, and taught me to relate to the world through my lens in a different way. Furthermore, the intense sadness that I came across so frequently, in individuals, families and whole communities, was in marked contrast to the abundance of laughter I heard from children, who simply enjoyed what life had to offer in the present moment. I have carried this experience with me, and cherish the overall feeling of warmth, positivity and hope that I witnessed in the Israeli people.

ABOVE: **A rabbi in Mea Shearim, Jerusalem, one of the oldest Jewish neighbourhoods in the city.**

Famous Faces

IN THE MID-1980s, my career took an unexpected turn. I had photographed a few famous faces back in the 1970s but I was now about to embark on an entirely new path as a professional portrait photographer. As I had had no training, this was a daunting prospect; however, I found that, ultimately, it was my work with Henry Moore that gave me the confidence to press forward. My skills and my style had been honed by Moore's guidance, and I found in my responses to form, light and shade, the echoes of those years with him.

It all started one winter's day over a cup of tea with my friend Marcia Falkender. 'Why not photograph people from all walks of life who have reached a peak in their particular field of expertise?' she suggested. It sounded a spectacular idea: a record of our times, and of the characters who were shaping our society. Marcia and I set to work on it together, agreeing that all proceeds from the book, *Faces of the 80s*, would go to the Sharon Allen Leukaemia Trust.

In the midst of moving home, I set up a studio in my new apartment in Wimpole Street. Together, Jane Russell, secretary for the Leukaemia Trust, and I undertook the tremendous task of managing the diary. At times I was attempting to photograph six sitters a day, 300 in all, without assistance, making it a very ambitious project; so, while it was an exhilarating year, it was also rather arduous, and neither evenings nor weekends were my own. But I was privileged to meet, practically on a daily basis, a wonderful collection of interesting and distinctive people; many of these connections would go on to change my life in ways I could not have anticipated.

One of those people was Jonathan Miller, who was to become a good friend. Not long after we first met, I told him I was about to make a start on another book, this one called *Faces of British Theatre*. He was curious and asked whom I planned to include; I listed several names of famous actors, actresses, playwrights, producers and directors. He remarked that it was not a fair representation of the world of theatre, and suggested the inclusion of relevant backroom artists, electricians, technicians, wardrobe and costume designers. I realised he was right, and I asked him if he could advise me and assist with some introductions. He proved to be crucial to the structure of the book, and we spent a year working on it together. I was very

ABOVE: Jonathan Miller, the director and presenter of theatre, opera, film and television, played an instrumental role in developing the book *Faces of British Theatre* (1990).

much in awe of him; he was articulate on such a range of subjects, from opera to religion to sex. I found his insights and opinions to be fascinating and our discussions broadened my horizons.

Working with some of the most dynamic people in the West End and in subsidised, regional and fringe theatres was inspirational; a welcome chance to interact with a community of prodigiously gifted people. I used my studio for my photographic sessions in most cases but when necessary, went on stage or backstage to catch a moment in between performances, experiencing at first hand the

much-envied vitality of British theatre. The glow that surrounded my days during this period was life-enhancing. If I were asked whom I felt richer for having known in my lifetime, Jonathan Miller would be one person that springs to mind, along with John Gielgud, who wrote the foreword to the book, as the supporting cast.

A short while later, I was delighted when my friend Paul Winner came to see me to suggest a book with the same theme as *Faces of the 80s*, but this time for the 90s, in aid of the Malcolm Sargent Cancer Fund for Children (now known as CLIC Sargent). The book would coincide with the centenary celebration of the birth of Sir Malcolm Sargent, the conductor in whose name the charity had been established in 1968.

Sylvia Darley, the director of the charity, and I decided on a list of 205 people in all, representing all areas of British culture. And the charity's patron, the Princess of Wales, would contribute, writing the foreword and permitting me to photograph her for her official photograph of 1995. This was an incredibly exciting opportunity for me; particularly as, some time after our session, a cream envelope arrived on the doormat with the Royal crest embossed in blue and the initial 'D' elegantly scrolled within the crown. I tore open the envelope to find an invitation to lunch, from Kensington Palace.

The day arrived, the summer of 1996; a typically English, grey, sultry morning, comfortably warm. I had been looking forward to this moment for several weeks. Regrettably I had a temperature and the start of a bout of 'flu, but was determined not to cancel. I wore a new navy trouser suit bought especially for the occasion. I agonised as to what I could buy the Princess. Finally I went to a shop in Mayfair called Halcyon Days and bought a small circular pink enamel gift box with the word 'friendship' inscribed in the centre. There was nothing she could need, so this was solely a token for the occasion.

On arrival I was greeted by her butler, Paul Burrell, who helped me out of my car and escorted me into the entrance hall. Princess Diana was waiting by the door dressed in a pink cashmere cardigan and white gabardine trousers and white flat pumps on her feet, looking cool and elegant. She kissed me on both cheeks and I handed her my gift. She opened it in front of me and exclaimed how special and beautiful it was, and said she would find a home for it. I was relieved that it had been so graciously accepted.

OPPOSITE: **Legendary British actor John Gielgud, photographed for *Faces of British Theatre* (1990), for which he wrote the foreword.**

When lunch was announced, we entered the genteel dining room. Paul Burrell courteously assisted the Princess and me to be seated. He placed the starched white linen napkins on our laps and discreetly retreated to the background in the far left corner. Even so, I felt a little uncomfortable at his continued presence – our conversation was personal, discussing marriage, divorce and the tabloid press. I wondered whether the butler was always in attendance at these intimate occasions. The delicious meal was light: a cold tomato soup, grilled sea bass and salads, followed by a lemon mousse and, to drink, a cold crisp white Burgundy.

After lunch, I asked to be directed to the cloakroom. As I was applying lipstick at the dressing table, I couldn't help but notice approximately fifty small enamel gift boxes, all with messages inscribed in the centre. I realised that perhaps my choice of gift was not as original as I had thought. Oh dear …

It was the Princess who escorted me to my car, where we said our farewells, and she waved to me as I drove away. The day was memorable and I thought how fortunate I was to have had the privilege, just that once in a lifetime. However, this was not to be our last encounter.

Some months later, I was attempting to return a malfunctioning telephone to what was turning out to be a disreputable shop in Tottenham Court Road. After being subjected to a barrage of verbal abuse, I was told that a manager would contact me shortly to arrange a replacement. I then received an equally belligerent telephone call, saying I should return to the shop to collect the new telephone. In view of the way I had been treated so far, I asked the local police to accompany me for fear of another contentious encounter.

Within ten minutes of my call, eight policemen arrived at my front door in a van. Somewhat bemused by the size of my escort, I climbed in, edged to the back and sat next to PC Nigel Bishop. We chatted whilst held up in traffic, and ended up on the topic of his daughter, Danielle, who was currently in the Great Ormond Street Hospital. She was aged nine, and had been wrongly diagnosed with glandular fever, when in fact she had cancer. The doctors told him she had only a short time to live. I was utterly stunned and could not find the appropriate words of comfort.

By coincidence I was carrying a copy of *People of the 90s* with its foreword by Princess Diana. PC Bishop noticed the book and remarked how much he admired the Princess and how his daughter was spellbound by her. My immediate reaction was to give him the book, and I would ask Princess Diana if she would inscribe it for Danielle. We arrived at Tottenham Court Road and PC Bishop escorted me into the shop. Without any harassment, I was given a new telephone. That was that.

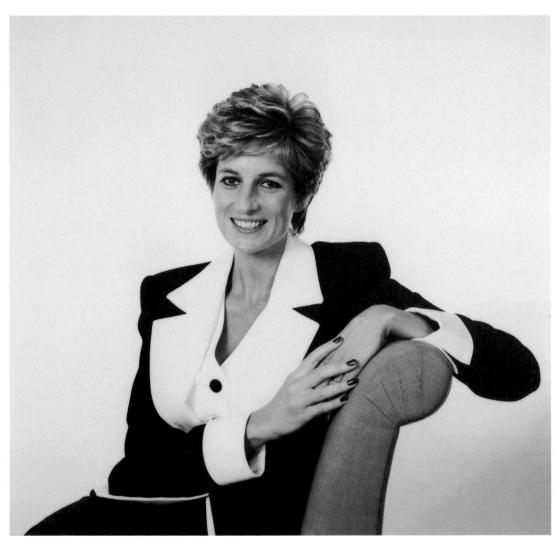

ABOVE: **Diana, Princess of Wales, photographed in 1994. The Princess was patron of the Malcolm Sargent Cancer Fund for Children, to which proceeds from *People of the 90s* were donated.**

As soon as I returned home that afternoon I wrote a note to Princess Diana. Shortly afterwards I received a message from St James's Palace, telling me the Princess would be happy to help in some way. The very next morning at 9 a.m. a messenger delivered a parcel to me. I opened it to find the most exquisite photograph of the princess, set in an elegant leather frame with a crown embossed in gold leaf, gleaming at its head. The photograph was inscribed lovingly to Danielle.

I drove immediately to Marylebone Police Station. When PC Bishop opened the box he was stunned and could not utter a word. His eyes filled with tears

and, with genuine emotion, he uttered: 'You have no idea what this will mean to Danielle.' The next day he telephoned me to tell me of his daughter's reaction: she could not believe it was the 'real' thing, but, once she understood, she was ecstatic. He said that she had not shown so much spirit for a long time; that she couldn't wait to go to school to show all her friends when, a day before, she did not think she would ever be going back to school. He said this incredible gesture had lifted her to such an extent that he felt it would help to prolong her life. I wrote to Diana and told her this wonderful story. I feel so lucky to have known, if only briefly, a woman who was capable of giving so much happiness to others.

I was to meet many more inspiring people during these years and would have many more poignant moments. I had a particularly personal connection to my next project; the book *Memories* was conceived as I was driving in traffic down Finchley Road and being held up, as one often is, in a long tailback almost to Swiss Cottage. I was listening to the radio, when suddenly I heard the instantly recognisable voice of Jonathan Miller talking about medical and scientific research into dementia by the president of the Alzheimer's Disease Society. As he had been a medical doctor before entering the world of opera and theatre, Miller's thoughts on the subject were interesting and informative – for me, particularly, as my mother had suffered from dementia. At the end of the programme, I made a mental note to call the charity as soon as I reached home.

Over the next few weeks, I contacted Jonathan Miller, who agreed to write the foreword to the book, and I met Gail Rebuck, head of Random House UK, who subsequently arranged for its publication with Ebury Press. Seventy-six famous personalities were asked to write a personal memory related to the value of memory itself. I approached people I had known from all walks of public life such as Tony Blair, Georg Solti, Greg Rusedski, Harold Pinter, Norman Foster, John Suchet, Joanna Lumley, Steven Isserlis amd Trevor Nunn. I was flattered that everyone I asked was more than happy to participate, particularly as we were all working hard for a cause that was very close to home for me.

Of course, not every project is a happy experience, and my next proved disappointing in many ways. *My Favourite Hymn*, published by Robson Books, was a collection of celebrity photographs accompanied by the celebrity's choice of hymn. Unfortunately, this did not turn out as well as my previous books, primarily because I found the sponsor difficult to work with, and I was not able to take many new photographs – most of them were gathered from my archives, with one main exception: Prince Michael of Kent, who wrote the foreword. The fun part, of course,

was connecting with my sitters and obtaining texts from them. But for this project I focused on the fact that the proceeds went to a good cause, the British Red Cross.

However, the occasional low points were vastly outnumbered by the happy times. I have been lucky to meet such exceptional people – many only fleetingly, though with a precious few I formed lifelong friendships – and all of those memories are treasured.

Becoming a portrait photographer started a completely new chapter in my professional life; it provided me with the opportunity to learn so much more and to continue to develop my skills and style. I always kept in mind Henry Moore's lessons on light, shade and dimension, and I also began to appreciate more deeply how to observe angles, profiles, posture and body language; how to draw out one's sitter and capture an aspect of their character. The early days were a learning experience for me, bearing in mind that on most occasions my sittings only lasted approximately twenty minutes; therefore not all of my first attempts were a complete success. But I faced all of the setbacks and obstacles head on, and embraced these experiences of trial and error; for me the 'error' was the essence of learning.

September 1994

My photographic session with **Diana, Princess of Wales** was scheduled to take place at Kensington Palace. However, when the arrangements were being discussed I suggested that the sitting should be at my studio in Wimpole Street, as it would be helpful if my lighting and equipment were in situ. My request was granted.

The day before the session I planned the design of the studio: the chair, the backdrop, the refreshment tray. I used a fine white linen cloth with blue and white Limoges china and a vase of fresh blue cornflowers in the centre. At the start of the day I went for my regular early morning swim. Afterwards, still in my tracksuit and trainers, I drove to Knightsbridge as I needed to return a package to Harvey Nichols. Smelling of chlorine and my hair still dripping, I rushed inside and headed for the nearest lift; head down, I edged my way to the back. The lift was full, we were all squashed in together, and when I looked up at the person next to me, I realised to my horror it was Princess Diana. This was not how I had envisioned our first meeting! Knowing I would be face to face with her the next day, I tried to keep my head down in the hope that she wouldn't remember me in my slightly bedraggled state when we met again.

The following day arrived. The front doorbell chimed and I released the catch to see this glorious lady, looking fresh and radiant, run down the hallway to greet me. 'So pleased to meet you,' she said. I bit my lip and hoped she did not remember the previous day. We instantly had a rapport. She flipped through some of the photographs I had already taken for the book while we gossiped and exchanged stories of the sitters we both knew. She threw her head back and laughed, revealing an abundance of vitality and joy. Turning away from me at one point, with a slight frown, hesitatingly, she did say, 'I have a feeling we have met somewhere before …'.

The time had come for me to assemble my equipment. We needed privacy. She asked me where to hang her clothes, as she had brought a few changes. We looked at them and discussed which outfits would be suitable She did not need mirrors to refresh her makeup or hair; she was totally natural. I had bought a special Perspex chair to make sure she sat at ease. She was a pleasure to photograph, having a natural knack for altering her position so that I could capture the slightest singular variation on her profile. How could anyone falter with such a subject? Whilst I was adjusting the lenses on my Hasselblad, the Princess chatted enthusiastically about her two boys. I wanted this exchange, to capture diversity in her expressions.

A week later, she returned with an enormous bouquet of flowers to thank me. We sat on the studio floor selecting the photograph we both favoured for the book. We chose the simplest one. She was wearing a black, low V-neck halter top with black trousers, no jewellery whatsoever, at my request. I wanted simplicity. That unique face and form of the sitter was as perfect as could possibly be. It was a memorable encounter, with a lady who held my esteem, for her charm, warmth and graciousness.

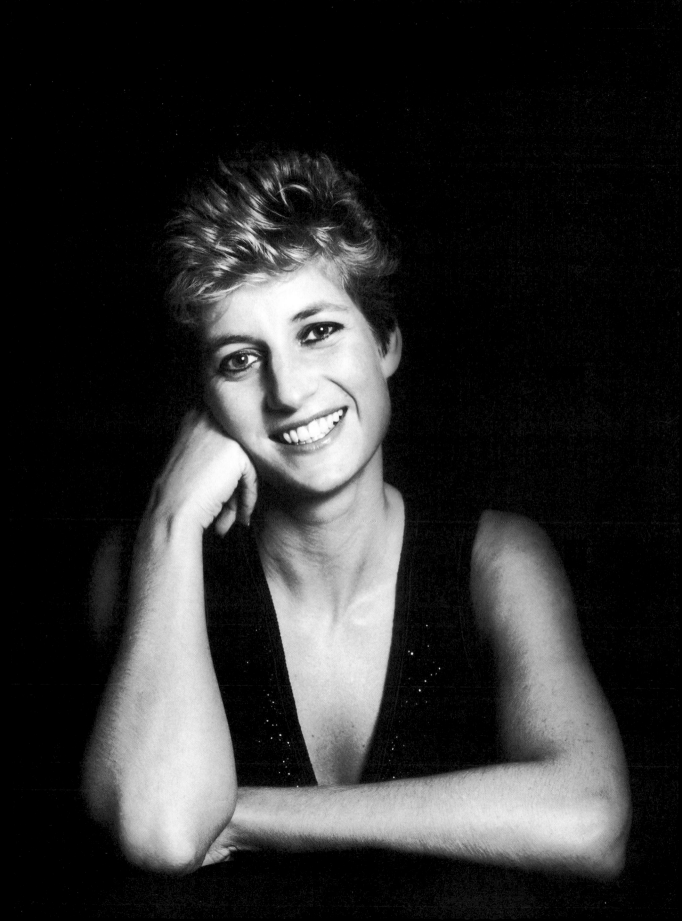

January 1987

The Earl of Spencer, then **Viscount Althorp**, was reflective and quiet while I was photographing him. But he did tell me how to address an envelope to his sister, Princess Diana, so that she would be sure to open it herself – for which I was extremely grateful.

June 1994 and March 1998

In 1994 Greville Janner, a Labour MP, suggested that I include a young politician called **Tony Blair** in *People of the 90s*. His name was unfamiliar to me but I was assured he was an up-and-coming figure, so I arranged for an appointment to photograph him at his office in the St Stephen's building, across the road from the Houses of Parliament.

Blair's office was small, not big enough for me to step backwards to focus on my subject, so I suggested we relocate to the terrace outside and use Big Ben as a backdrop. Perfect! The weather was mild and the rain held off for the few minutes we were there. I found him subdued and rather shy.

As one would expect, the scenario was dramatically different four years later when I went to Downing Street to photograph Tony Blair, then prime minister, for *Memories*. With my assistant, Rob Carter, I set up the lighting equipment in one of the formal rooms. I was curious to see the changes that had taken place since our last encounter; I had prepared myself for a transformation.

At noon on the dot, the door burst open and Anji Hunter, the prime minister's special assistant, entered, clutching a clipboard. Blair followed, striding briskly into the room with a line of his political staff at the rear. I felt very grand and important to warrant such attention. He was welcoming and amicable, as though we had known each other for years. The session went well and he could not have been more accommodating. My brief was ten minutes. It was all over in eight.

It was intriguing to see such obvious changes in the man, from the first introduction to the second. It was like meeting two completely different individuals. In 1994 Tony Blair lacked confidence, was hesitant and ill at ease with me. In 1998, he was sophisticated, in control, engaging and challenging. It was apparent on our first eye-to-eye contact, and I think is visible in the two portraits. The first portrait, showing the rising star under the face of Big Ben, is featured in the collection of the National Portrait Gallery, London.

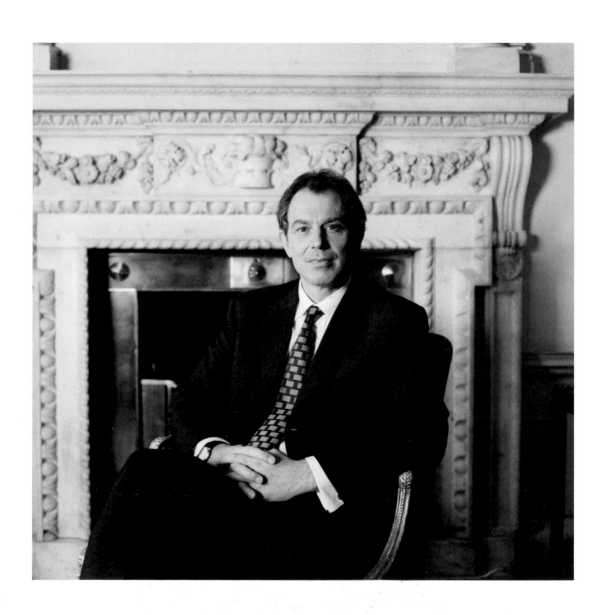

June 1987

One of my most fun sessions was with the mischievous **Roux brothers**. I drove to Maidenhead to photograph Michel and Albert at their restaurant, The Waterside Inn. They set up a small table and chairs at the end of a narrow jetty on the River Thames. At 11 a.m. I stood with the camera at the opposite end, where they had placed a magnum of champagne in a silver bucket filled with ice and two flutes. I think their aim was to see me topple into the river. By noon, after constantly sipping the champagne, I was taking far more photographs than I had intended. Needless to say, the results showed very jolly images but the majority were way out of focus. Thankfully, one of the first shots came out well. Thirty years later, I am proud to say, this photograph is still hanging on the wall at Le Gavroche, the Roux Brothers' celebrated restaurant in Mayfair.

July 1994

In 1985, **Brian Keenan** travelled from Belfast to Beirut, where he was kidnapped by fundamentalist Shiite militiamen and held in a suburb of Beirut for four and half years, shut off from all news and contact with anyone other than his jailers.

I made a trip to Dublin to meet Brian. He arranged to meet me in one of his local pubs, The Brazen Head. We talked over lunch and I photographed him in the pub, and then he took me on a short tour of the city, acting as my guide.

Speaking of his experience, he said, 'I refuse to get morbid about it, I learnt too much whilst I was there.' He wrote a bestselling book about his experiences called *An Evil Cradling*, considered by some to be one of the best books ever written by a victim of such an ordeal. Those years in captivity he now calls his 'holiday'. In the book he even thanks the Islamic Jihad, without whom it could not have been written.

My time spent with him was invaluable and a most moving experience. He is a man I shall always admire for his bravery and positive aspect on life.

November 1986

A gale was blowing as I stood on a boat in Little Venice, Maida Vale, camera case at my feet, waiting for **Richard Branson** to appear for my first encounter with him. Richard finally surfaced from a cabin below, as a gust of wind shook the boat and we both swayed to and fro. I could not call this session a 'sitting' – it was more a 'standing'.

Back then Branson was the founder and chairman of the Virgin Group and had acquired over 400 companies, including Virgin Atlantic Airways. Since I photographed him a couple of times for two of my books, we became quite friendly, and the following year he asked me to stage an exhibition of my famous *Faces of the 80s* in the Virgin Departure Lounge at Heathrow Airport. It was wonderful to see my photos displayed prominently for so many people passing through to see.

Some years later, in 1997, I photographed him at his home in Holland Park for *Memories*. The shot was taken in his garden surrounded by trees; he was dressed in a white shirt and casual trousers, looking handsome, relaxed and happy. His text for the book was a diary piece about his attempt to circumnavigate the globe in a balloon.

As he wanted to expand the routes of his airline, he was looking to establish a connection in Israel. He asked me, knowing I had friends in the Israeli Embassy, if I could make an introduction. I arranged for Moshe Raviv, the Israeli Ambassador, to come to my home in Wimpole Street for a breakfast meeting at 8 a.m. one weekday morning. Moshe and I were seated at the table by 8 a.m. Shortly after, the doorbell rang. I opened the door to find Richard had arrived, out of breath, red in the face and sweating. I enquired if he was well and he replied, 'Yes. I've just run all the way from home … in Holland Park!' This was about four miles. The coffee and scrambled eggs went down well and the meeting was convivial, but I gather the outcome was abortive.

My final professional encounter with Richard was in February 2002, when I asked him to join David Frost and Trevor McDonald in conducting a charity auction at the Royal Academy, which I had initiated with Rudolph Giuliani, mayor of New York, for the Twin Towers Appeal. Richard then gave an extraordinary party that evening at Babylon, his Kensington Roof Gardens restaurant, to mark Guiliani's visit. We were treated on arrival to a magnificent firework display. Champagne flowed and during the meal we were serenaded by Paul McCartney. Who could beat that?

Since then we have corresponded, but I have not seen him. I am sorry he has decided to put his feet up on Necker Island, but I would imagine the word 'retire' does not come into his psyche. He is, without exception, one of the most dynamic, passionate people I will ever come across in my lifetime. As he says, 'Screw it … just do it.'

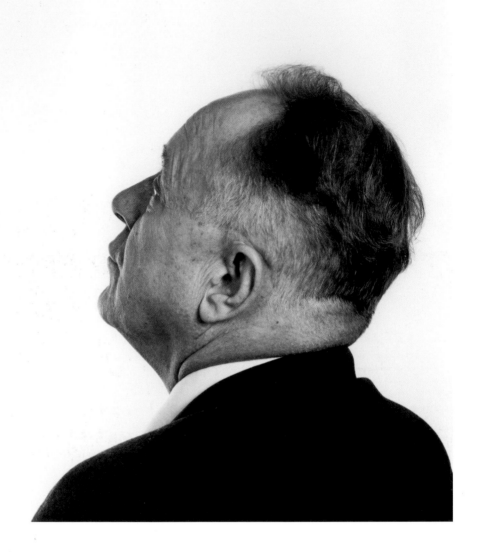

April 1989

As time was limited, I had put aside twenty min-utes for each sitting for *Faces of British Theatre*. One afternoon, at approximately 5.30 p.m., the producer and director **Ned Sherrin** arrived and, before being seated, remarked he had only five minutes, so would I be quick. This was not a ques-tion. He fidgeted and was ill at ease. I could not initiate a rapport, so I photographed in silence, feeling this was a sheer waste of time. After three minutes, I said, exasperated, 'If you are in so much of a hurry, why don't you leave now.' Happily, he

rose from his chair and strode towards the door. As he did that, I took one last shot, which was a fine image of the back of Ned's head, angled in profile, looking upwards with an expression of be-wilderment. That was the photograph chosen for the book.

As he left, he apologised, saying he was com-mitted to attend an important meeting the other side of London that could not be postponed. I looked at my watch, as I had been invited to a party at Partridge in Bond Street. Those parties were

always dazzling but, in view of my sitting obligations, I had declined the invitation. However, due to the sudden departure of Ned, I changed quickly, caught a taxi and was at the party within minutes. Poised with a glass of champagne, I happened to turn around and there facing me, also with a glass of champagne, was Ned Sherrin.

Some years later, we met at a mutual friend's home and, relating this story to the other guests, we both roared with laughter; from then on we became great friends.

December 1986

Ben Kingsley immediately struck me as a vibrant, energetic man. For our session, he decided to bare his chest, removing his shirt. A few years later I wrote to him at his home address, but forgot to address him as Sir Ben Kingsley, as he had only just been knighted. I received a reply telling me off in no uncertain terms for my lack of respect. Reading this, I suddenly remembered him in my presence half naked: that was not in keeping, I thought, with a knighthood, and I wondered how he dressed for the Queen?

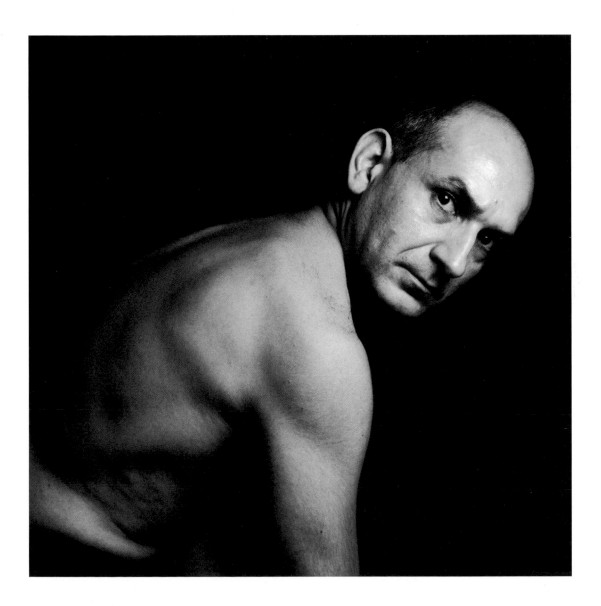

June 1987

Joan Collins arrived at my studio on a blustery evening, emerging from her chauffeur-driven car onto the waterlogged pavement without a coat or umbrella. She was dressed elegantly, in a layered black polka-dot dress with a low heart-shaped neckline. She wore fine black stockings and black high-heeled stiletto shoes, a pearl-and-diamond necklace and matching earrings – she was breathtakingly beautiful. Brian, the caretaker from the block of flats, who opened the door to her, exclaimed, 'I've never seen anyfin' like it in my lifetime, and never will again – cor!'

The studio was arranged simply, with a high-backed chair without arms, so she was free to move any way without restriction. She requested the bathroom on arrival. My bathroom door handle was temperamental – when forcibly twisted the door would not open or close. Needless to say, on this occasion, when Joan had perfected her make-up and was fully prepared for the session, the handle jarred. Oh dear. My immediate thoughts were to telephone the fire brigade or call the police; anything to save an utter catastrophe. 'Your bathroom needs attending to,' she shouted. After a few twists and turns with the handle, she reappeared, legitimately irritable.

I was convinced the session would now be an utter disaster. However, she was masterly. With a fraction of a turn of her head, or twist of her body, she would find the perfect angle. Within a mere twenty minutes, regardless of the initial disarray, the session passed without a hitch: barely one shot was flawed. I might add that this was entirely due not to my skills, but to the innate professionalism of one of the most glamorous women in Europe.

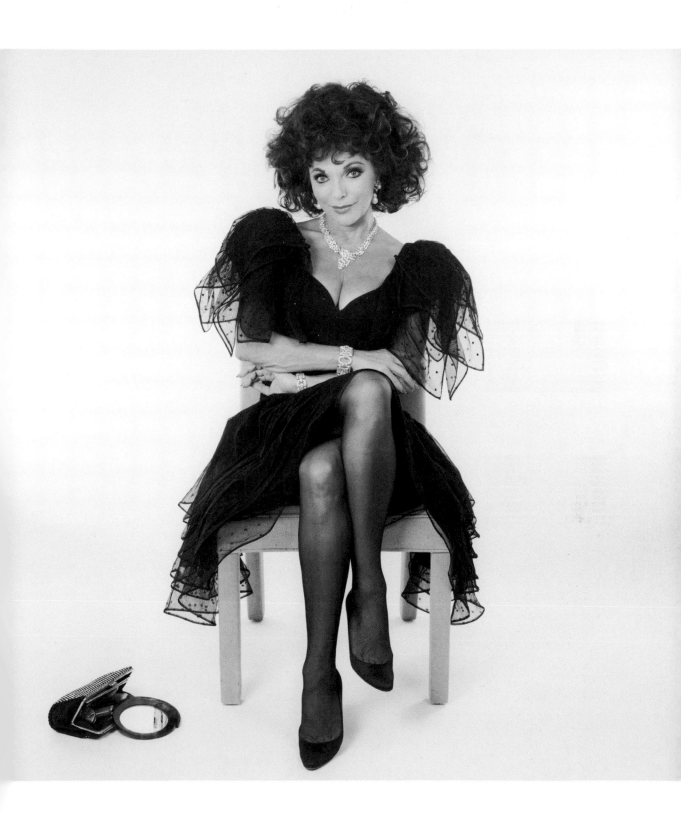

April 1987

I photographed **Frank Bruno** at the Royal Oak in Canning Town, East London, the gym where he trained. I was greeted by his manager, Frank Lawless, who took me to watch Frank in training. They didn't want me to photograph him in action, so I waited until he came to sit with me, and then we chatted whilst he cooled down. He was easy to talk to but said little himself. I took a few relaxed shots. His extraordinary physique made him a fascinating subject to photograph.

Many years later, I invited Frank to join us at the Royal Academy Twin Towers charity evening, as a celebrity to welcome the guests. He accepted with enthusiasm. Many of my photographs were on auction that evening and I had printed several pictures of Bruno, which he signed for the auction and made several hundred pounds. People were queuing up to meet him and shake his hand – some were kissed I noted! He had a magnetic personality and generated an abundance of warmth.

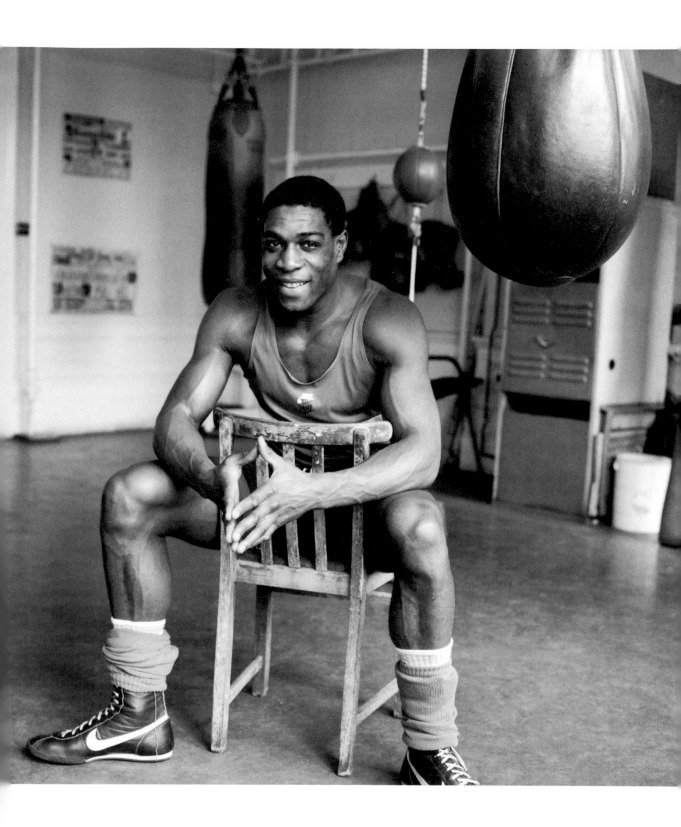

July 1987

My friend Nigel Hawthorne took me to have lunch with the actress **Gwen Ffrangcon-Davies** in her country cottage in Stambourne, Essex. She had bought the cottage fifty years before for £500. Gwen, a very thin, elegant 98-year-old lady, greeted us warmly on arrival. She was almost blind, wearing thick horn-rimmed spectacles and a large hearing aid, as she was also virtually deaf, but she was bright, had a great wit and was so articulate when relating her tales. She told us she was a Christian Scientist, but not a very good one. We lunched in her jewel of a garden full of fruit trees, shrubs and brightly coloured blooms, overlooking fields in the distance. She had arranged for us all to have a vegetarian meal, which was delicious. While reminiscing passionately with Nigel about their mutual friends in the theatre, she showed us a wonderful painting of herself as a girl in costume, playing the lead in *Romeo and Juliet*. She also told us about having lunch with Margaret Thatcher before she became prime minister, and how they had discussed recipes, and that Thatcher had cooked all the fabulous food herself. Born in 1896, Gwen was one of the legends of the British stage, having played almost every great role with every great actor for over seven decades. Whilst Nigel was washing up, I photographed her in a relaxed mood and was entranced by this extraordinary, frail woman, who embraced us with such vitality and grace. Nigel asked her how she felt about dying. She replied, 'I haven't had the experience yet; I'll let you know when I do.'

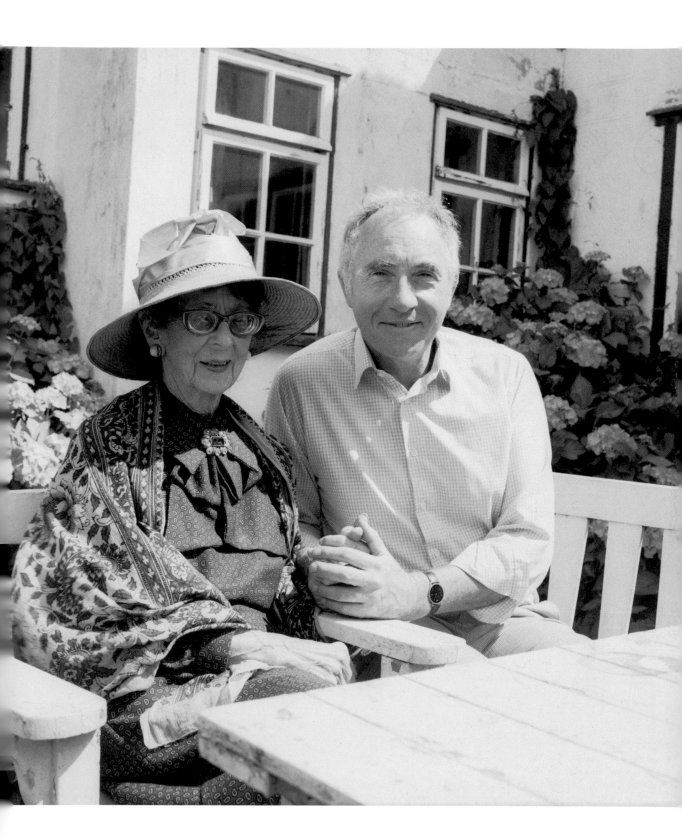

March 1987

I first met **Nigel Hawthorne** on stage before a performance of Pinero's *The Magistrate* at the National Theatre. It was one of the first sessions for which I recall being nervous. But he was quick to make me feel at ease, and the session soon became relaxed with his easy conversation and natural charm. He was a joy to be with.

However, when I looked at the contact sheets, I noticed that in most of the frames his image was cut in half. I had my camera checked and found there was no fault with the lens. What could it be? I agonised over this for some time before taking the contacts over to Nigel for the selection and, shamefully, showing him the defective ones too. He laughed and said, 'You were wearing a soft shawl over your shoulder. I noticed when you stood at the side of the stage, a draught was blowing and I saw the fabric waft over the front of the camera! I didn't want to say anything as I thought it was so charming!'

Shortly afterwards Nigel told me he was going to Jerusalem. As I would be there at the same time, I hosted a party to introduce him to some politicians and actors, including my friend **Topol**, who subsequently became friendly with Nigel through the years. When speaking to Yitzhak Shamir, the Israeli prime minister, the conversation went as follows. Shamir to Nigel: 'Have you ever thought of going into politics?' Nigel in response, quick as a flash: 'No, have you ever thought of becoming an actor?'

I subsequently had many happy times with Nigel, and his partner, Trevor Bentham, their dog Twitch and their many other pets, at their home in Thrundridge, Hertfordshire. We had lovely long summer lunches on the lawns under the fruit trees; both Nigel and Trevor were passionate gardeners and wonderful cooks. As I look back on my photographs I recall one magical New Year's Eve that we all spent in Wimpole Street, together with Marcia Falkender, her sister Peggy, John and Bonnie Suchet, and one or two other friends. Nigel was always the life and soul, with his wicked sense of humour, making us all roll with laughter.

His tragic death came only too soon in his rich and colourful life. But my memories won't fade. From the time we met until he passed away, he called me 'Squash'. If I were ever to have a dog now, its name would be Squash. Without doubt, Nigel was one of my closest and most favoured friends.

January 1988

Dawn French came to my studio in 1988 to be photographed for a proposed book on women, *Breaking the Glass Ceiling*, which did not take off in the end.

What do I recall from the session? Very little of our actual conversation, I just seemed to be crying with laughter ninety per cent of the time. What I do remember clearly is the warmth, humour and vitality that radiated from her, which is so wonderfully apparent in her beaming, slightly mischievous smile.

Her flowing silk scarf remains clear in my memory as well; it was a vivid scarlet with a white pattern which was striking against her black outfit. It stole the show!

May 1987

I walked into the office of **Norman Willis**, the general secretary of the Trades Union Congress and chairman of the Poetry Society, at 9 a.m., and was immediately surrounded by many people scurrying about. On entering the room, Norman Willis asked whether I would mind if he recited a poem that he had written. Its subject was his next-door neighbour, who was complaining that Norman's pear tree was blocking the light. The poem was hilarious. Norman was laughing so much I captured him, literally, about to fall off his chair.

March 1987

My appointment with **Robert Maxwell**, owner of the *Mirror* newspaper, was for 2.15 p.m. at the *Mirror* building, near Fleet Street. The secretary told me to wait and be seated. At 5.45 p.m. I was asked to go in. I had some lighting equipment and was about to set up. Noticing he looked distracted, I said, 'Sir, I will only keep you a few minutes.' His sharp reply was, 'You'll be ONE minute, then OUT!' Petrified, I dropped my camera, tried to compose myself, took only one shot and hurriedly withdrew.

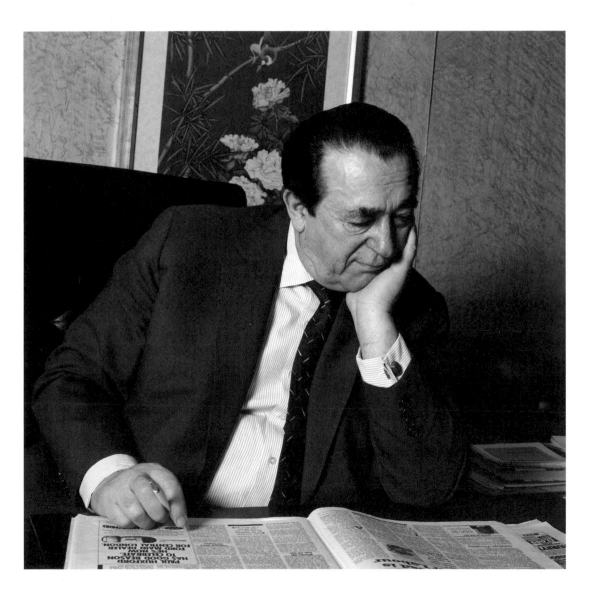

October 1998

I met **Paddy Ashdown** at the House of Commons in October 1992. He was then the leader of the Liberal Democrats. I took some rather casual photographs of him walking along the terrace of the House of Lords in a gale, and I enjoyed the session regardless of my camera swaying in the wind. The photograph, slightly out of focus, featured in *People of the 90s*.

I invited Paddy to feature in my next book, *Memories*, as well, and he agreed to provide diary extracts from his visit to Bosnia in 1992 to accompany the photo. This time, I wanted a rather different image of Paddy. I took a general straightforward shot of him and decided to crop it, showing just half of his face. It was striking; one could not mistake the identity of the man. He launched my photographic exhibition of *Memories* at the Berkeley Square Gallery, and so I had this photograph enlarged to four feet high. As guests entered

the image had an overpowering effect. When he opened the exhibition Paddy's first comment, to roars of laughter, was, 'I am not half a man!'

On a cold February day in 2013, I happened to bump into Paddy Ashdown at the traffic lights on Wigmore Street. 'Hello,' I said. I was ignored. 'Hello … Paddy?' I queried, not quite sure it was him; we had not met since my retrospective at the National Portrait Gallery in 2001. He looked at me with a confused expression. 'Gemma Levine,' I said. 'Oh, hello, how are you?' he replied, but before I had a chance to respond, he stared at me and said, 'I don't like ageing. Do you?' Then the lights turned green and he walked on. I know I have white hair now and I don't look quite as I did pre-cancer days or twelve years ago, but that brief encounter made me feel rock-bottom. I guess that was in retaliation!

April 1998

In April 1998, **Paul Burrell**, former butler to Diana, Princess of Wales, came to my studio to be photographed for *Memories*. Most of my sittings lasted twenty minutes; this one lasted two hours. During our conversation, he told me of his recent trip to America, and mentioned that he had met Tom Hanks and been very impressed by him, even wanting to know if I thought he resembled the actor a little.

As Princess Diana had died in August 1997, our conversation was naturally dominated by our shared sadness at such a loss. Paul was fragmented by emotion, recalling the horrors of the tragedy; his memories of her overwhelmed him. He said he always stood in the shadows, always protecting her, and we spoke of his ambitions for the future, linked with the Memorial Fund and other charitable work that the Princess had created. He told me he would never tell the press his story and never write a book, emphasising that he would never betray her.

Well, history has rewritten that story, on which it is not for me to comment. I merely met a young man who at the time was beholden to his job and was the Princess's dutiful servant, and who had been dazzled by her charm and dynamism.

April 1998

I met **Joanna Lumley** in my studio in 1998. She walked in having never met me before and seemed to be my best friend in less time than it took to boil an egg. We both enjoyed the session and I loved her hat which became a feature of the photograph for *Memories*. The session took a mere ten minutes but she stayed and we talked for a good half hour. Since then she has supported my work and was willing to write a few lines for my cancer book, *Go with the Flow*. She was sympathetic, particularly as her friend and colleague Jennifer Saunders was having treatment for her cancer at the same time as me. We have kept in touch through letters. She has a wonderful way of expressing herself that you can hear in her voice and her laugh, which mirrors her personality. I hold her in high regard and have exceptional respect for the extraordinary work she does, and for her warmth and humility.

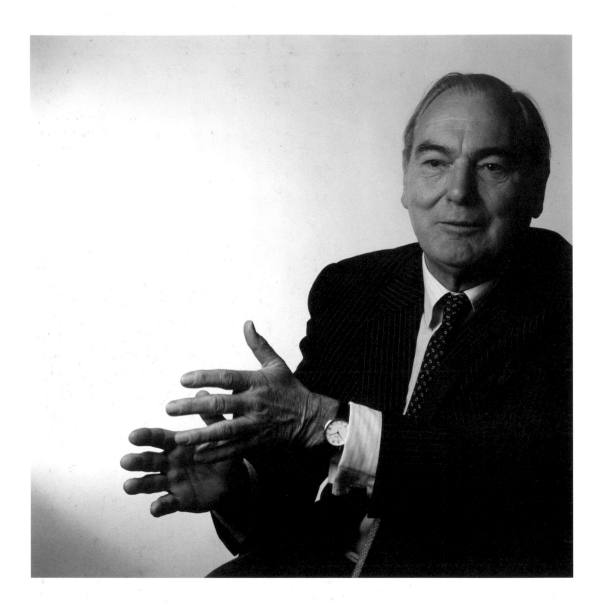

March 1987

My diary notes about **Peter Parker**, the former chairman of British Rail (and chairman of six or seven other organisations, too – he explained that he likes 'diversity'), are headed 'milk bottles'. In the morning I would always go to my front door to collect the bottles left by the milkman. On one occasion, there was no milk but instead I found a sizeable bunch of white tulips wrapped in layers of white tissue paper, tied with white satin ribbon. Attached was a beautiful postcard that showed Giovanni Bellini's *Madonna and Child*, saying 'thank you'. Each time I see milk bottles now (which is rare these days) I think of this poetic gift from the exciting Peter Parker.

November 1987

An American friend of mine, Pat Tigrett from Memphis, Tennessee, together with her husband, John, every year gave a small private Thanksgiving luncheon at their home in Regent's Park. Year after year, Eric and I were invited, joined by **David Frost**, Jimmy Goldsmith and one or two others. David and I became friendly over the years, so he was no stranger to me when I was seated opposite him on the beige leather couch in the television studios in 1987. I remember vividly being one of the *Frost on Sunday* interviewees on that cold November morning. It was my first TV interview for *Faces of the 80s*. I was petrified. I seemed to always look at the wrong camera as the red light confused me. I was more conscious of the red light than focusing on what I was saying. A complete disaster. But to add insult to injury, the following week there was a technical breakdown and the BBC showed the previous week's programme as a repeat. I was mortified and embarrassed to see myself a second time. I vowed I would never go on TV again, but I have, and survived!

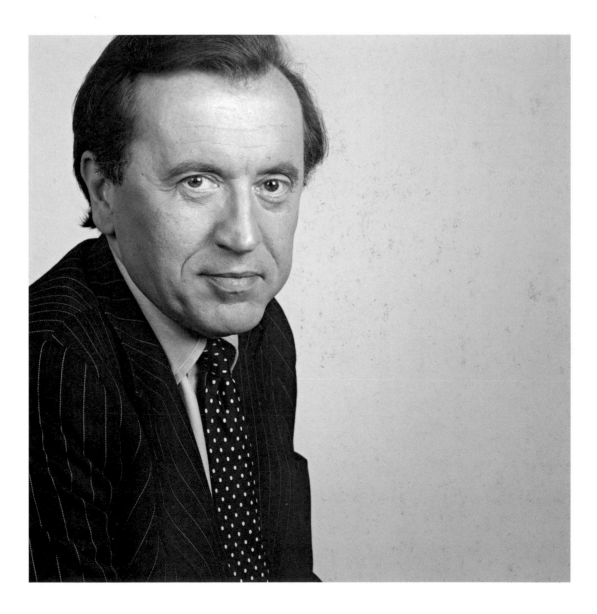

January 1987

I think I will begin at the end. **Bernard Levin**, one of the greatest English journalists in my lifetime, died from Alzheimer's disease in 2004. I received a letter from Liz Anderson, Bernard's closest companion, inviting me to his flat in Marylebone to collect a drawing that Bernard had left me in his will. A Rembrandt, from circa 1633: *Joseph's Coat Brought to Jacob*. Endlessly, I have wondered: why this particular drawing, for me?

We first met briefly in early 1970 at the apartment of Arianna Stassinopoulos, with whom I was friendly at the time. Several years later, I wrote to Bernard at *The Times* asking to photograph him. He was happy for me to do so and we had several sessions, during which we warmed to each other and became friends. We talked with John Tooley (former chairman of the Royal Opera House) of working together on a book of opera houses around the world. Sadly, we could not raise the finances to further the project – just one of the regrets in my professional life. Bernard was intellectual and he was articulate. He loved relating stories from his travels and I loved listening. He would discuss 'people' with me for the purposes of

including them in the books of the 80s and 90s. He knew far more about the personalities who were making an impact in the country than I did; I valued his opinion and would follow his advice. My regard for him was absolute.

One winter's day, Bernard travelled by train to my home in Chipping Norton. He came to join me for lunch and to reunite with Quentin Crewe, an old friend of his and a close friend of mine. At that lunch he told us: 'I am not well. I have something called Alzheimer's.'

From then on, I saw little of Bernard. I did receive a letter from him shortly after our lunch, thanking me: 'That was a splendid day! With your beautiful new home and that tremendous lunch – I reeled out happy and particularly so did "Q" [Quentin]. That man is a magician and will last for a thousand years.' Other than that, I would occasionally glimpse him walking the streets of Marylebone, looking forlorn and displaced, and always carefully guided by Liz. He passed away soon afterwards, but has remained with me; each time I glance at his Rembrandt drawing, I hear his voice.

June 1989

Judi Dench has supported me throughout my career. She has been included in *Faces of British Theatre* (right); *Memories*; *My Favourite Hymn: Claridge's* and contributed with text to my book on cancer, *Go with the Flow*.

My first encounter was with her backstage at the National in 1989, where she was playing Gertrude in *Hamlet*, alongside Daniel Day-Lewis. She was in her dressing room applying make-up when I walked in. She explained to me the difficulties of her profession: cramped dressing rooms;

scurrying up and down several flights of stairs; endless cups of coffee and snacked meals. Then to the sharp contrast of becoming Gertrude or Ophelia or whoever for a couple of hours. But the heart of her mystery is the need to communicate, to share knowledge, tears and laughter. She exclaimed, 'What could be more glamorous or exciting!' For me it was thrilling to watch her being dressed by Ann Hoey (above) and preparing for her entrance; I was fortunate to get some timeless shots before the drama began.

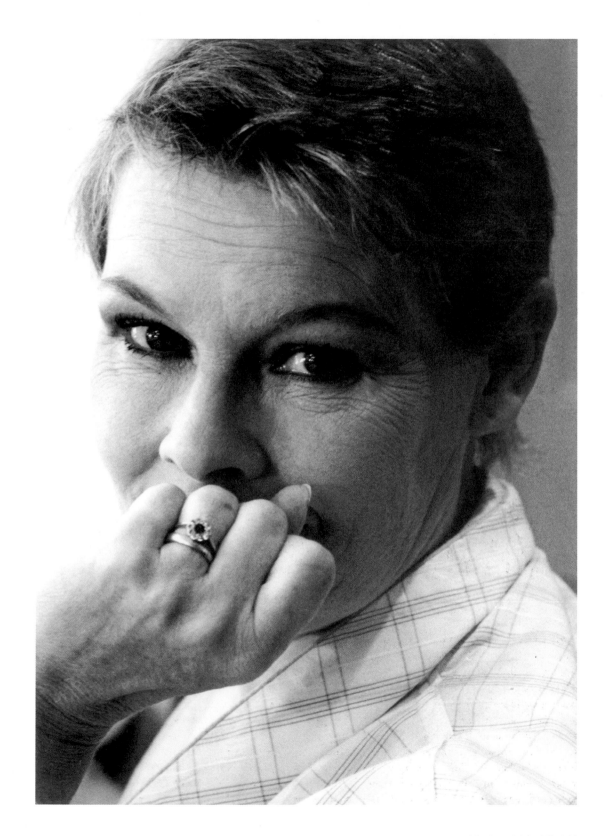

February 1987

I arranged to meet **Michael Gambon** at the National Theatre. He came out to see me and stood just by chance by the NT van. I took two shots and that was it: a session in one minute and a great shot. I felt he looked as though he was a van driver who had been sacked. He was relaxed and looked amused; I am sure he guessed what I was thinking.

December 1986

The celebrated restaurateur and cookery writer **Prue Leith** was one of the first people I photographed for *Faces of the 80s*. I met her, dressed in 'whites', climbing the steps outside her restaurant in West London, called 'Leith's'. I took a full-length photograph of her, wearing her kitchen boots, which had heels – it's very rare to see heeled boots worn with kitchen 'scrubs', so these were a unique feature in my composition. The photograph was subsequently used in exhibitions and several newspaper articles. Through the years, Prue and I formed an honest friendship and visited each other's homes from time to time. She has even opened two exhibitions of mine in Chipping Norton at our famous local bookshop, Jaffé & Neale. One evening Prue and I dined at a local restaurant and throughout the meal she was

very sweet to the staff and quite complimentary. When we left, saying our goodbyes, she said, 'Life is too short to eat bad food in bad restaurants.' By chance, the restaurant happened to close a just few weeks later!

One day, when I visited her home in Castleton, I gasped to see on the wall my framed photograph of her. I was mortally offended by the fact that, in order to fit it into the frame, Prue had cut off her feet, ruining the whole composition. When she saw my reaction, she was shame-faced, but, of course, this small infraction was not enough to ruin our friendship. When I photographed her again for *Memories* in 1998, I featured only her head and shoulders; there was not much that could be sliced off that image.

May 1988

Photographing **Kenneth Branagh,** who was at this point a rising star in British theatre, was a difficult task as we only had two minutes backstage. This did not give my flash unit enough time to charge, so I had to use the natural light on the back stairway, which was grossly insufficient. Sadly, seeing the final proof, there were many ugly unwanted shadows.

July 1987

Michael Crawford was like the wind … I couldn't catch him, so have a face with a whirlwind motion of a body – full of action and laughter.

May 1990

I was sitting next to the actor **Donald Sinden** at a dinner party in the House of Lords. People at the table were asking about the progress of *Faces of British Theatre*, and he looked quite miffed when someone asked him if he was in it. I hurriedly interjected, 'Of course, but no appointment has been fixed yet.' And so the very next day we called him to set it up.

February 1987

Aled Jones, a beautiful, innocent young man, aged 13, came to my studio in Wimpole Street on a cold February morning to be photographed for *Faces of the 80s*. We wanted to include this talented young protégé who had become renowned for the purity of his treble voice in a repertory ranging from Handel to Lloyd Webber. He was the youngest person in the book, and on the facing page was the oldest person, Gwen Ffrangcon-Davies.

On an equally cold day in December, nearly thirty years later, I was delighted to reunite with Aled, who was hosting ITV's early morning show, *Daybreak*, with Lorraine Kelly. When I went onto the set Aled said, 'When your name came up on my notes for an interview, I wondered if we had met before; the name was so familiar.' We all burst out laughing as I showed them Aled's picture in the book, seconds before we went on air. Oh my, what a different person now: mature, good-looking and with such a welcoming smile. I was interviewed by him, but was itching to ask him to sing!

January and May 1987

Two of my most engaging and captivating sitters were **Sir John Gielgud** and **Dame Peggy Ashcroft**. At 11.30 a.m. on 23 January 1987, Sir John came to my studio in Wimpole Street. His personal manager had telephoned me to say that Sir John could only spare ten minutes on his way back from a nearby dental appointment. Would that be sufficient time? Even two minutes with one of the greatest acting heroes of our day would be more than I could wish for.

The studio, overlooking my secret garden, with its white walls and stripped beech wood floors, presented a feeling of serenity. On arrival I made Sir John some freshly brewed coffee. Resting on a tray, with a linen cloth of pale lemon, I placed a spray of mimosa; the scent was alluring. In the background were strains of early baroque music.

I received Sir John with a firm handshake, and on hearing one of the finest voices in the world I was instantly mesmerised. The allotted ten minutes turned into twenty, thirty, then fifty … after an hour and a half I finally let him go! Before leaving, he asked me if Dame Peggy Ashcroft had an appointment to be photographed. I replied that it was difficult to locate her agent. He reached for the telephone and dialled a number: 'Darling,' he said to Peggy, 'I suggest that you should be photographed by Gemma Levine for her book, it will be congenial and you will enjoy the tranquillity of her surroundings.'

At noon on 11 May 1987, Dame Peggy arrived at the studio. She was graceful, offering an affectionate greeting and a kiss on both cheeks. She thanked me for seeing her and repeated the conversation she had had with John. On this occasion there were marigolds on the tray and Mozart in the background. The room was in semi-darkness and we talked in a quiet and relaxed way.

Half an hour passed, and I was almost finished when the doorbell rang. I left the studio door ajar as I went to answer the intercom. A man's voice, slightly muffled, said, 'It's me … Danny.' For an instant I was shocked, though of course I recognised the voice. It was my former father-in-law. We had not spoken for two years; this was no fault of his, but after my divorce I could not bring myself

to have contact with either of my parents-in-law, Jessie or Danny.

In that split second, the memories of our times together flooded back, recalling the sadness of our disunited family. For two years I had struggled to suppress the pain; now the agony came surging to the surface and I broke down, crying uncontrollably. I saw Danny walking down the long hall to my apartment. For a man in his seventies, journeying by train from Brighton especially to see me must have been an enormous strain. He wore a dark blue tweed coat with a beige wool scarf tucked tightly into the collar, and in his gloved hand he clutched a brown trilby hat.

He walked slowly but deliberately and, on reaching my door, put his arms around me and sobbed. 'Would I let you vanish from our lives? Do you realise, it has been twenty-five years?' Breathlessly, and with emotion, his words spilled over one another. 'You can't brush twenty-five years aside as though they never happened,' he said, whereupon, he gently took my arm and guided me into the lobby directly outside my studio.

The intimacy of the moment was disturbed by a soft voice conveying genuine concern. 'My dears, please explain. May I help?' I had totally forgotten that Peggy was sitting in the studio and could overhear every word. Amidst my sobs I told her about my marriage which had broken down. She expressed sympathy and put both her arms around the two of us. 'I know what you are going through, my dear. I too have had similar experiences and I know the pain. I will leave you now, to your reunion. Goodbye. So pleased to have met you,' she said, nodding to Danny; she then embraced me and quietly withdrew.

Danny clearly did not recognise Dame Peggy Ashcroft, nor did he realise that I was in the midst of a photographic session. He simply thought he was interrupting a tête à tête with one of my girlfriends. Later that afternoon, Dame Peggy telephoned. She said that she would never forget the drama she had encountered that day, and nor would she ever forget me. She went on to say she had called Sir John to thank him for suggesting she spend a 'tranquil afternoon' within 'peaceful surroundings' with the photographer Gemma Levine.

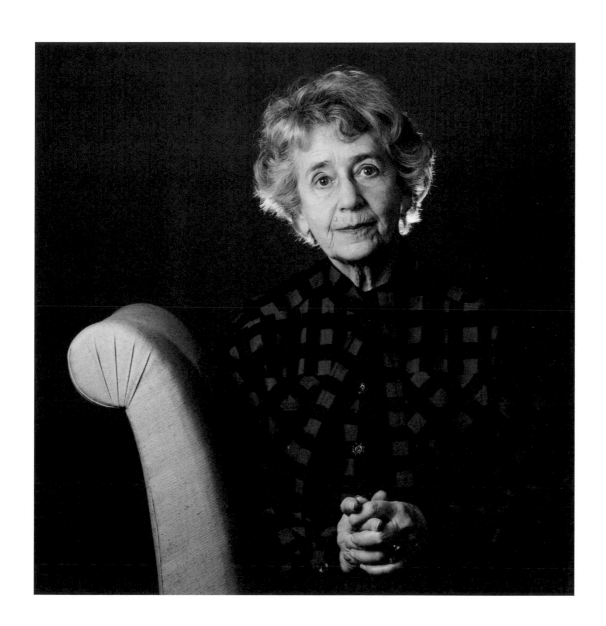

May 1991

It was difficult to establish a connection with **David Hockney**. He lived in California and it took six months of telephone calls and fax messages to confirm a date to photograph him in London. Eventually, we met at his studio in Pembroke Square, Chelsea, close to the Embankment. He appeared to be a most colourful character, both in personality and appearance.

I am usually a strictly black-and-white photographer, but I thought it would be absurd not to photograph him in colour. His bright red socks and the vivid alternating tones of his shirt, necktie and trousers were a tribute to an artist's palette. To photograph him both in colour and then black and white seemed the most logical way of dealing with the problem.

The session finished half an hour before schedule. Having watched me arrive at his gate in my Saab convertible, he suggested we take a drive by the river with the roof down. He climbed into the front passenger seat, put both his feet up onto the dashboard, rested his head back and thumbed through my CD collection. We spent a wonderful hour as the sun was setting, on a perfect summer's evening, accompanied by Mahler. I dropped him off for his next appointment thinking that, however much effort it had taken to arrange this session, it had proved to be well worth it.

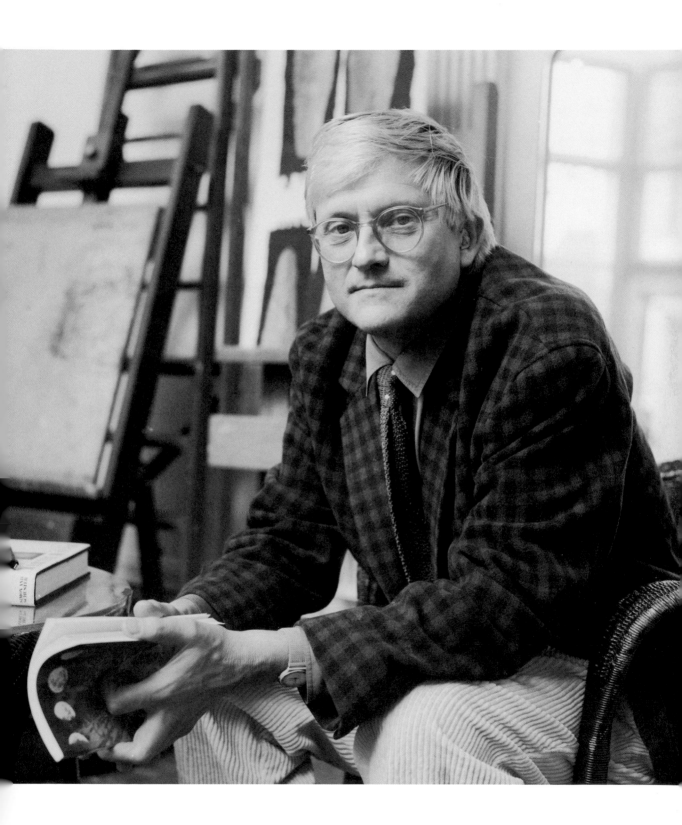

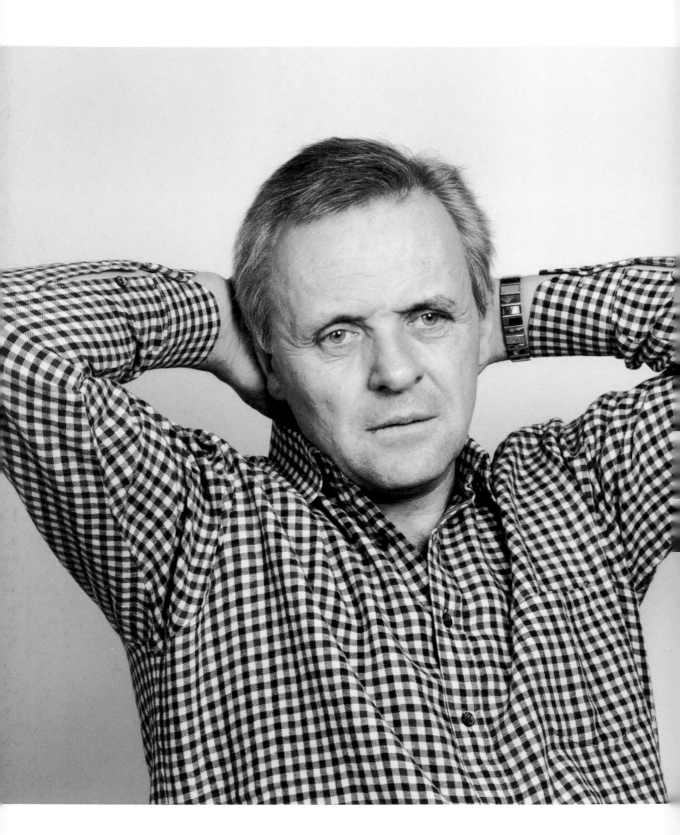

March 1988

I just love **Anthony Hopkins** – check shirt and
all; hands clasped behind his head, with an ex-
pression on his face that indicates, 'Oh, I have
been here before … I wish she'd get on with it …'.
From my standpoint, I would have liked him to
stay forever. As he was getting up to go, I did say,
'Just one more …'

June 1987

Having run through one roll of film, **Bob Hoskins** obviously became bored: 'May I use your bathroom?' Mischievously he put his head under the shower and returned dripping wet. 'You may get a more interesting shot?' he challenged. I did. But I used the first shot with his cap on, as I thought the hat was cute and framed his face well. Needless to say, I had quite a job cleaning up the bathroom after he left as I didn't want Helena Bonham Carter to have to wade through pools of water.

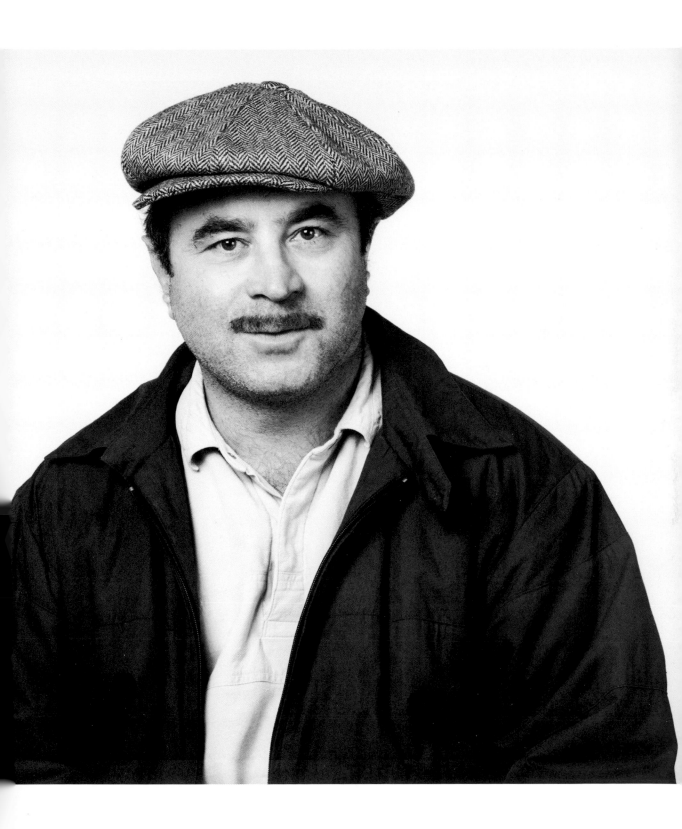

Trying to establish a date and time to photograph **Alistair McAlpine**, the former Conservative politician for *People of the 90s* was a near impossible task.

Each year in August I go to Venice for a few days' holiday. On this occasion I took a friend, the author Susan Crosland, as I had been commissioned by the famous Cipriani Hotel to photograph the day-by-day running of the hotel, and Camera Press would then publish the portfolio with captions by Susan. Quite coincidentally, on the outgoing flight Alistair was seated next to me. In conversation he told me he owned a villa in Venice and we then spent the rest of the journey discussing our mutual passion for Venice, resulting in an invitation to visit him during my trip.

His villa, situated on the outskirts of Venice, was spacious with high ceilings and dark interiors, which kept the rooms cool in the heat of the summer. He was proud to show me his 'salon' where he hung his ties, as one would see displayed at the V&A museum. There were hundreds, if not thousands. He also showed me his collection of jewellery, which he had crafted from ancient stones and Murano glass, and he generously asked me to select one for myself. What a marvel.

At his suggestion we had lunch before the photography session. I was anticipating a romantic Venetian restaurant. But that was not to be. He took me on to the pavement outside his villa, where there stood a man in a navy-and-white striped vest, shorts, a straw sombrero. By his side were a wooden crate, an umbrella, a sleeping dog and two dilapidated wooden chairs, which we sat upon. Alistair ordered some water and two cheese sandwiches. I felt like asking for the wine list… but that was clearly not on the carte du jour! The sandwich was delicious and this rustic lunch turned out to be enormous fun – better, at the time, than any glamorous restaurant.

I photographed Alistair in the gardens of the Cipriani. This photograph also appeared on the front cover of his memoirs, *Once a Jolly Bagman*. He was a cultivated and colourful character, a bon vivant, and his lifestyle in Venice suited his exuberant personality as an artist and enthusiastic advocate of theatre.

I have always had a particular attachment to the city of Venice. As much as I was mesmerised by the light in Jerusalem, I felt the same about the light in Venice. The soft glow, held within mists, of the early morning sun, which I watched rise above the domes of San Giorgio Maggiore; the bursts of radiant light as the first rays glistened and reflected onto the lagoon. These endless sensations of joy replenished my spirit. They say Venice is dying; Venice is on the verge of crumbling, a city worn through the centuries. For me, it is magical.

On my last evening this year in Venice at the Cipriani, I dined at Cip's restaurant on the deck, supported by stilts in the water. Watching the sun go down across the lagoon, another year was over, but before I left, I received a 'key' to the city of Venice from the management of the hotel; this key for the Cipriani and a 'key to their hearts' was awarded to me on the final hour. This was a great honour and I know (health permitting) that I will return year after year for my few days of mystical revitalisation.

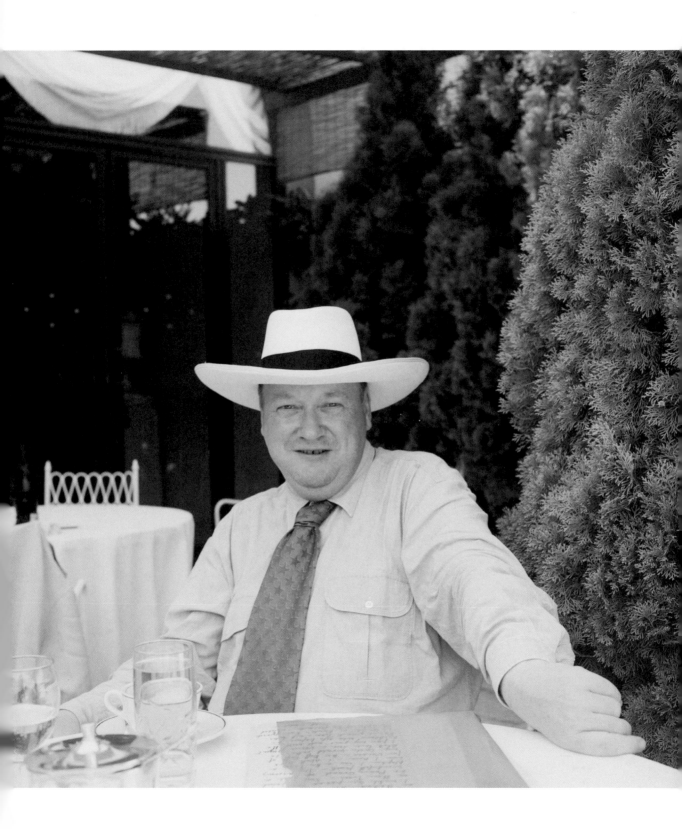

June 1987

I was slightly uneasy meeting **Arthur Scargill**, president of the National Union of Mineworkers, about whom I had read so much in the press. He broke the ice, saying, 'The English do not look at each other in the eye. I can look at you, eye to eye, but it's very rare.' With that, I felt at ease.

January 1987

I went along to the Theatre Royal Haymarket to photograph **Derek Jacobi** backstage, and the rest of the cast on stage, at a performance of Hugh Whitemore's *Breaking the Code*, in which Jacobi was playing Alan Turing. I was given a box above the stalls to afford me a good vantage point, and when I glanced down at the audience, I happened to spot my son Adam. He was mesmerised by the play. To attract his attention I gave a little cough. He didn't notice, so I coughed again and again, but he still didn't hear me. Then a steward came into the box and asked me to leave immediately as I was distracting the actors … but not my Adam.

March 1995

Quentin Crewe and I were first introduced at a luncheon party given by Lady Reading in the Cotswolds in 1995 where I had the privilege of being seated next to him. He arrived, pushed by an attendant, in his wheelchair; a weighty man in his sixties, Quentin suffered from muscular dystrophy for over forty-six years but amazingly lived his life to the full.

We lived as neighbours in Bliss Mill, a Victorian converted tweed mill built in 1872 in Chipping Norton, with a small pond flowing and rippling between our two homes. We shared a ritual together: every Friday evening at six we would savour a glass of wine or Armagnac, sharing problems, thoughts, reminiscences and gossip.

Quentin's head dropped heavily on one side, which made his gaze appear lopsided, but his eyes were alert, with genuine warmth, sparkling with wit, humour and a slight hint of mischief. When animated, his face lit up and, together with his natural reddish complexion, produced a vibrant glow. His spectacles hung round his neck and when he lifted them to his brow, they slid to his temples until he gingerly perched them on to the edge of his nose. One could not fail to be aware of his nose: a well-defined feature; thin, sculpted,

acicular, the inheritance from a long line of aristocratic ancestors.

His voice was soft and sensual. In the years that followed his vocal cords became weaker and weaker, until one craved to hear the familiar sounds that had once enriched and enchanted our days.

This was his life. With a vital spirit and nerves of steel he led far more of a fulfilled existence than most. Women, music and his family were an essential part of his life. He also had a great deal of passion for travel, wine and food, and he wrote several books on all three subjects. He founded and owned a restaurant in London called Quentin's. He was acknowledged as an eminent writer, publishing many books and contributing to most major UK newspapers. His achievements were staggering.

To have met and known such a man with so much compassion and dynamic vitality, who had also endured endless pain and suffering during his days, was a unique and life-enriching experience. I mentioned in a previous chapter that Henry Moore was my 'mentor'. Quentin was my 'professor' and one of the closest friends I have had. The day he died, I grieved … and, to this day.

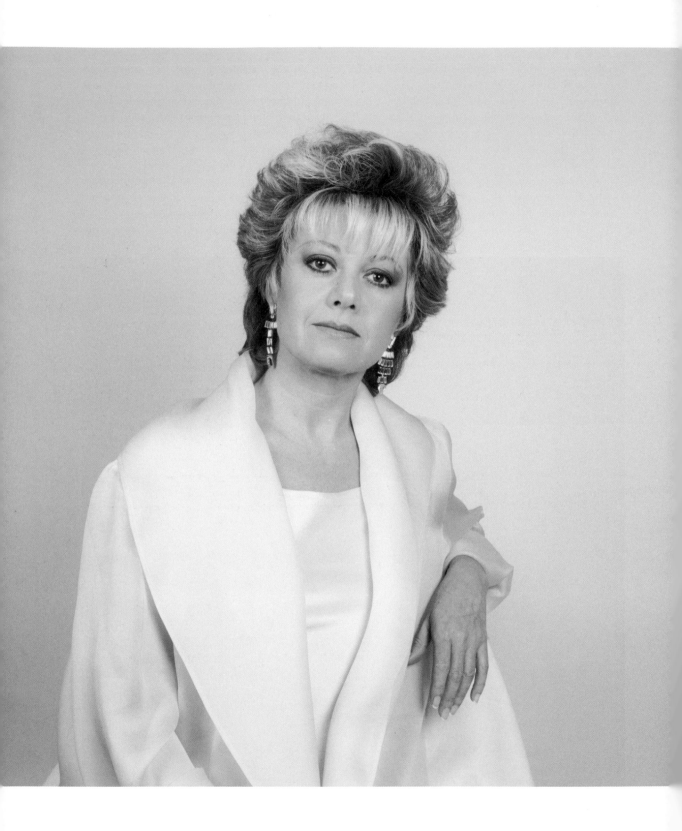

April 1985 and September 1998

When photographing people, I tried to avoid all of the trappings of fame, the demands and the entourages that one sometimes encounters when dealing with celebrities. I would try to find the human interaction in any session, above all else. In 1985, for *Faces of the 80s*, I was sent a list of requirements for my session with **Elaine Paige**: a make-up artist; a hairdresser; correct lighting in the bathroom; a chauffeur-driven car to fetch, deliver, wait and return; her choice of the photograph for the book, not mine; and her assistant to accompany her. I explained politely this was a book for charity and

that I had to keep requirements as simple as possible, but that of course Kate Weston, her assistant, could come with her. However, on the day, Elaine was charming and down to earth. We laughed and gossiped, and the session could not have been nicer. She came back to feature in *Memories* in 1998 (above), visually a complete transformation from the traditional formal and statuesque figure in 1985, it could have been two different people. She returned without any prerequisites – I always found that a relaxed and informal approach was far more satisfying, both for photographer and sitter.

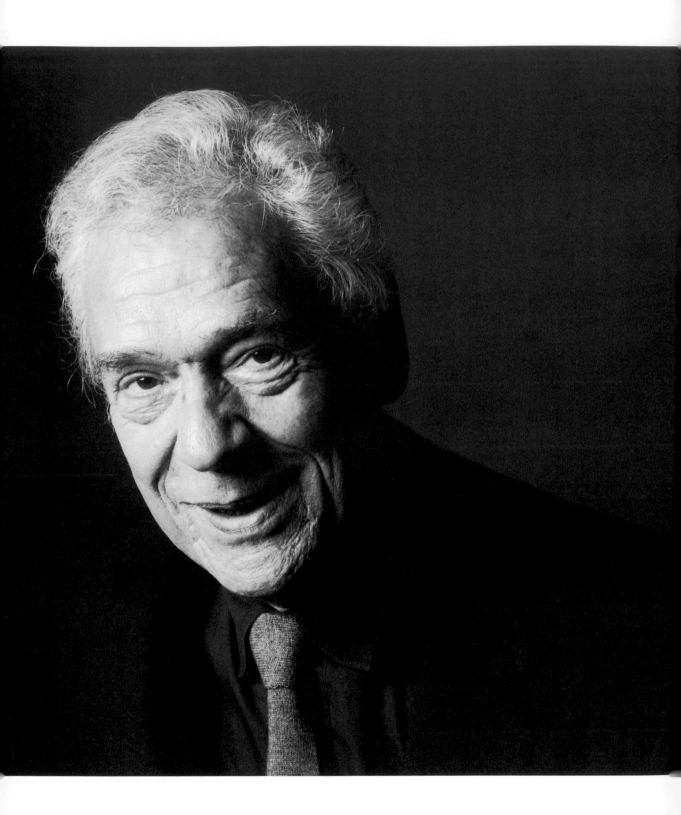

March 1987

The actor **Paul Scofield**, one of the greats of British theatre, travelled a long way to see me in London. As he entered my studio, I observed his face, which was heavily lined and showing immense character. I decided not to use a standard white background but just concentrate on a study of the character in his face, using one light and leaving the other side of his face in shade. The background was black and, with a single beam highlighting his features, I felt an instant sense of drama. We were both silent with strains of Bach playing in the background. After twenty minutes, we were both able to relax. It was a strain on the eye, delving into such detail, but the moments of photographing in this session were magical. He agreed, and said he felt the tension and anticipation; he later told me these were some of the best photographs of himself that he had seen.

June 1989

A colleague of mine, Gerald Jacobs, a journalist from *The Jewish Chronicle*, telephoned me one day asking if I had any photographs of **David Suchet**, who was becoming famous with a new TV series called *Poirot*. I said I had not heard of him. Gerald's reply was, 'Well you should have done,' whereupon I invited David to appear in *Faces of British Theatre*. He arrived at my studio in Wimpole Street and we became immediate friends. He was full of warmth and great enthusiasm. His eyes in particular attracted me: with variegated browns, they were penetrating and expressive, and this came through in the pictures. His hands, with long thin fingers, were also an expressive feature, making him a wonderful photographic subject. David and his wife Sheila invited me to a garden party in 1990 at their home in Pinner. I sat next to Trevor McDonald, the TV newscaster, and, after an animated conversation, I was thrilled to have another commitment for *People of the 90s*. David and I have kept in touch through the years, and he wrote a wonderful letter to me after my cancer operation. He has been one of my favourite sitters, appearing in four of my publications.

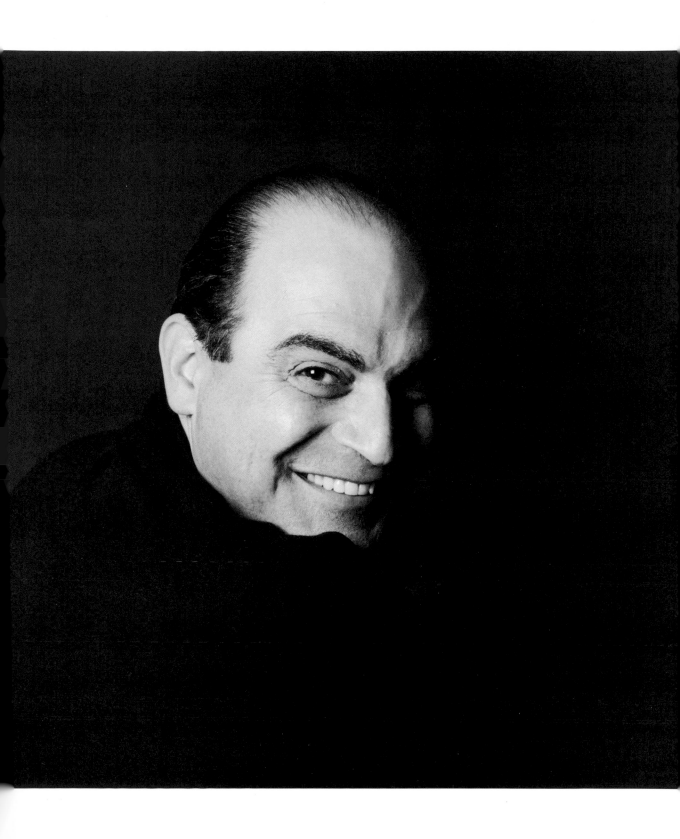

March 1987

Thomas Allen, the virtuoso opera singer, sat for me for twenty minutes. As I finished the session I asked him which opera he would be performing that evening at the Royal Opera House: 'Puccini's *La bohème*,' he said. 'Would you sing an aria for me?' I pleaded. He cleared his throat several times, took a deep breath, and broke into 'O soave fanciulla'. His voice was electrifying. The acoustics in my small studio were adequate but, with the full strength of the baritone's voice, I thought the walls might cave in.

Within minutes there was a knock at the door. A neighbour from the top floor impatiently exclaimed, 'Could you please turn the volume down, it's disturbing me, the cat and the other neighbours!' Thomas and I burst out laughing. He said, having made that impact, he would perform especially heartily that night.

March 1987

I was wearing a polka-dot blouse, brown with cream spots. **Ernie Wise** walked in with his wife for his session. He said, turning to his wife, 'We better get out quickly, she's got measles …' He left hurriedly, but a couple of minutes later came back giggling. It was such fun, the entire session. When it finished we spent time chatting over coffee. Ernie was so quick-witted, he had an answer for everything; his wife obviously was his great support, as she laughed at everything he said. I was happy to have my own private comedy hour, which made me smile for the rest of the day.

November 1992

I met **Betty Boothroyd** in 1992 when she was the first woman Speaker of the House of Commons. Spending a short time with her, for my book *Faces of the 90s*, I soon realized that for her, nothing seemed too much. She was helpful, charming and if I wished to return for further sessions she would gladly give her time.

I took her up on that offer and asked her to sit for me again, for my *Memories* book and, a year later, for *My Favourite Hymn*. I needed a text from her, too, on both these occasions. Over the years, we got to know one another quite well. I felt comfortable asking her to open my retrospective exhibition at the National Portrait Gallery, celebrating twenty-five years of photography. I even took a special photograph of her for that event. As she was going to Ascot for the day I captured her in a stunning large red straw hat. She looked magnificent and the photo was given centre stage at the exhibition. The retrospective was such a significant occasion for me; Betty spontaneously responded with great enthusiasm and was perfect for the occasion.

When I held a publishing party at Claridge's for my book on the iconic hotel, I organized an auction for charity and asked Betty if she would like to mastermind it. Promptly, she said 'yes' and, together with David Frost, put on a splendid show and made vast sums of money for one of the charities that she headed, Fight for Sight.

We have dined together often, celebrated on many occasions and spent some jolly times. On one of our lunches I was wearing a silver watch with charms, which was rather exotic. She admired it so much that I took it off and gave it to her. 'It's yours,' I said. 'No,' she insisted, 'unless I pay for it?' I saw her face drop as she was imagining that it must have cost hundreds. She said, 'Would £100 be enough?' I laughed and said there would be no charge whatsoever. She was thrilled, somewhat embarrassed to accept, but I insisted. Some time later she told me many friends admired the watch and asked where it was from. She responded: 'Tiffany's, I think ... a friend gave it to me.' When I finally told her the truth – 'I bought it from Primark for £5!' – we laughed so much. It is always such fun to be with her, and she has given me so much encouragement in my career, that a watch from Tiffany's/Primark was the least I could do.

Three of my sitters, scheduled to arrive within half an hour of each other, all appeared at the same time. The bench in the hallway resembled a dentist's waiting-room, with the **Earl of Longford** on the left, John Quinton, chairman of Barclays Bank, on the right, and between them **Samantha Fox,** the *Sun* newspaper's prettiest and sexiest Page Three topless model. No one spoke. The men carried vacant expressions whilst Samantha was relaxed and full of smiles. I noticed Lord Longford had a scruffy newspaper stuffed into his raincoat pocket but didn't attempt to read it. As John Quinton walked out he said, 'Who was that pretty girl who you photographed before me?'

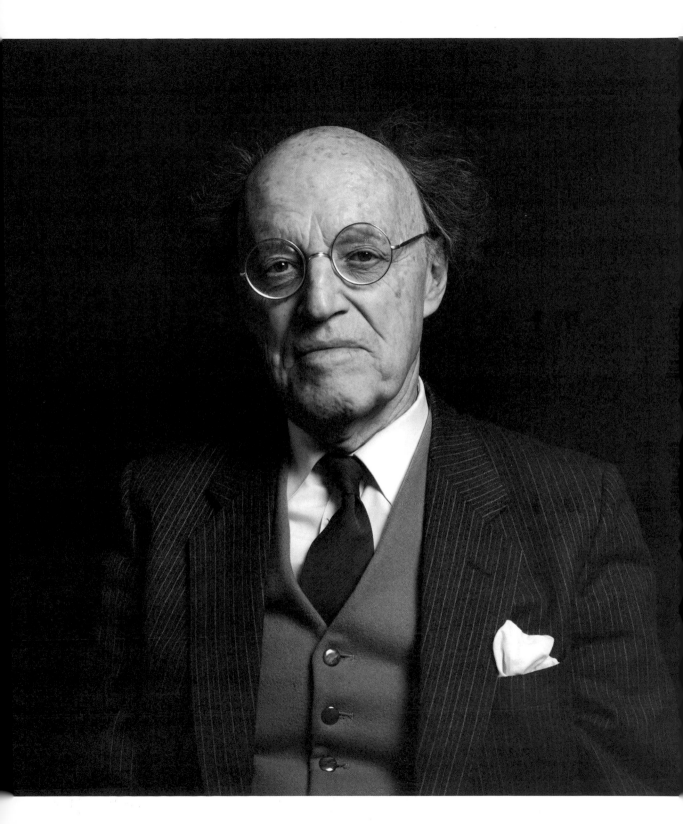

The playwright, actor and director **Steven Berkoff** seemed a little cross; Deborah Warner had been late for her sitting, and so we had had to keep Steven waiting. He said, 'Do I have to sit on the seat still hot?'

April 1993

I made an appointment through the press office at Downing Street to photograph **John Major**, who was at that time prime minister. I took my assistant, Rob Carter, as I relied on him to manage the lighting and relieve the weighty burden of my equipment. The press officer, Ian Beaumont, greeted us on arrival and escorted us through to the area where he felt it would be appropriate for me to photograph the prime minister. I glanced around the room and found there was no adequate backdrop, which I had hoped for. Slightly dispirited, I thought there was little I could do, as Ian was adamant that we remain in this area. Silently, I waited.

The prime minister entered the room together with his aides, approached me and formally shook hands. He stood back and, after making affable conversation, asked me if he looked suitable for the photograph. I immediately said, 'Prime Minister, your tie is off-centre.' He fiddled a while, but it was still askew. I walked up to him, put the camera down and redressed the tie. I could see he was embarrassed, as was I. Rob blushed but remained expressionless and Ian was fuming.

The prime minister asked where I would like to take the photograph. The room adjacent was the dining room, where I saw a highly polished table loaded with an array of exquisite silverware. I said, 'Prime Minister, would it be acceptable to you if we use this room?' He nodded with amusement. Hesitatingly, I asked him to be seated. Again I made note of his tie and walked towards him, but decided not to touch the tie again; I stepped back and, as I did so, he cupped his head into his hands and burst out laughing. I swiftly took one shot. This photograph has since been used as the front cover for *The Sunday Times Magazine* and many other newspapers, usually with an amusing caption within a speech bubble (which I had better not repeat).

April 1986 and January 1994

The first time I was invited to Downing Street to photograph **Margaret Thatcher,** I was filled with trepidation. I was told she was occupied with the Cabinet and therefore, when she arrived, I would have to be ready. I was given five minutes to set up and just five minutes of her time. I heard her high heels clacking on the wooden floors outside before she briskly entered the room. Abruptly, without hesitation, she asked me where she should sit and how. Was her dress falling correctly? Was her collar in place? I was nervous but also in awe of this powerful lady. I noticed her piercing eyes and direct gaze as we exchanged brief words. We spoke of Golda Meir, whom I had met; I felt the two had a great deal in common, both being powerful women of state. Mrs Thatcher expressed admiration for her and mentioned she had known her well. We stopped talking and I proceeded to photograph her without a moment to pause. I intuitively took a profile shot, in which her eyes were not focused on the camera. She seemed deep in thought, which gave her a reflective expression, showing a half smile; she looked completely relaxed, and yet at the same time there was an unmistakable dignity in her expression. This particular image she chose for her Christmas card that year.

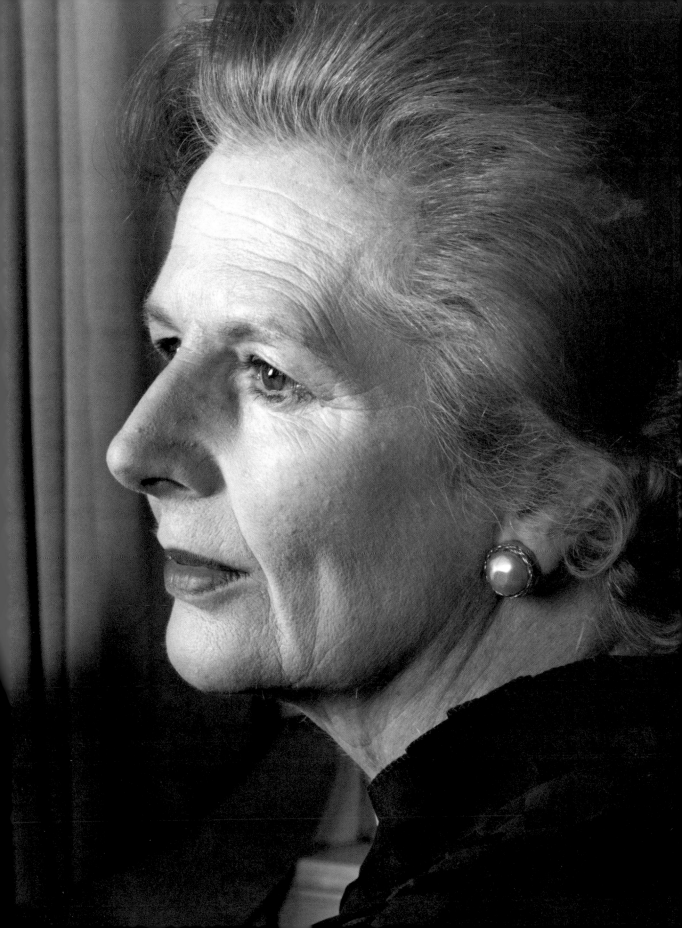

I photographed Margaret Thatcher a second time in 1994, was when she was sixty-nine years old and was no longer prime minister. Our meeting was at 8 a.m. at her London home in Chester Square. She opened the door herself, wearing a white blouse, black skirt and a pinafore. I heard her husband Denis in the background saying, 'Who is it?'

She asked if I would like a drink, but I declined as I wanted to proceed. She excused herself and returned, elegantly dressed in a black suit, white blouse, pearl necklace, jewellery, with her hair coiffed and immaculate.

She volunteered to show me her drawing room and the other rooms on the ground floor. She was immensely proud of the gifts she had received from dignitaries around the world during her various diplomatic and Commonwealth visits. I smiled to see one of these priceless gifts being used as a door stop. I asked her about some of the stories behind the artifacts, and she could have talked for hours on the subject, but time was pressing on. She asked me where I would choose for the sitting, and I selected a couple of different locations, in her drawing room by the bookcase and the dining room by the window. I worked quickly and efficiently, which she appreciated. The session took half an hour; I left feeling pleased with the way we had connected and hoped the pictures would reflect that.

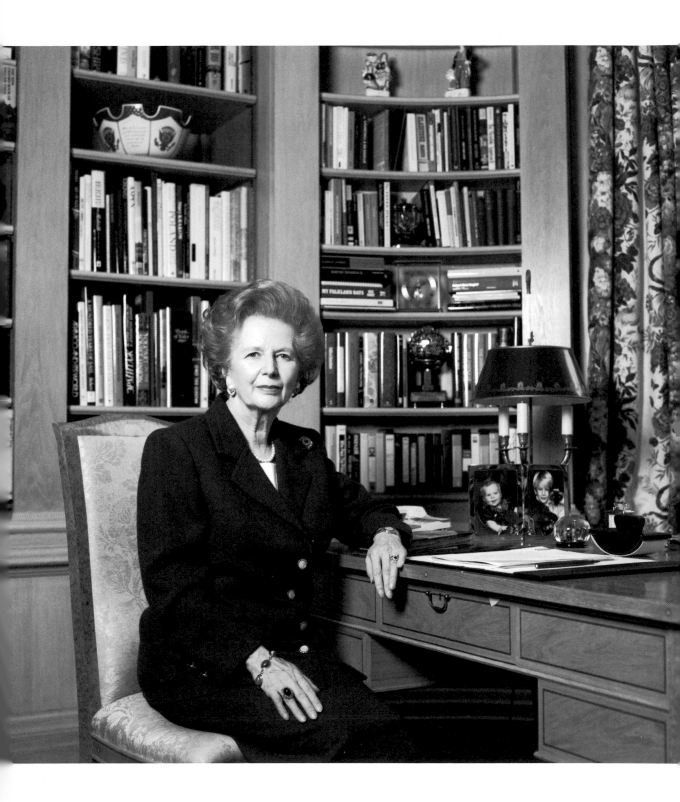

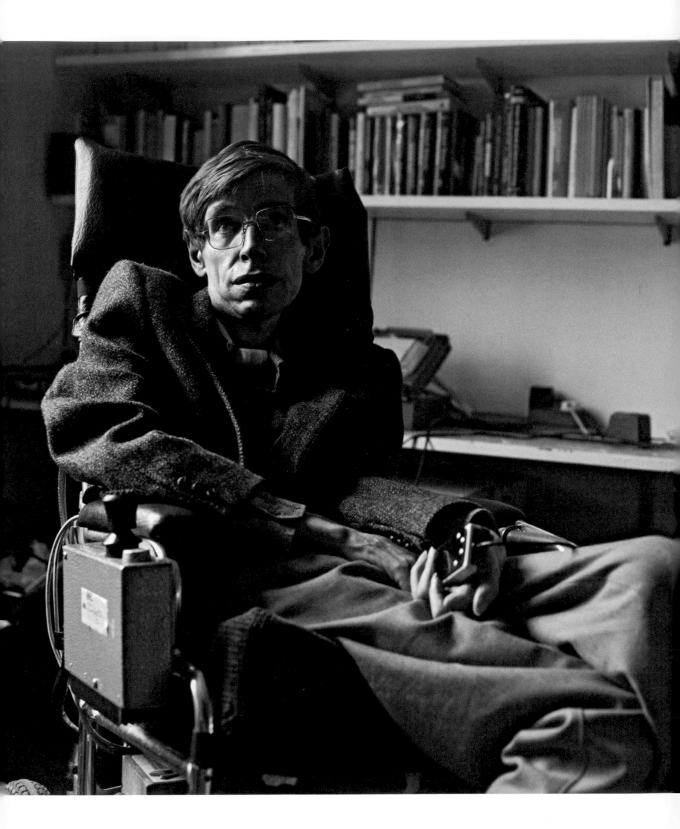

April 1987

On entering Professor **Stephen Hawking's** basement room at the Department of Mathematics in Cambridge, I said, 'Hello.' After a short delay, the penetrating sounds of his voice synthesizer filled the room. It was mildly disconcerting at first, but I soon grew accustomed to it. We had a short delay as my flash would not function due to the electronics pervading the small space. A charming Japanese lady assistant came to help me, and after a few minutes of flicking various electrical switches, my flash lights resonated. After the session Professor Hawking asked for copies of all the images I took, as he explained he loved photographs. Looking around the room, I could see many displayed in frames on tables and shelves. I drove back to London enormously moved by one of the most memorable experiences I have encountered; I was struck by the spirited intelligence in his eyes, and grateful to have had the chance to be in the presence of one of the greatest minds of our time (not to mention, I was later told, reputedly one of the wittiest men in the scientific community).

May 1998

I went to the offices of the Conservative Party in Smith Square in Westminster to photograph **William Hague**, then Leader of the Opposition, for *Memories*. On entering there was great difficulty with the security. My cameras were searched and re-searched and I was worried my film, which I had put into the casing, had been slightly exposed to light and the results would be foggy. There was no time for me to change the film so I had to take more images than necessary and take up more valuable time.

The room was small and there was one chair. I needed a stark, plain background so I asked Mr Hague to sit down, and I was given five minutes. I took two rolls of film with my Hasselblad. He thanked me, wished me luck with the book and left. A lady came into the room with a mug of tea. In the rush to leave and pack up my equipment I noticed just two things. There was a long crack in the wall behind where Mr Hague had been seated, and the mug I was given had 'Tory Tea' printed in large letters in blue around it.

The bad news was it cost me a great deal of money to have the crack removed from the photograph before publication (probably as much as it would have cost to have a decorator fill in the crack in the wall). The good news was that I became the proud owner of a lovely ceramic mug, which has remained with me all these years. One of the newspaper gossip columns even picked this up and printed the news that 'Gemma Levine stole a mug from the Conservative Party'.

January 1993

For *People of the 90s*, the Malcolm Sargent Cancer Fund directors and I decided we needed to include **Chris Patten**, who was then 'our man' in charge of handing Hong Kong back to the Chinese. We asked Sir Colin Marshall, chairman of British Airways, to sponsor my flights. Since it was for a notable cancer charity, he agreed. I visited the Hong Kong Government office in London, who put me in touch with Kay and Tom Dunton of the Standard Chartered Bank of Hong Kong; they would handle all the arrangements. My diary was full. Every day I was scheduled to photograph politicians and dignitaries. I met with Sir Horace Kadoorie, aged 93, who showed me his world-famous jade collection, which felt like entering an exclusive private museum.

My session with Chris Patten took place at Government House, which was built between 1851 and 1855. The main building was a combination of rich colonial features with British and Asian styles; I decided to feature him in front of a portrait of Queen Elizabeth II for, as the weather was cold and cloudy, I could not use the veranda as I had hoped. Chris Patten seemed to me a typical member of the establishment, liberal elite. He could not have been more charming, helpful and genuinely interested in the charity and the success of the publication.

My week in Hong Kong for *People of the 90s* was a great success and a memorable event. My thanks to British Airways, who made it possible.

June 1995

Shortly after photographing **Max Hastings**, then the editor of the *Daily Telegraph*, a bottle of champagne arrived, without a note, but sealed with a *Daily Telegraph* sticker. I couldn't think why Max would have sent it, but duly wrote a thank you note. Some weeks later it all became clear: back in June, Quentin Letts, the editor of the Peterborough column at *The Daily Telegraph*, had written an article about one of my portrait volumes, slating my work. His comments upset me and I wrote a letter telling him exactly how I felt, though I didn't expect a reply. However, soon after thanking Max for the champagne, mistakenly as it turned out, I received a missive from Quentin Letts: 'I hope this letter helps to explain the mysterious bottle, and that you will forgive its non-appearing forerunner, in the fray of critical appraisal many things are said, many words printed, but few are intended to wound and I am sorry this occurred. But I was glad to be able to pick out individual photographs for praise – your portrait of Michael Portillo is the best I have ever seen.'

June 1987

It was pouring with rain when I reached the House of Commons. The police would not allow me to park nearby, so I walked for forty-five minutes with all my equipment, arriving soaking wet at the Shadow Cabinet Room, where **Neil Kinnock**, then Leader of the Opposition, was waiting. It was the last day before the hustings, prior to the General Election on 11 June. I was allowed ten minutes with him, but was disturbed throughout by members walking in to ask questions. I did request that we have a few minutes alone but we could not manage this. On top of that, my equipment was damp and the moist shutter functioned far too slowly. It was a thoroughly uncomfortable and gloomy session.

June 1993

I first met **Paul Dacre**, editor of the *Daily Mail*, when I went to photograph him in his office. We subsequently stayed in touch; and, since Anne de Courcy and other journalists were writing about me at this time, we had cause to speak quite often. Some time later, the several sessions I had with Princess Diana became common knowledge through newspaper diaries. However, I was surprised to receive a telephone call soon after my final photographic session with the Princess to say she needed to have a private conversation with Paul Dacre. Would I be able to arrange it? Since by then I had met with Paul a number of times, it seemed appropriate to help her with this request. In response, Paul thought an informal tea with the Princess would be a good idea and I was happy to be able to offer the privacy of my home in Wimpole Street.

For about an hour, they spoke in my sitting room overlooking the courtyard. I returned to my upstairs studio and remained out of sight until the conversation had ended, when I escorted Paul to the front door. The Princess and I continued chatting about other matters for some minutes until she left. She sent flowers the next day thanking me for my hospitality and the valuable time she had spent at my home. I think Paul was happy too. Whatever the outcome, it seemed successful on both sides. Paul and I have since been in touch several times throughout the years.

April 1990

One day I received a telephone call from the actor **Dinsdale Landen**, requesting an appointment for a sitting for *Faces of British Theatre*. I searched the list of my chosen people from the theatre community, but he was not mentioned. I was amused to discover that one of his indiscreet colleagues had suggested he should gatecrash the book – we still included his image, albeit at a slightly reduced size.

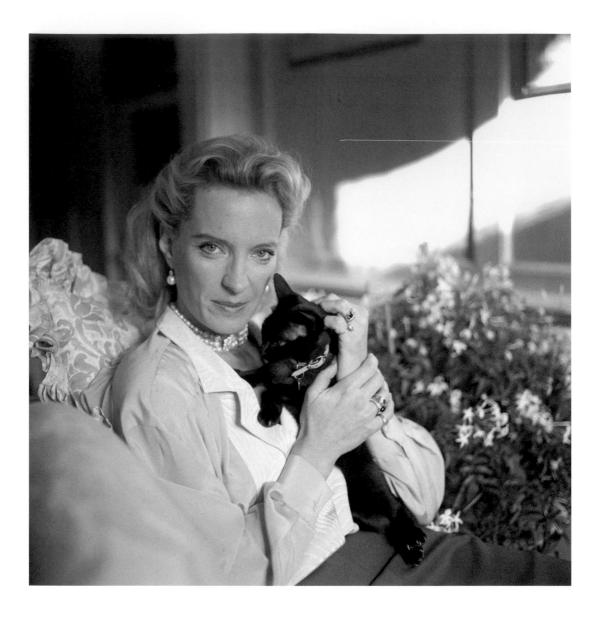

December 1986

I met **Princess Michael of Kent** at Kensington Palace in the midst of preparations for a dinner party that evening. I attempted to photograph in between her giving orders to the staff, with servants rushing in front of me carrying magnums of champagne. It was a difficult task, especially as I kept tripping over her Burmese and Siamese cats, of which there were seven – I was not surprised to see deep scratches on the furniture and heavy stains on the white tablecloths. By contrast, exclusive, expensive Fortuny wall coverings adorned the elegant room. The Princess was natural, with hair uncoiffed, wearing a pink shirt and a brown skirt. I decided to photograph in natural light, without flash lights; I feared that the many cats scampering everywhere might have caught the flex and brought the lamps crashing down.

One Friday morning I was due to photograph **Michael Grade**, then controller of BBC1, when his secretary called to say he would be a little late and could only spare ten minutes, as he had to leave sharply for his next appointment, which was quite a long distance away. This was perfect as it meant I could get my weekend shopping early and be back in time for my next sitting. We had a relaxed session and, as he left, he was most apologetic. He left from the front door, and I left from the back, rushing to Marks & Spencer on Oxford Street. It being a Friday the store was extremely busy. I grabbed a trolley, collected my items and joined the long queue. Directly in front of me I greeted, with basket in hand, a speechless, red-faced and mortified Michael Grade.

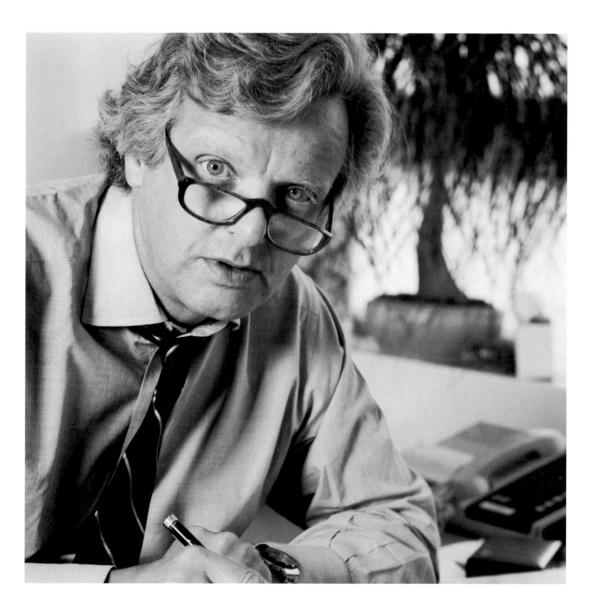

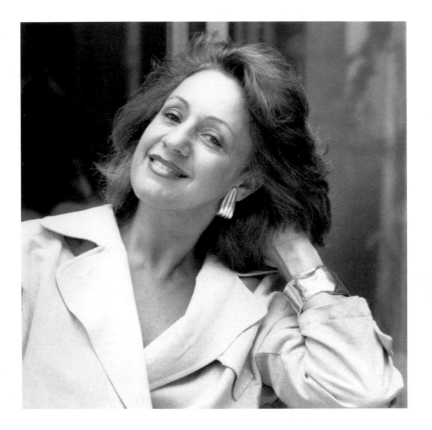

May 1987

Sitting in my secret garden having a drink after our photography session, the actor **Peter Bowles** remarked, 'There should be a photograph of you in the book.' Whereupon he took my Hasselblad and shot just one frame. It turned out to be one of the best photographs anyone has ever taken of me.

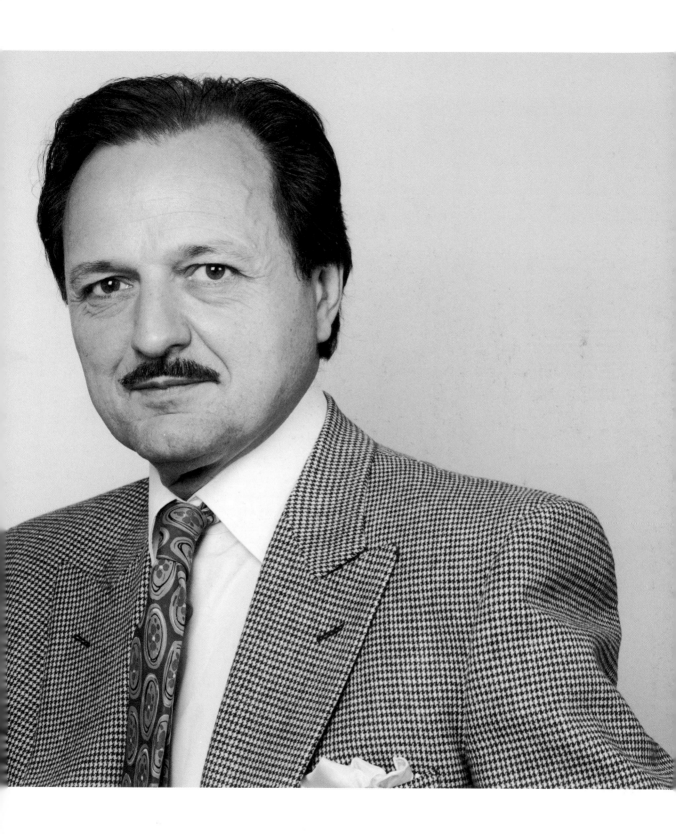

July 1987

On a clear and sunny day, I was due to drive to Henley to photograph the writer **John Mortimer** at home in his garden. Having planned to be there by 3 p.m. to catch the good natural light, I set off on the motorway. However, the traffic was bad, bumper to bumper for several miles. I worried as I watched the light fade and the minutes ticking by. Musing as one does, I was thinking about which of my cameras I should use. Just at that moment I realised I had forgotten them; they were still lying on my studio floor. There was nothing I could do; I was at a standstill. Eventually, we were able to move on, and with a quick turnaround I returned to the studio at great speed, grabbed my equipment and hit the road again. Finally, at 5 p.m., I arrived at John Mortimer's house. Surprisingly, he received me gracefully and I managed to take several shots before the light faded. This photograph is one of my favourites. John's dog, patiently sitting to his right, enjoyed being photographed too. As soon as John rose from his chair, the dog panted after him, quite ready to pose for the next shot. John was sitting barefoot – a short time later he confessed that, as he grew older, he found it too difficult to put his socks on, so it was easier and more comfortable to go barefoot.

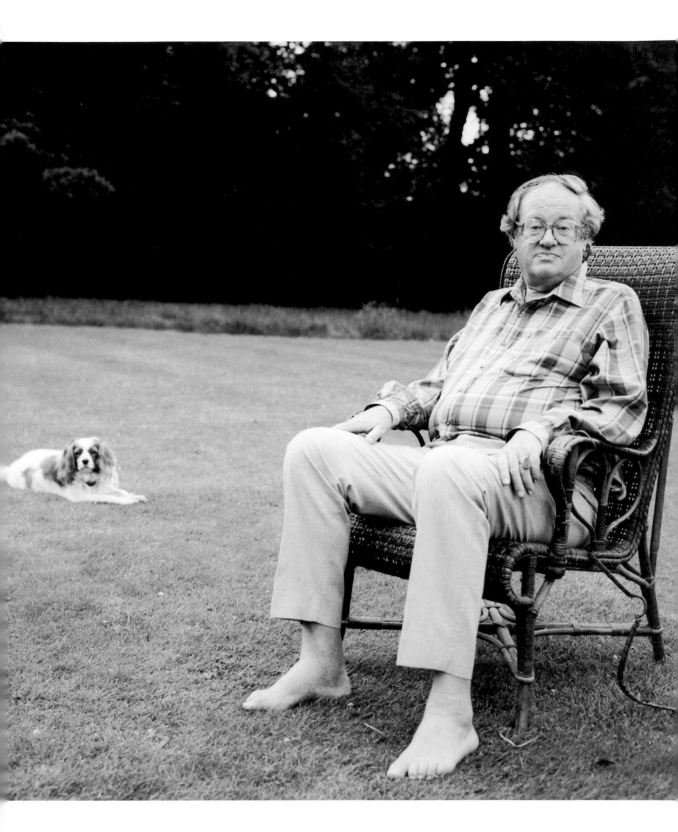

Going with the Flow

AFTER MANY HUNDREDS OF REMARKABLE ENCOUNTERS as a por-
trait photographer, an unfortunate event occurred in my life that set me on a new
path again. One fine English summer day, I returned home to Wimpole Street to
find the traffic had come to a grinding halt, with three fire engines blocking the
road. In the space of an hour, my home and haven had become a mound of cinders
and debris. I was utterly devastated. Everything else in my life was put on hold for
a year while I tried to restore my home. When I was eventually able to move back
in, it was a very strange homecoming, eerily foreign, as though I were living in a
stranger's house. It felt so bare, with so many treasured and irreplaceable items
badly burnt or completely destroyed – books, photo albums, handwritten recipes,
wedding gifts, all gone.

Although it took some time to recover from this shattering misfortune, as
spring came and the lilac trees began to bud, I soon realised I had to move forward
with fresh hope. I started looking for new projects to inspire me. No matter one's
age or experience, there are always new sources of motivation, and I soon found
one, although it turned out not to be a photography project, as such.

In the shocking aftermath of 11 September 2001, I felt it was essential to
do what I could to help raise money for the Twin Towers Appeal. I invited some
leading British photographers to donate their photographs for sale at an auction,
the proceeds of which would go to the charity. The President and Council of the
Royal Academy kindly granted permission for the use of their spacious vestibule
at the top of the main stairway, Sir Harry Solomon, Sir Stanley Kalms and Dogus
International generously sponsored the event, and I gathered together various
friends to help me organise the evening.

Among those photographers who kindly agreed to participate were Brian Aris;
Eve Arnold; Sven Arnstein; Jane Bown; Anthony Crickmay; Jillian Edelstein; Tim
Graham; Marcus Harrison; Barry Lategan; Trevor Leighton; Patrick Lichfield;
Gered Mankowitz; David Montgomery; Terry O'Neil; Sally Soames; John
Swannell; Geoffrey Shakerley; Rankin; and Richard Young. As an added bonus,
Rudolph Giuliani, the mayor of New York, donated twenty of his dramatic

photographs of Ground Zero to the auction. The majority of the photographs were signed and we were able to raise over £150,000.

The dynamic event was opened by Rudolph Giuliani and the auction conducted by Nicholas Bonham, Richard Branson, David Frost and Trevor McDonald. The star-studded guest list attracted a lot of attention – the next day, the press announced that the queue to attend the function, stretching down the pavement all the way from the Royal Academy to Piccadilly, had been at least 400 strong. The whole experience was an inspiration to me, seeing the dedication, hard work and generosity of so many people coming together to help in the wake of such a tragedy. I was extremely proud to have worked on this event. It gave me the opportunity to make a positive contribution on an entirely new level; it felt like the culmination of all my previous work with charities.

It also served as a natural break point in my career, a time to start exploring new ventures.

An opportunity soon presented itself. In 2002, I found a new apartment in Davies Street, just next door to Claridge's. When I was a schoolgirl, my mother regularly took my sister and me, as a treat, for afternoon tea at the Causerie at Claridge's – being one of the most luxurious hotels in London and, for me, the most special. (Now, as a grandmother, I treat Ariella, my eldest granddaughter, to a birthday tea there.)

When I heard the Causerie was due to close, I was immediately hopeful I could embark on a project that had been a private dream of mine: to open a piano bar. I had the support of Alistair McAlpine, and we talked through this lavish plan together and finally approached Claridge's managing director, Christopher Cowdray, but sadly it was not to be; he politely declined, saying they had 'other plans'.

However, Claridge's was to provide me with a completely different opportunity. As the refurbishment of my new flat was due to last three months, I needed somewhere to live in the interim. A friend from the book trade, Terry Maher, told me that the Savoy hotel had hired a Writer in Residence, and suggested that I write a letter to Claridge's to ask if they might consider a Photographer in Residence: in exchange for bed and breakfast for three months, I would photograph guests and staff for their publicity, and the end result would be a publication.

To my surprise, Christopher Cowdray responded positively. I moved into my new quarters on 25 February 2003 into suite 505/6. Bewildered by my newfound

FOLLOWING PAGES: **The grand stairway at Claridge's, London, 2003.**

fortune but happy, I focused on devising a plan for my weeks ahead. I began by constructing a small, narrow studio in the corridor of the suite. I lined the walls with black fabric and created suitable backdrops with cardboard, then set up my Broncolor flash lights and borrowed two simple chairs from the hotel. Within an hour I was set to go and waiting for my first sitter, who was Mr Cowdray's secretary, Pat More.

The very next morning, having been too excited to sleep, I arose at 5 a.m. I was interested to see how a hotel commenced work for the day, and eager to capture it all on film. In the foyer, it was quiet except for the humming of the rotary machines. I photographed the cleaners polishing the vast high-gloss marble floors; the night porter was putting fresh logs on the fire; I watched a man measuring the temperature in order to regulate the air for the guests; the breakfast trolley was wheeled into the hall for early morning guests who were departing. The strong aroma of coffee that wafted through the rooms was an exhilarating start to my day.

My main brief was backstage photography, and each day I covered a different area of the hotel. On reflection, I think I enjoyed photographing in the kitchens most of all: the gleaming pots and pans; the array of fresh foods being prepared; the concentration on decorations and food sculptures; the chefs jostling about looking crisp and chic in their uniforms, with their chef's hats and starched aprons neatly tied in the front. Each morning I would watch and wait for the freshly baked golden-brown croissants to glide along the conveyor belt direct from the ovens, and smuggle one or two into my camera case for a treat later. I was involved in a variety of events and excursions, as well as the day-to-day bustle of the hotel, which were wonderful – such as the executive outings to Billingsgate and Smithfield and the fruit and vegetable markets, watching the chefs select and buy the produce. I was there to photograph, but I learnt a great deal as well.

During the day and evening the place was always buzzing. There was laughter, children running tirelessly up and down the grand stairway, babies in prams placed next to adoring parents during celebratory occasions in the main foyer. The elegant trio of musicians played Gershwin and Cole Porter favourites, adding an air of romance. The paparazzi lined the pavements by the main entrance and passers-by stopped to catch a glimpse of the rich and famous; politicians, film stars and, on occasion, royalty. I even managed to gatecrash an event attended by the Manchester United football team and its manager, Alex Ferguson, who introduced me to a number of the players. Out of the corner of my eye, I spotted a football cast aside on the floor, with signatures inscribed by the key players. Knowing that

in a few weeks I was having my launch party at the hotel, which would include an auction for charity staged by Betty Boothroyd and David Frost, this would be a top-notch prize so I was happy to be allowed to take it with me. On occasions gate-crashing does have its virtues.

There was no end to the variety and surprises. The contribution of each individual person to the operation and spirit of Claridge's was something I tried to capture in the photographs – every picture tells a story of the myriad daily acts that, together, create something unique. It was magic to be a part of this extraordinary world, even if only for three months. I am grateful to Christopher Cowdray, who made my work at the hotel so comfortable and pleasurable. With his guidance, the project was a great success. On the day I left, one of the senior waiters, Giovanni Cappodici, wheeled in my breakfast trolley. He stood back and held himself stiffly upright. Avoiding my gaze, he withdrew from his pocket a small crumpled piece of paper, adjusted his glasses and read the sweetest speech I have ever heard. Tears came to my eyes as I acknowledged this wonderful adventure had finally come to an end.

Having completed this spectacular project, I then moved into my new home in Mayfair, an area synonymous with glamour, wealth and style. I was instantly struck by its pulse: the people; the architecture; the elegance. I knew immediately that this colourful neighbourhood was another place I wanted to explore with my camera. So, I went with the flow … and what a captivating area it turned out to be. It has been home to a long list of notable residents over the years: Winston Churchill lived next door to the cigar shop in Mount Street; Benjamin Disraeli lived in Curzon Street; Robert Peel, Charles James Fox, John Adams had all lived there; and, of course, HM Queen Elizabeth II, who was born at 17 Bruton Street on 21 April 1926.

I walked endlessly, through four seasons, admiring the architecture, attempting to capture the spirit and style of the village. I quickly became familiar with the local residents and soon discovered the most popular restaurants and pubs, including Scott's in Mount Street, where one sees all the celebrities coming and going. In contrast, Shepherd Market has a unique blend of Bohemian style with a cosmopolitan air; little sandwich bars and cabman's shelters that serve hot drinks and snacks from wooden huts on the pavements. I visited, behind the scenes, the fashion houses and their workshops (including Dougie Hayward and Hardie Amies), which constituted a much-loved and vibrant part of Mayfair for many years. Dougie Hayward passed away soon after the book was published; the man and his shop are still sadly

missed by the community. I ventured into art galleries; arcades; private gambling clubs and social clubs; churches; environmental services; the medical centre; shops; schools; secret gardens; street life and seasonal festivals, all to reveal the lively spirit of Mayfair.

A particularly intriguing experience was visiting the disused underground station at Down Street, which was closed in 1932. It was the secret wartime headquarters where Winston Churchill met with the cabinet during the air raids. I was escorted by the police, wearing protective clothing to walk through knee-high

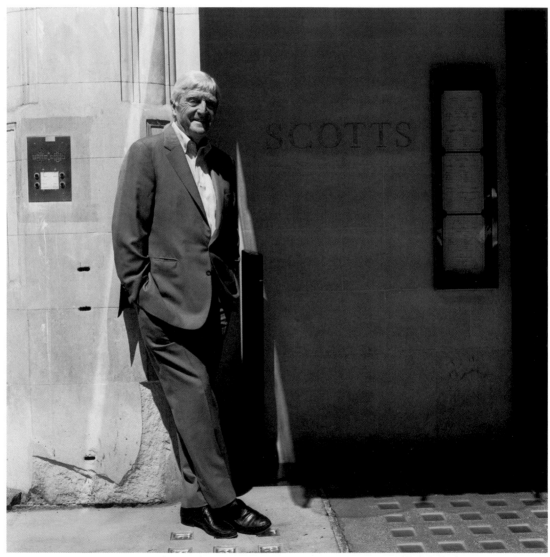

ABOVE: **Michael Parkinson standing at the entrance of the newly furbished Scott's Restaurant in Mayfair, 2008.**

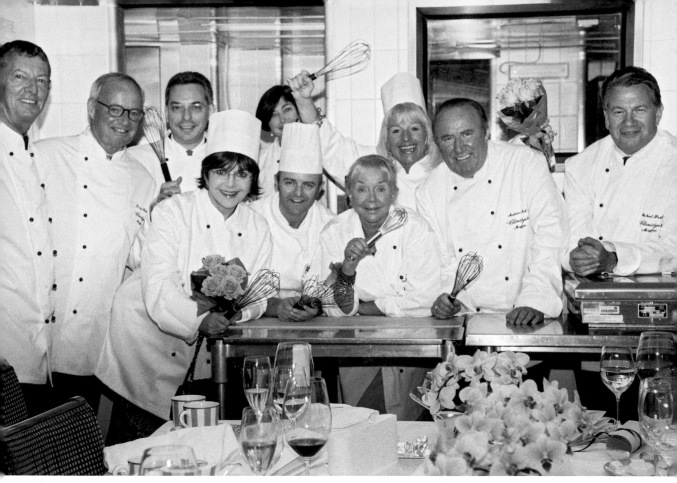

ABOVE: Lunch in the chef's kitchen at Claridge's with (from left to right): Roger Eldridge, Terry Maher, Councillor Robert Davis, Dr Miriam Stoppard, Gill Christophers, Martyn Nail, Sarah Kennedy, Carol Thatcher, Andrew Neil and Michael Portillo. FOLLOWING PAGES: Shepherd Market, Mayfair: a village in the heart of central London.

trenches of water. I photographed (without flash, as it was not permitted) the committee rooms, offices, dormitories, bathrooms and the old lift shafts, although it was too dangerous to go onto the train platforms. It reminded me vividly of my trip to Yorkshire, crawling through the mines for my Henry Moore book, and, fascinating though it all was, when it was over I found myself thankful once again to be standing in the fresh air above ground.

Having completed the project, to thank my most loyal supporters I arranged an interactive lunch in the chef's kitchen at Claridge's organised and orchestrated by Martyn Nail, the executive chef. I invited Andrew Neil, Carol Thatcher, Michael Portillo, Miriam Stoppard, Terry Maher, Sarah Kennedy and Robert Davis. We all had great fun preparing the meal, under Martyn's direction, and making a general mess of his immaculate professional kitchen. With everyone laughing and joking, it became out of control; wooden spoons were thrown in the air and flour scattered

everywhere, even over my lens! We also initiated a competition, boys versus girls: who could scrape out the remnants of the soufflé bowl fastest, using just their finger? The prize was a whisk!

This book, published simply as *Mayfair*, was a joy to create and I greatly appreciated the opportunity to work with historian Martin Gilbert, who wrote the introduction, and Michael Portillo, who contributed a series of lively texts on the six main squares that make up the village of Mayfair. Piecing together a view of such a special place at a specific moment in time, and bringing it all together in a

BELOW: Former Conservative cabinet minister Michael Portillo, now a broadcaster and writer, encapsulated the spirit and style of Mayfair in his texts for the book.

book, was challenging and wonderful. I have always loved capturing the world that surrounds us and meeting people from all walks of life; and I never planned to stop. To retire from my work would be to retire from life, and I looked forward to more plans and ever greater inspiration. But it is impossible to know what is around the corner; and things should never be taken for granted. Shortly after completing this book, my life took an unexpected turn.

◆ ◆ ◆

'You have cancer ...' might possibly be the most terrifying words a person could ever hear. Inevitably, my life changed course in an immediate and dramatic way.

For two years, sessions of chemotherapy and radiotherapy became my new routine. I was reliant on the support of my family and friends. My son suggested that I set up a 'chemo buddy' list, of people who might like to sit with me for an hour each week. This turned out to be a marvellous idea, as I looked forward to these times when I could focus on other people rather than my own problems. At weekends, every Friday, my friend Michael Bernstein popped through my letter box a different DVD each week, knowing I was not able to focus on reading. This too was a great joy and an enormous comfort.

On returning home after my operation, the porters from my block of flats fetched and carried for me. Food was packed into the fridge, mainly by my sister; flowers placed everywhere. One of my favourite restaurants, the Wolseley, sent a taxi delivering a three-course meal for two with all the trimmings. It was a splendid celebration for my first meal back home. My thanks to you, Jeremy King.

The result of my operation left me with lymphoedema, which has affected the strength and mobility of my right arm and hand. I can no longer use my heavy film cameras. This has been a devastating blow. However, there is always humour to be found in terrible situations. One day I was in Waitrose, carrying a large basket of groceries on my left arm and unable to carry two bottles in my right. I asked a man in a smart dark suit to help me, thinking he was a manager; with charm and grace he said he would be delighted and guided me to the checkout, smiled and left me to pay. Another man in a smart dark suit came up to me, introduced himself as the manager of the food department and enquired if I knew whom I'd just asked for assistance. When I told him I didn't, he hesitated and said with a flush of embarrassment, 'That gentleman is the King of Sweden,' and pointed to a gathering by the cheese department surrounded by Swedish flags. Red-faced, I went on my way.

Once I had become used to the routine of my treatments, I started searching for something to occupy my mind and keep me busy. At my clinic, the LOC, Leaders in Oncology Care, I had met some remarkable people, from Professor Paul Ellis to all the nursing staff. I chatted during treatments to many of the patients, and soon started to wonder if perhaps I could produce a positive book to help other cancer sufferers.

It would have to be completely different from all the books I had done before, as I was no longer able to use my equipment. Regardless, I decided that the project

would be worthwhile. I would need to take shots of the clinic, simple portraits of the writers and any details that caught my eye, so I needed a small, light camera that I could hold in my left hand and shoot instantly. And so I purchased my very first digital camera, a Lumix.

I jotted down endless lists of people; the chapters would contain essays from medical practitioners, researchers, support staff, therapists, make-up artists, the media, mastectomy specialists and experts from Paxman, the company that makes the Cold Cap device – a remarkable invention designed to reduce hair loss during cancer treatments. I wrote to a few of my famous sitters from my previous books and invited them to write one or two positive lines to head each chapter. The response was heart-warming.

Samantha Cameron, whom I had previously met in Chipping Norton in 2005, offered me a party at No. 10 Downing Street for my favoured charity, which I immediately accepted before she could change her mind. I had already decided to donate my royalties from the book to the Maggie's Cancer Caring Centres, so it seemed perfect to offer this spectacular event to them also. I very much hoped, by working with Maggie's, and by writing the book itself, to be able to offer some comfort and help to the many people who were undergoing similar experiences.

The experience of having cancer was horrific; like so many other sufferers, I was worn out with the treatments and stress. I am now physically weaker and I bitterly regret the loss of my cameras, which for so many years had been like an extension of my arm. But, having come through it all, I find that I have a renewed energy, which I have not felt for some time. More importantly, the experience has confirmed for me that quality in life is to be found in relationships, whether family or otherwise. When I reached out, when I needed help and support, people – friends, family, even incredible people I had only just met – responded with a warmth and generosity I could never have imagined.

◆ ◆ ◆

There have been so many moments, people and places that have influenced me during my life. Some, like Henry Moore, shaped my development as an artist; and some people had an effect on other areas of my life. I feel it important to recall here one individual: Elisabeth Bergner. Elisabeth was born in 1897 in what is now Ukraine, but was then an outpost of the Austro-Hungarian empire. We first met at a dinner party in 1985; I was unaware at first that she had been an internationally renowned actress. Upon introducing ourselves, she asked in which year was I born, and when

I replied 1939, she enquired if my mother had had an interest in films. I thought this was a strange question but, when I responded, the mystery soon unfolded.

Elisabeth had been nominated for an Oscar in 1935 for a film entitled *Forget Me Never*, in which she played a character called Gemma Jones. Apparently the name Gemma was unusual at that time, and she wondered if my mother had been influenced by this film when naming me. She even took the trouble to visit my mother in her dress shop to ask her. On hearing that this was indeed the case, they celebrated by opening a bottle of champagne (at eleven o'clock in the morning!).

Elisabeth was interested in my recent work in Israel, as Jerusalem had meant so much to her throughout her life, her faith being very important to her. I hesitated, and then, embarrassed, I revealed that I was writing a series of poems on Jerusalem, and that they were being displayed alongside my photographs in an exhibition in the Jerusalem Theatre. The passion I felt for my work, for the people and places I photographed, sometimes went beyond my vision through the lens, and touched me deeply; and on these occasions I was moved to write poetry. It was Elisabeth who made me realise how poignant my poems were and it was she who persuaded me to give readings.

On visiting Elisabeth, walking into her sitting room I was in awe of seeing so many framed theatrical photographs on her very large grand piano. Each time I went there was a tall, deep red amaryllis that had been freshly placed in a single vase on the piano. That was the first time I had seen amaryllis, and now I too have white ones each week, when in season. On the book stand sat a large copy of the Bible with a worn red silk marker keeping the place from her last reading. It was a striking room filled with remarkable memorabilia from floor to ceiling. Her life must have been full with rich memories.

After several very pleasant meetings over a mint tea or coffee at her home, she asked me if I would appreciate some tuition so that I would be able to read my poems publicly without feeling awkward or embarrassed. At school I had been chosen for a minor role in a production of *The Rivals*. My one line was, 'You jest, Lydia,' which came out as, 'Your chest, Lydia.' That was the beginning and end of my acting career. So I accepted her offer gratefully and had a dozen sessions or so.

Sadly, she became ill not long after, and our meetings became less frequent. She died in 1986. My regret is that I did not photograph her; she did not wish to be remembered as she looked towards the end of her life.

After her death I gave many poetry readings. Elisabeth had taught me to hold myself well. To breathe, enunciate, to use punctuation in the right places and, most

of all, to express myself with delicacy. Learning in this way from a great artist was inspirational, and everything she taught me in those months has continued to guide me through the years. Since knowing her, my name has taken on a new meaning: that simple tribute my mother made to Elisabeth's role was important to the actress, and was what brought us together. Without her friendship, I would never have been able to face an audience with courage.

Having come through the journey of cancer, I now look back on the life I lived before, and anticipate the life that stretches ahead with the same passion and enthusiasm I had in my youth. I am grateful for my many adventures; reading through my diaries while writing this memoir has made me realise just how fortunate I have been, how much joy and happiness I have experienced, and how blessed we all are to be here each day.

'I went with the flow which carried me through. I looked at the angel eyeball to eyeball, one of us blinked and it wasn't me … I refused.'
RABBI JONATHAN SACKS

ABOVE: A summer's day by the pond at Bliss Mill, Chipping Norton, Oxfordshire.

Afterword

ALL MY PROFESSIONAL LIFE I have photographed people, and my focus has been on them. The obvious exception is my last book, *Go with the Flow*, published in 2012, which was about my journey through cancer. Health, as we all know, is the most important issue in our lives; without it, none of us has any real advantage. The foreword for this memoir has been written so sensitively by Paul Ellis, professor of medical oncology at LOC: Leaders in Oncology Care. I asked Paul to write this foreword to demonstrate something poignant.

The richest moments of my professional life occurred during the years in which I was strong, vibrant and healthy. When I was diagnosed with cancer in 2010, I did not know what I would be able to do, or achieve. I retained my self-respect and was determined to do something valuable with each day as it came, but you don't know what you can do until you stand up and try.

Rabbi Jonathan Sacks recently gave a Yom Kippur sermon on the topic of change. This made me reflect that even without good health – without, in my case, the full use of my right arm, which is essential to my life as a photographer – we are not predestined to continue to be what we were. But change can be a positive thing nonetheless. If we are eloquent and visionary and retain our courage, then we will have the strength to grow. One of the most important things I have learned is that our greatest creation is our self.

I conclude by paying tribute to the people who, throughout my career, have opened a window into their worlds for me and given of themselves so generously. As a result of this, my life has been rich, varied and unforgettable. But at the heart of my existence, throughout all those years, has been my family. Watching my sons succeed and grow through the decades, into the people they are today; both vibrant individuals, and an honour to their father and to me.

Exhibitions

DURING MY CAREER I have held over sixty exhibitions, most of them in the UK and a few in Israel. I would like to mention some that represented interesting or crucial moments in my career and have proved particularly memorable.

1977: My very first exhibition was in a small gallery in Marylebone, the Casson Gallery. The owner, an acquaintance, saw my watercolours of the changing seasons in parks in London together with the photographs I took in colour, in order to paint from the images, and immediately wanted to create an exhibition. On one wall were the photographs and on the opposite wall the watercolours. The exhibition was titled 'Four Seasons' and was exhibited for a month. She sold several of the paintings, but not the photographs. It was particularly exciting as I was very much still an amateur and this was my first attempt to expose my work.

1977: I became a member of the Arts Club in Dover Street, London. At the time I was working on my books with Henry Moore and the directors encouraged me to exhibit as many photographs as I could, which were shown for several months at a time. This was an excellent venue – there were so many important artists as members and regular visitors as well, so it was great exposure for me. Together with a friend of mine, Linda Agran, who was the script director at Thames TV and a director of Euston Films, I started a monthly luncheon, inspired partly by the Bloomsbury Group. We invited writers, intellectuals, philosophers and artists, and it proved popular. The conversation was electric and the exchange of views at times quite controversial … but always interesting.

I encountered a great number of fascinating people this way: it was there that I met Elisabeth Frink, the sculptor. We used to swap photographs for drawings, which I still display on my walls today. Many times I visited her and her husband at her studios in Dorset for lunch, with the table always laid up for at least twenty people, most of whom were artists and publishers. It was there that I also met Christina Foyle, which led to a number of invitations to the legendary Foyles literary lunches at the Dorchester Hotel.

1978: The Arts Council put on a large black-and-white exhibition of my Henry Moore photographs at the Serpentine Gallery in London to mark Henry

ABOVE: **Lord Forte with Gemma Levine at the Arts Club, London, 1978, where many of her photographs of Henry Moore were exhibited in 1977.**

Moore's 80th birthday, entitled, 'With Henry Moore'. It was on view for three months. This was very special for me.

1982: I had an unusual exhibition erected at the National Theatre in Jerusalem. Teddy Kollek, the mayor of Jerusalem, chose a selection of my watercolours, photographs and poetry on the subject for a display called 'My Jerusalem'. I had not exhibited all three different arts in an exhibition before, nor in fact since. 'My Jerusalem' was again shown in 1983, but this time only the poetry and photographs, at the Royal Festival Hall and then at the House of Commons.

1982: HM The Queen inaugurated the Henry Moore Centre for the Study of Sculpture at the Leeds City Art Gallery, where a selection of my photographs was on view. In 1984, my photographs from the book *Henry Moore: Wood Sculpture* were also shown at the gallery, and again in 1985 at the House of Commons.

BELOW: **Lord Gowrie with Gemma Levine at the opening of the 'Henry Moore's Wood Sculpture' exhibition at the House of Commons, London, in 1985.**

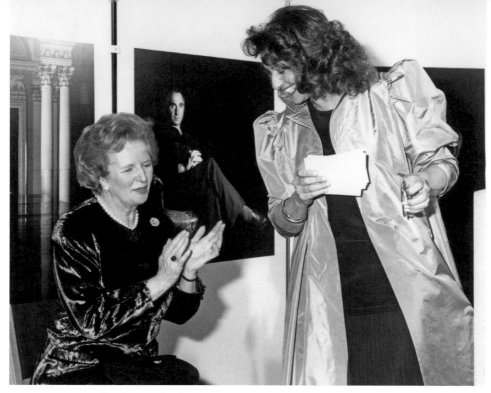

ABOVE: **Margaret Thatcher applauding Gemma Levine's speech, given at the launch of the exhibition 'Faces of the 80s' at the Barbican, London, in 1987. The prime minister had opened the event.**

1984: I invited four of the most distinguished photographers to visit Israel and produce photographs of their individual expertise: Lord Snowdon for portraits; Lord Lichfield for landscapes; Sir Geoffry Shakerley for archaeology; and Eric Hosking for wildlife. I initiated and coordinated the programme, liased with Teddy Kollek, the mayor of Jerusalem, and hosted the photographers for two weeks. I learnt a great deal from watching Snowdon photographing people in different settings such as in churches, the desert, cities and so on. I travelled with him each day so was able to observe from close proximity. The exhibition, entitled 'Impressions of Israel', was shown at Selfridges, London, opened by HRH Prince Andrew.

1987: I held the largest exhibition of my life, entitled 'Faces of the 80s', at the Barbican. Margaret Thatcher opened the event, where I exhibited 300 photographs. She walked around the exhibition asking me questions about several of the personalities. I was quite nervous and, embarrassingly, forgot some of their names. We had an auction for the Leukaemia Trust, with Jeffrey Archer and David Frost taking the hammer; £8,000 was raised on Margaret Thatcher's portrait alone. It hit the headlines!

1990: HRH Prince Edward opened my exhibition at the Royal National Theatre: 'Faces of British Theatre'. It ran for one month before being shown at

ABOVE: **Prince Edward with Gemma Levine at the launch of the exhibition for 'Faces of British Theatre' at the Royal National Theatre, London, 1990.**

Camera Press, in London. This exhibition was my most striking visually as the walls were covered with enlarged versions of my photographs – the one of John Gielgud was over 6 feet high. Jonathan Miller, a prolific force in British theatre, had written the introduction to the book, and he spoke on the state of flux in the British theatre and how hard it was to predict how things would settle down as we entered the last years of the twentieth century.

1996: At the Café Royal, on London's Regent Street, I created a 'Masked Venetian Extravaganza', an event to raise money to restore the auditorium of the opera house Teatro La Fenice. I made murals for the walls using enlarged grainy black-and-white photographs of Venetian piazzas, canals and buildings, and also crafted Venetian poles, symbolizing the waterways of the city. I invited an opera singer, David Romano, whom I had met in Venice, to perform at the event, and he sang throughout the evening during the elegant dinner. Nigel Hawthorne made the appeal, and the evening was a great success, selling out and raising sizeable funds. The event required a great deal of detailed attention and work, but it was a wonderful project and worth every moment of my time.

2001: To celebrate twenty-five years of my photography, the National Portrait Gallery held a retrospective exhibition of twenty-five portrait photographs of actors, politicians, dancers, philosophers and lawyers who had made a major contribution in their field. This event was perhaps the most prestigious recognition of my professional life. Baroness Betty Boothroyd launched the proceedings. Amongst the guests were many of my sitters, whose portraits were on display throughout the gallery.

2003: I gave my entire photographic archive from the months I stayed at Claridge's Hotel to the Maybourne Hotel Group.

2005: I gave my collection of Israel photographs to the Hebrew University on Mount Scopus, Jerusalem. The Osborne Samuel Gallery erected an exhibition for the public and a separate event for students from Queens College London. A lecture on the content of the archive was delivered by Moshe Raviv, a former ambassador of Israel, and myself.

2010: Tate Britain acquired my complete Henry Moore archive; photographs and tape recordings of my talks with him, used as the text for my books. The gallery exhibited my photographs and I was also given the opportunity to present slide lectures to the public.

ABOVE: **Gemma Levine with Henry Moore recording text for the book *With Henry Moore* in 1978; this material was also later used in her lectures at the Tate Gallery.**

Chronology of Exhibitions

1975 'Personalities', Café Royal, London.

1977 'Four Seasons', Cason Gallery, London.

1978 'With Henry Moore', Serpentine Gallery, London; Arts Club, London; Henry
 Moore Foundation, Perry Green, Much Hadham, Hertfordshire; Berkeley
 Square Gallery, London; The Catto Gallery, Hampstead, London.
 'British Artists', Arts Club, London.

1982 'My Jerusalem', Jerusalem Theatre, Israel.
 'Henry Moore', Tel-Aviv University, Israel.

1983 'My Jerusalem', House of Commons, London.
 'Henry Moore: Wood Sculpture', Barbican, London.
 'My Jerusalem', Royal Festival Hall, London.

1984 'Tel-Aviv Faces and Places', Tel-Aviv Museum, Israel.
 'With Henry Moore', The Royal Festival Hall, London.
 'Henry Moore: Wood Sculpture', Leeds City Art Gallery.

1985 'Henry Moore: Wood Sculpture', House of Commons, London.
 'Ethiopian Jews', The Sternberg Centre, London.

1987 'Faces of the 80s', Barbican, London; Claridge's Hotel, London; Berkeley
 Square Gallery, London; Virgin Airways Terminal 3 Heathrow, London; Scott's
 Restaurant, London; House of Commons, London.

1990–1 'Faces of British Theatre', The Royal National Theatre, London; Camera Press,
 South Bank, London.

1995 'Gemma Levine – 20 Years of Photography', The Tom Blau Gallery at Camera
 Press, London.
 'People of the 90s', The Tom Blau Gallery at Camera Press, London.
 'Henry Moore', Sotheby's, London.

1996 'People of the 90s', Claridge's Hotel, London.
 'Venice Extravaganza', Café Royal, London.

1998 'Memories', The Dorchester Hotel, London.
 'Memories', Chipping Norton Theatre, Oxfordshire.

2001 'Retrospective to Celebrate 25 Years of Photography', National Portrait Gal-
 lery, London.

2004 'Claridge's – Within the Image', Claridge's Hotel, London.

2005 'Israel Retrospective', Osborne Samuel Gallery, London; Hebrew Jerusalem
 University, Israel (where the archive remains).

2008 'Mayfair', Sotheby's, London; The Lansdowne Club, London; Claridge's Hotel, London; Mayfair Library, London.

2010 'Henry Moore', Tate Britain, London (where the archive remains).

2012 'Go with the Flow', Westbury Hotel, London.

Chronology of Publications

1978 *Israel: Faces and Places* (foreword by Golda Meir), Weidenfeld & Nicolson (UK); GP Putnam's Sons (USA)
Living with the Bible, Weidenfeld & Nicolson (UK); Morrow Books (USA)
With Henry Moore: The Artist at Work, Sidgwick & Jackson (UK); Times Books (USA)

1981 *We Live in Israel*, Wayland Educational (UK)

1982 *Living in Jerusalem*, Wayland Educational (UK)
The Young Inheritors, Dial Press (USA)

1983 *Henry Moore: Wood Sculpture*, Sidgwick & Jackson (UK); Universe (USA)

1985 *Henry Moore: An Illustrated Biography*, Weidenfeld & Nicolson (UK); Grove Press (USA)

1987 *Faces of the 80s* (foreword by Margaret Thatcher, text by Jeffrey Archer), Collins (UK)

1990 *Faces of British Theatre* (introduction by Jonathan Miller, preface by John Gielgud), Prion (UK)

1995 *People of the 90s* (foreword by HRH the Princess of Wales, text by Sheridan Morley), HarperCollins (UK)

1998 *Memories* (foreword by Jonathan Miller), Ebury Press (UK)

1999 *My Favourite Hymn* (foreword by Prince Michael of Kent), Robson Books (UK)

2004 *Claridge's: Within the Image* (foreword by David Frost), Collins (UK)

2008 *Mayfair* (foreword by The Duke of Westminister; Introduction 1. by Martin Gilbert; 2. Introduction by Michael Portillo), Collins (UK)

2012 *Go with the Flow* (foreword by Daniel Hochhauser), Quartet (UK)

2014 *Just One More ... A Photographer's Memoir* (foreword by Professor Paul Ellis), Elliott & Thompson (UK)

Acknowledgements

I WOULD LIKE TO OFFER MY APPRECIATION to those who have supported me with enthusiasm, when I have needed guidance and reassurance, specifically: Michael Bernstein, Susan Bradman, David Elliott, Rachel Johnston, Lilian Hochhauser, Adam Levine, Dr James Levine, Terry Maher, Bernie Martin, David Mitchinson, Dr Nazeer, Peter Osborne, Madhu Palma, Rachel Paul, Zelda Pomson, Mike Shaw, Denise Sinclair, and Sir Harry Solomon.

A particular mention goes to my friend Pat Froomberg, who always supported me with her friendship, crystal clear judgement and sense of humour. Pat sadly passed away in 2011, before she could witness this memoir.

I would also like to acknowledge the Management of the Health Club at The Marriott Hotel, Park Lane, where each morning my swim has been an essential part of my day in order to write this book.

My gratitude to the Hulton Archive, part of Getty Images, who not only syndicate my photographs but who also kindly provided the digital scans for this book, and a special mention to Paul Prowse for his time and significant help.

In admiration and gratitude to Ann Harezlak, art historian and curator, who worked tirelessly on translating my Henry Moore archive from film into digital at the Tate Gallery and is instrumental in collaborating with me on current lectures on Henry Moore.

To Professor Paul Ellis and the Leaders in Oncology Care (LOC), who have generously contributed to this memoir.

A big thank you to Richard Caring, who so graciously hosted the launch party at No. 34 Grosvenor Square, Mayfair, and to Baroness Boothroyd, my celebrated guest of honour.

And thanks also to my publisher, Elliott & Thompson: Lorne Forsyth, the chairman, who permitted me to join his long list of authors, and Jennie Condell, my editor, who has worked diligently with me throughout the development of the book. Jennie has proved outstanding in her meticulous attention to detail and her perception of the work. My thanks also go to the fantastic team surrounding her: Karin Fremer, who designed this book so stunningly, Pippa Crane and Alison Menzies.

Index

Page numbers in *italic* refer to illustrations.

ABOVE: **Self-portrait, 1988.**

Biography

With a gift for creating unobtrusive settings that reflect the individual style of her sitters, Gemma Levine's career has encompassed hundreds of encounters with the most well-known and fascinating people in Britain. She has published 20 books, most recently *Go with the Flow*, describing her journey through cancer; and she has shown over 60 exhibitions around the world, including a celebration of 25 years of her work at the National Portrait Gallery in 2001. A Fellow of the Royal Society of Arts, Gemma lectures at Tate Britain on Henry Moore, and images from her extensive archive are regularly seen in the media. She lives in London and Chipping Norton, Oxfordshire, and has two sons.